Bruce Lee

THE CELEBRATED LIFE
OF THE GOLDEN DRAGON

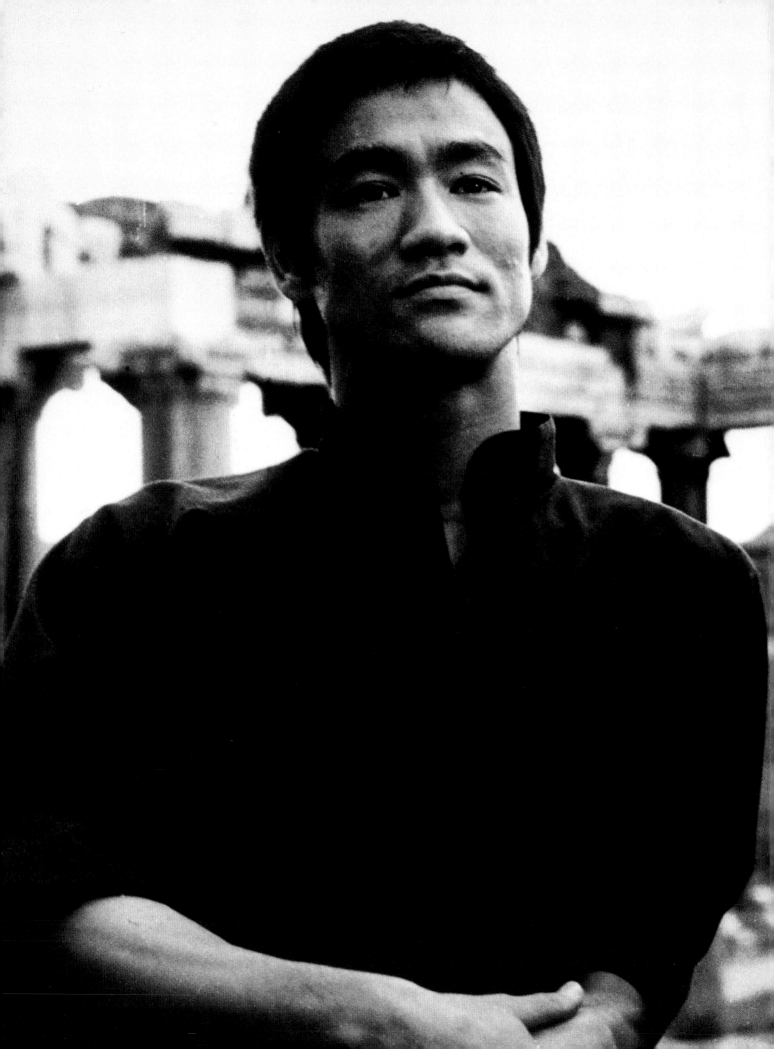

Bruce Lee

THE CELEBRATED LIFE
OF THE GOLDEN DRAGON

TEXT BY BRUCE LEE

SELECTED AND EDITED BY JOHN LITTLE

Based on the award-winning Warner Bros. documentary
Bruce Lee: In His Own Words by John Little

Tuttle Publishing
Boston • Rutland, Vermont • Tokyo

First published in 2000 by Tuttle Publishing, an imprint of Periplus Editions (HK) Ltd,
with editorial offices at 153 Milk Street, Boston, Massachusetts 02109.

Library of Congress Cataloging-in-Publication Data
Cataloging in Progress

ISBN:0-8048-3230-7

Distributed by

North America
Tuttle Publishing
Distribution Center
Airport Industrial Park
364 Innovation Drive
North Clarendon, VT
05759-9436
Tel: (802) 773-8930
Tel: (800) 526-2778
Fax: (802) 773-6993

Asia Pacific
Berkeley Books Pte Ltd
5 Little Road #08-01
Singapore 536983
Tel: (65) 280-1330
Fax: (65) 280-6290

Japan
Tuttle Publishing
RK Building, 2nd Floor
2-13-10 Shimo-Meguro,
Meguro-Ku
Tokyo 153 0064
Tel: (03) 5437-0171
Fax: (03) 5437-0755

First edition
07 06 05 04 03 02 01 00 10 9 8 7 6 5 4 3 2

Book Design by Dutton & Sherman Design
Printed in Hong Kong

Contents

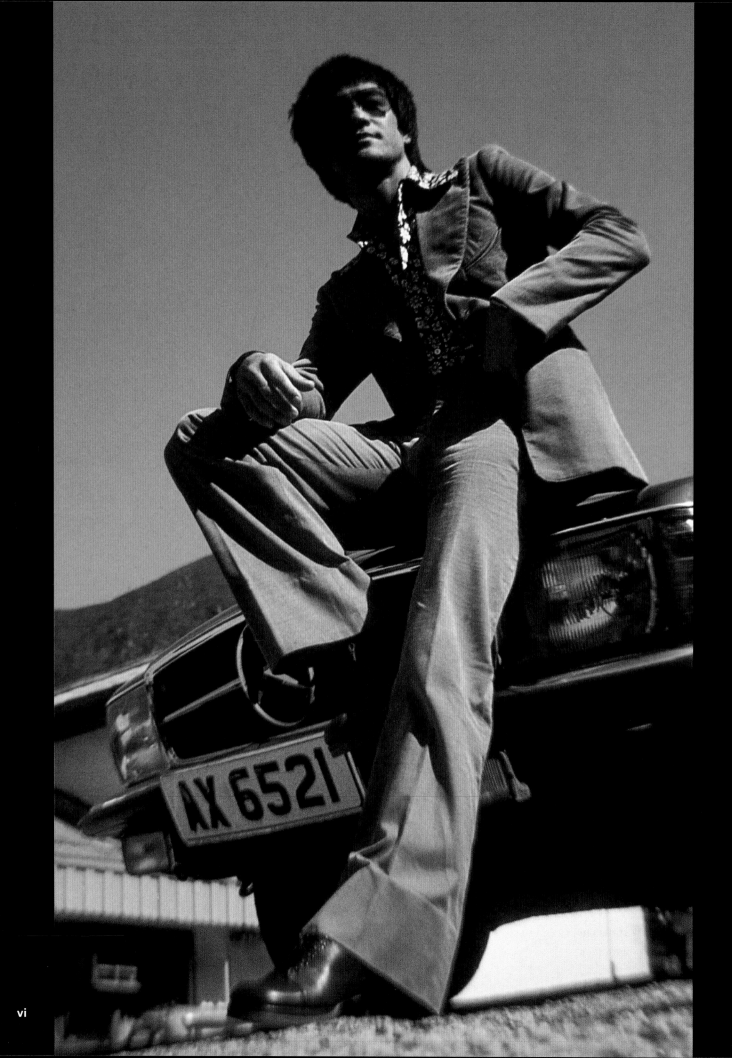

Preface

INSPIRATION, THE FATHER

The term "martial art" can be troubling. I know that I have given it some thought over the years. How is it art? When one thinks of art, the usual images come to mind—paintings and sculpture. As a matter of fact, when you look up the definition of art in the dictionary, the first expositions are just these. There are references to music, literature, drawing, and on a more simplified plane, there is mention of the "aesthetically pleasing arrangement of words, colors, sounds, shapes, and the like."

Further definitions of "art" go on to describe it as "forms of human activity whose chief character is determined by a meaningful arrangement of elements," and "any system of rules and principles that facilitates skilled human accomplishment." Martial art has rules, and it is human activity. It requires skill and accomplishment. But what strikes me here are the words "meaningful" and "human." Why? Art is human expression and it has the utmost of meaning for the artist. And, martial art, when taken to its depths, is the art of expressing the human body; it is the baring of one's individual soul—as all great art should be.

So, martial art can be art—but it takes a true artist to render it to us. Anyone can draw or dabble in paints or bang on a piano or write a story, but artists are interpreters of personal insight. And this is what Bruce Lee was for the martial arts. The life of the artist is the life of self-examination, of honest expression. It is a life of personal extremes, and in going to extremes, we push against the boundaries of creation and change. It is my honest belief that in examining the journeys of artists, we can begin to recognize the necessity of art in our lives and to understand that we can all be artists of our passions, whatever they may be.

Bruce Lee was an artist in the true sense of the word. In his thirty-two years on the planet, he produced volumes of writing on a multitude of subjects. He developed his own system of martial art, he acted in, choreographed, directed, and wrote for film and television, he was the Cha-Cha champion of Hong Kong, and he was a father, a husband, a friend, and a teacher. This is a tall order for anyone, and certainly we all have our own pursuits, but in an appreciation

of all this accomplishment, we can become inspired. And, all he accomplished directly influenced and culminated in his understanding of his art and, ultimately, himself.

This book is the literary realization of the documentary *Bruce Lee: In His Own Words*. The film is a beautiful collage of statement and example. It's an amazing thing for word and deed to walk so gracefully hand in hand. It is my sincere hope that in this medium, you, the reader, can be touched imperceptibly if not dramatically by the beauty of a life truly lived and sculpted—ever a work in progress.

Here in these pages is an originator. And, as you will see, in adventuring into the realm of individual thought, the originator brings us closer to the commonplace; the individual, closer to us all. Bruce Lee said, "I want to think of myself as a human being." It sounds so simple, and, truly, it is. And maybe in striving for this simple thing first and foremost, he shows us the path of our individual journey.

Growing up as Bruce Lee's daughter, I have often been daunted by the example set forth for me to follow. But, as I grow older, I find a greater understanding of the dedication of but a man and the necessity for me to do but one thing: follow the path of my own journey and live in the flow of life's stream.

—*Shannon Lee Keasler*

Foreword

A great many years have passed since my husband Bruce died in 1973. At first, my devastation was complete. Had it not been for the two small products of our union, Brandon and Shannon, the wound may have consumed me. But the wheel of life continued its relentless turning and in the next two decades our children grew strong, happy, and competent to encounter the world.

Bruce's memory has enlarged my heart and enabled me to find a rich and rewarding life. It had been a long time, however, since I recalled Bruce's voice, his laugh, his expressions, his gestures, the very real Bruce that I knew and loved. In John Little's brilliant piece, *Bruce Lee: In His Own Words*, my Bruce is vividly alive again, almost as if he is in the room, so real that I could imagine he was actually speaking to me.

As I watched the film of Bruce, the man, not the actor, tears came to my eyes, and I was transported back to that time when our lives were full of dreams coming true. Listening to Bruce express himself honestly and openly about his beloved philosophy of martial arts, his acting career, his family, his future, was, for a few minutes, like nothing had ever changed.

But of course, on July 20, 1973, with Bruce's death, change did happen. What you are fortunate to see of Bruce in the film and in this related volume is the essence of Bruce, and then there was no more. A few years ago, our son Brandon left to join his father, and with his tragic passing there is but one child left to carry on. We are not alone, however, for in the last twenty-five years Bruce's legacy has endured and our memories have been enriched by the stories of how Bruce's art and philosophy have influenced the lives of so many all around the world.

Chief among those who have enriched our memories is John Little, who, as historian and chronicler of Bruce's work, has adopted Bruce's passion as his own. In projects such as the film and this book, John has caused the legacy to grow and thrive, and thus has allowed Bruce's work to create positive change in the lives of many more who may not have been exposed to Bruce earlier.

For John, the writer, the temptation may have been great to "interpret," or "expound upon" Bruce's words, but for John, the philosopher, it took restraint and, ultimately, respect for Bruce, to let Bruce speak for himself. Our family is grateful to John Little for his soulful presentations of Bruce. It's been a very long time and we rejoice in seeing Bruce, as we knew him, once again.

—*Linda Lee Cadwell*

Introduction

Much to my surprise—and delight—my documentary film *Bruce Lee: In His Own Words* quickly became something much more than a poignant tribute to a man who died tragically young. I was fortunate that, immediately upon seeing a rough cut of the film, Warner Bros. snatched it up for distribution, making it the premium in their 25th anniversary re-release of Bruce Lee's greatest film, *Enter the Dragon*, in May of 1998.

Brian Jamieson, of Warner Home Video International, shared my long-held passion for Bruce Lee as well as my desire that people be exposed to facets beyond the mere physical prowess of his martial artistry. People who knew Bruce Lee—his friends and students Taky Kimura, Allen and Annie Joe, and Ted and Krina Wong in addition to those, such as John Saxon and Bob Wall, who worked alongside him in his films—have gone out of their way to tell me how great it was to "be with Bruce again." For it was Bruce Lee, the human being, rather than the legend

he has become, who they knew and it was *that* Bruce Lee I had hoped to bring back to life—if only for nineteen minutes in the documentary that had long existed only in my mind's eye.

Bruce Lee believed that we can communicate with each other fully only when we honestly express ourselves, and, with this counsel foremost, it was obvious to me that the best way to communicate the essence of Bruce Lee—the human being—was to fashion for him a platform from which he could forthrightly express himself. That is to say, the best way to make a film or book about Bruce Lee was to simply get out of his way and allow him to make it. Bruce Lee is his own best ambassador and hearing from him directly, speaking on issues that were significant to him, is far more substantive and meaningful than going the typical documentary route of simply having a bunch of talking heads sputtering away—decades after the fact—about what he was like.

It is my sincerest hope that the film, and this book, will clear the decks of misperceptions and serve to introduce you to a different Bruce Lee—the real one you might otherwise remain unacquainted with. Bruce Lee was not merely an actor—that was only one of his professions—he was a man who single-handedly created a new genre of film, a profound thinker and philosopher who amassed over 2,500 books in his personal library, and an avid researcher in psychology and psychotherapy, Eastern and Western philosophy and poetry, the health sciences, and physical fitness, in addition to being the innovator of a revolutionary approach to martial art that allows personal freedom and the seeking out of one's own path to replace centuries-old dogma and traditions.

Without question, the most important aspect of Bruce Lee's character was his unconditional love for humanity, most particularly his wife, Linda, and their two children, Brandon and Shannon. Ironically, no film or documentary prior to *Bruce Lee: In His Own Words* ever focused on these human qualities, preferring instead to highlight Lee as the greatest fighter of the 20th century.

I chose to use black and white for the film because it is, I believe, a far more powerful medium when the topic is a serious one, allowing the audience to focus on what is being said and on the expression of the individual's eyes and gestures—without the distraction of various colors meandering through the scene. The film profiles a relaxed and contemplative, although at times highly animated, Bruce Lee talking about his life, art, and philosophy. To obtain the audio and video materials of Lee speaking in his own voice was a task requiring extensive sleuthing in three countries—Hong Kong, America, and Canada. Lee's widow Linda Lee Cadwell provided additional home movie, audio, and photographic materials from the Lee estate.

Unfortunately, only one video interview with Bruce Lee had survived (aptly titled *Bruce Lee: The Lost Interview*, © 1994 Little-Wolff Creative Group), and of the three or so audio recordings of conversations with Bruce Lee in existence, only one was of sufficient quality to justify its incorporation into the film.

Fortunately, in this book, unlike the film, there is a far greater range of material to work with, including all of the titles I've had the privilege of editing for Linda Lee Cadwell that, collectively, comprise *The Bruce Lee Library Series* from Tuttle Publishing. This has allowed me to create here a far more comprehensive presentation of Bruce Lee's legacy, still in his own words. I've included within the pages of this book much of the dialogue and appropriate images from the film, but I've also been able to add "autobiography" so you can read at first hand what Bruce Lee himself has to say about his own life and development, rather than having to rely on the interpretation of a biographer or a Bruce Lee

"authority." Again, the prime authority on Bruce Lee and Bruce Lee's life is Bruce Lee himself. In this new material, you will hear from him directly as he tells you about his childhood, traveling to America, working in the United States, playing "Kato" on *The Green Hornet* television series, teaching martial art, his view on each of the completed films that made him so justifiably famous and, more poignantly, his plans for the future and his ability to look at life in perspective and as a whole.

The balance of the book follows as closely as possible the format of the film, treating Lee's belief that nationalities and martial art styles, such as judo and karate, serve only to separate human beings rather than to unite them. Additionally, Lee reveals his views on handling superstardom without letting the trappings of success blind him to his humanity. And, finally, Lee shares with the reader his philosophy of life and his prescription for dealing with challenges—whether they be specific challenges to fight or, metaphorically, any of life's adversities or more demanding times.

In addition, Lee discusses the need to always remember how important family is and how he wanted to be remembered more for being simply a good human being than for any of his other magnificent accomplishments.

As with all of the Bruce Lee–related projects I've been honored to have been associated with, this book, like the film, was created primarily for an audience of two: Linda Lee Cadwell and Shannon Lee Keasler, Linda and Bruce's daughter. By far the greatest compliment I will ever receive came in the form of a phone call from Linda shortly after she had viewed an advance copy of the film on video. I had asked her to watch it the first time by herself, so that it would just be she and Bruce, alone together again, after a period of some twenty-five years. During our telephone conversation, she confessed that she had found herself weeping and that "it was like Bruce was in the room with me again. I found myself really, really missing him after watching this." For Linda to have been affected like that was one of the most gratifying and moving experiences of my life. To be able to reunite a wife with her husband, a daughter with her father, and a human being with his closest friends, if only through video, and to stir strong emotions and move people is the very purpose of art.

I'm keenly aware that, with each Bruce Lee project, I'm dealing with a man's legacy. My hope is that, one day, when Bruce Lee's grandchildren ask their mother, "What was grandpa *really* like?" Shannon will reach for copies of *Bruce Lee: In His Own Words* and this book and tell them, "Here, why don't you see for yourselves?"

—*John Little*

A Chronology of the Life of Bruce Lee

SAN FRANCISCO

- November 27, 1940. Bruce "Jun Fan" Lee is born in the "hour of the dragon" (between 6:00 a.m. and 8:00 a.m.) and the "year of the dragon."

- February, 1941. Appears in his first film. He is three months old.

HONG KONG

- 1946. Begins to film the first of what will total 18 Chinese-language films before the age of 18.

- 1952. Enters La Salle College, a Catholic boys school.

- 1953. Begins to study Gung Fu under the venerated grandmaster Yip Man, of the Wing Chun system.

- 1958. Wins the "Crown Colony Cha-Cha Championship."

- March 29, 1958. Enters St. Francis Xavier high school.

- April 29, 1959. Departs Hong Kong for America.

U.S.A.

- May 17, 1959. Arrives by ship in San Francisco.

- September 3, 1959. Arrives in Seattle, Washington. Enters Edison Technical School—Fall quarter.

- December 2, 1960. Graduates from Edison Technical School.

- May 27, 1961. Enters the University of Washington—Spring quarter.

HONG KONG

- March 26, 1963. Returns to visit his family for the first time in four years.

U.S.A.

- August, 1963. Returns from Hong Kong. Leaves the University of Washington after Spring quarter 1964.

- July 19, 1964. Leaves Seattle to establish a Gung Fu Institute in Oakland, California.

- August 2, 1964. Performs at the International Karate Tournament in Long Beach, California.

- August 3, 1964. Starts Gung Fu instruction in Oakland.

- August 17, 1964. Seattle. Marries Linda Emery.

- February 1, 1965. Oakland. Bruce and Linda's son, Brandon Bruce Lee, is born on Chinese New Year's Eve day in the "year of the dragon."

- February 8, 1965. Bruce's father, Lee Hoi Chuen, dies in Hong Kong.

- March, 1966. The Lee family moves to Los Angeles, California.

- June 6, 1966. The shooting of *The Green Hornet* television series begins.

- February 5, 1967. Officially opens the Los Angeles chapter of the Jun Fan Gung Fu Institute.

- July 1967. Names his way of martial art "Jeet Kune Do."

- May 6, 1967. Performs at National Karate Championships in Washington, D.C.

- June 24, 1967. Appears at All-American Open Karate Championship at Madison Square Garden in New York.

- July 14, 1967. Hired to appear in one episode of the *Ironside* television series.

- July 30, 1967. Performs at the Long Beach International Karate Tournament.

- June 23, 1968. Attends the National Karate Championships in Washington, D.C.

- July 5, 1968. Hired as the technical director for the movie *The Wrecking Crew.*

- August 1, 1968. Hired to play a bad guy in MGM's *Little Sister* (later renamed *Marlowe*).

- October 1, 1968. Moved into Bel Air.

- November 12, 1968. Films an episode of the television series *Blondie* for Universal.

- April 19, 1969. Santa Monica. Bruce and Linda's daughter, Shannon Emery Lee, is born.

HONG KONG

- 1970. Returns to Hong Kong with his son, Brandon, to visit his family.

U.S.A.

- 1970–1971. Works with actor James Coburn and screenwriter Stirling Silliphant on a screenplay about the philosophy of the martial arts entitled *The Silent Flute*.

- June 27, 1971. Films the premiere episode of the television series *Longstreet* for Paramount.

- 1971. Begins to collaborate with Warner Bros. on developing a television series called *The Warrior* (later renamed *Kung Fu*).

THAILAND

- July 1971. Films *The Big Boss* (called *Fists of Fury* in North America), which breaks all previous box office records in Hong Kong, for Golden Harvest Studios.

HONG KONG

- December 7, 1971. Receives official word that he will not star in *The Warrior* and that the part has been given to American Caucasian David Carradine.

- December 9, 1971. Records what will prove to be his only surviving on-camera interview with Canadian journalist, Pierre Berton. Portions of this interview are incorporated into the documentary film *Bruce Lee: In His Own Words*.

- 1972. Films second film for Golden Harvest, *Fist of Fury* (called *The Chinese Connection* in North America), which breaks all records set by his last film, *The Big Boss*.

- 1972. Forms his own production company, Concord, and makes his directorial debut in *The Way of the Dragon* (called *Return of the Dragon* in North America), which, again, shatters all previous box office records in Hong Kong.

- October–November, 1972. Begins preliminary filming of fight sequences for his next film, *The Game of Death*.

- February, 1973. Interrupts filming of *The Game of Death* to begin filming *Enter the Dragon* for Warner Bros.

- July 20, 1973. Bruce Lee passes away in Hong Kong, his death the result of a cerebral edema caused by hypersensitivity to a prescription medication.

U.S.A.

- July 31, 1973. Laid to rest in Lakeview Cemetery, Seattle. His pallbearers are friends and students Steve McQueen, James Coburn, Dan Inosanto, Peter Chin, Taky Kimura, and his younger brother, Robert Lee.

Bruce Lee

THE CELEBRATED LIFE
OF THE GOLDEN DRAGON

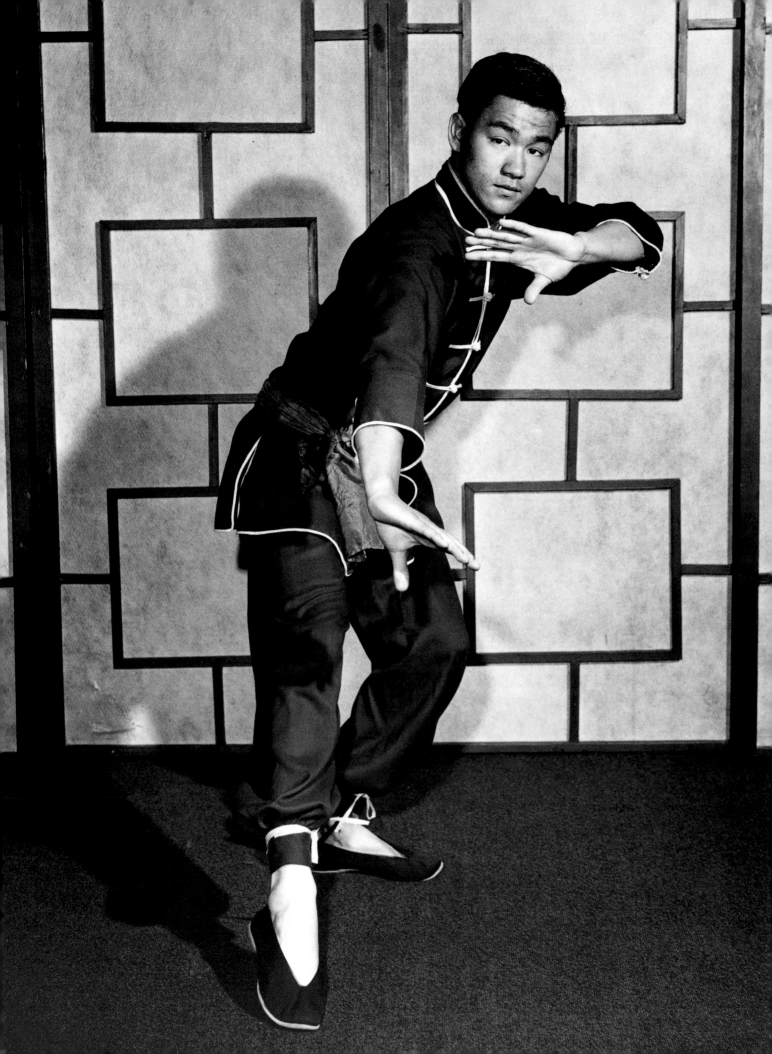

Early Years

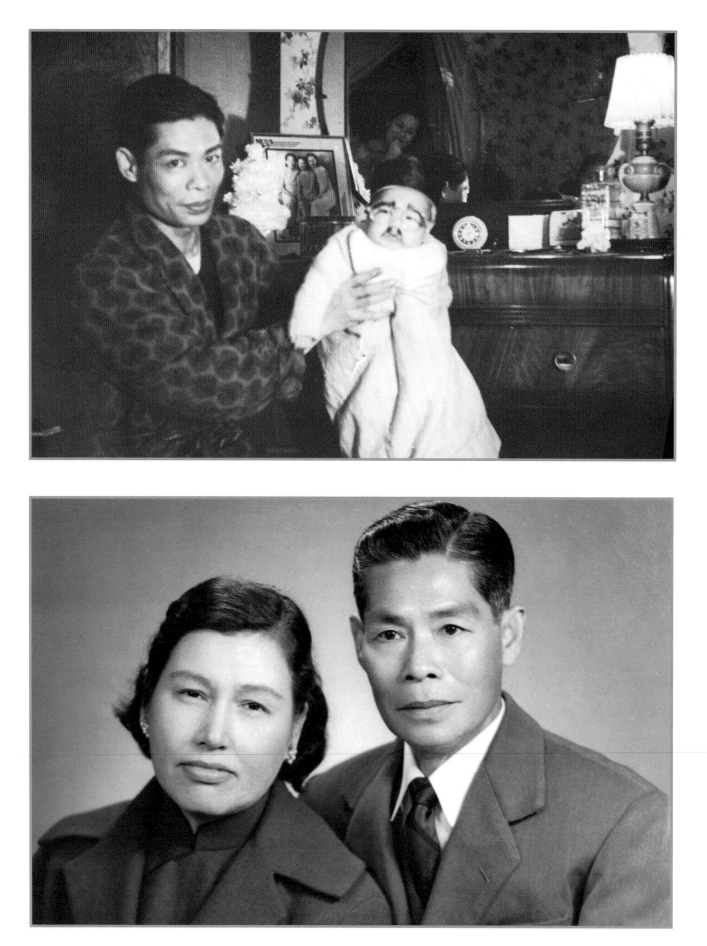

My name is Lee. Bruce Lee. I was born in San Francisco on November 27, 1940. My birth name is Lee Jun Fan. "Bruce" is a name I later acquired from one of the nurses in the hospital because it was Western and easy to remember.

My father spent a lot of time traveling. I was born when he brought along my mother on one of his performance trips in the United States. Yet, my father did not want me to receive an American education. When I reached three months of age, he sent me back to Hong Kong—his second homeland—to live with his kinsmen. [Living in Hong Kong] was a very crucial experience in my life. I was confronted with genuine Chinese culture. The sense of being part of it was so strongly felt that I was enchanted.

I didn't realize it then, nor did I see how great an influence environment had on the molding of one's character and personality… Nevertheless, the notion of "being Chinese" was then duly conceived.

That I should be an American-born Chinese was accidental, or it might have been by my father's arrangement. My father, Lee Hoi Chuen, was a famous artist of the Cantonese opera and was very popular with the Chinese people.

I started acting when I was around six years old.

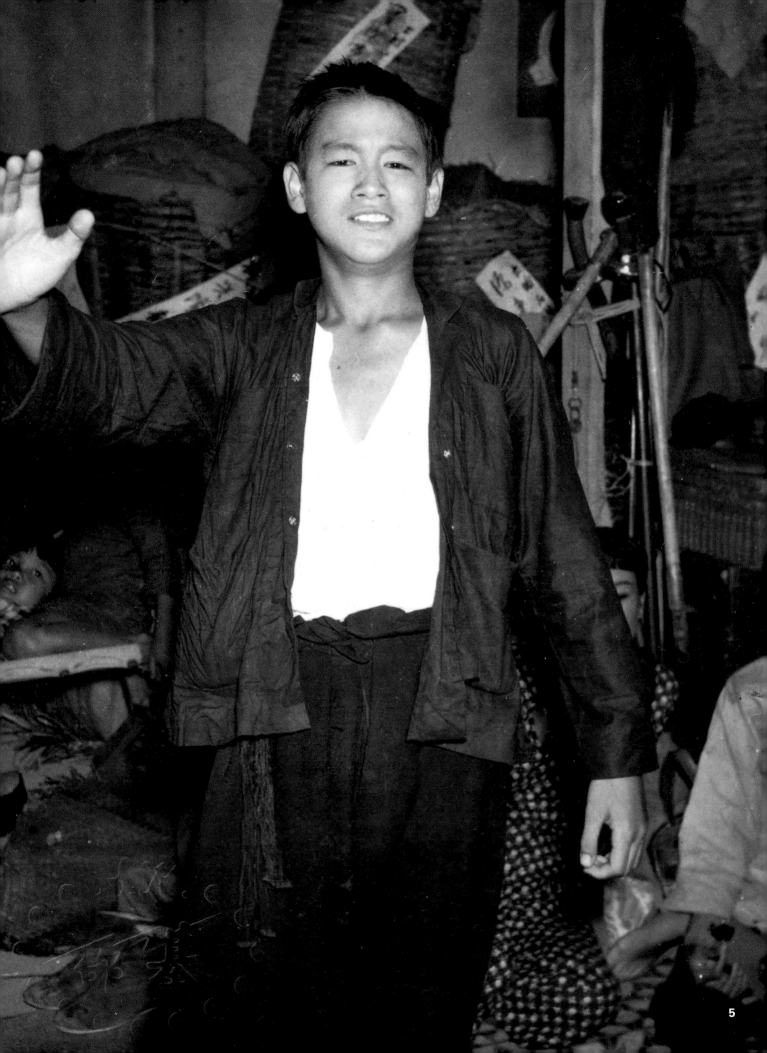

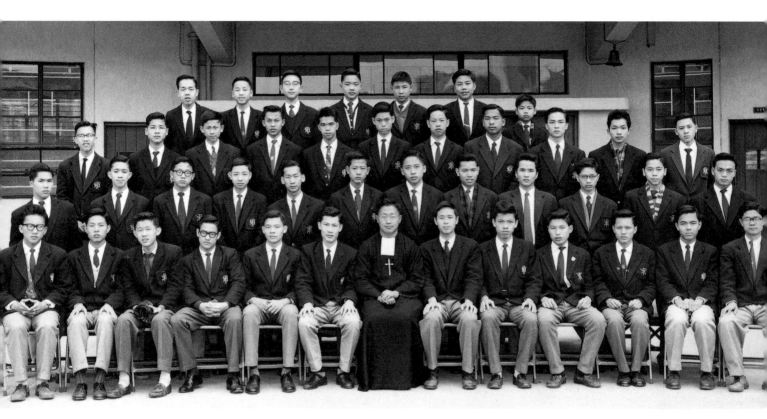

[Above] When my mother went to church on Sunday, my father sat at home. This didn't seem to worry her—and it didn't worry my father that she was sending me to a Catholic school [Bruce at St. Francis Xavier, Hong Kong—1st row, 4th from left.]

[Below] My father was then well acquainted with lots of movie stars and directors. They brought me to the studio and gave me some roles to play.

Up until I was around 18 years old, I did primarily "co-starring" roles.

It could have been a matter of heredity or environment, but I came to be greatly interested in the making of films when I was studying in Hong Kong. [Bruce on the set of **The Big Boss;** *his first starring role would prove to be an unprecedented success.]*

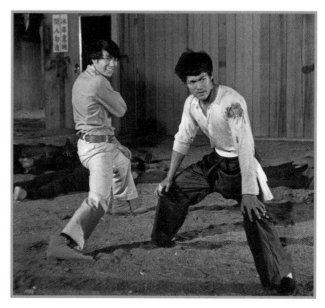

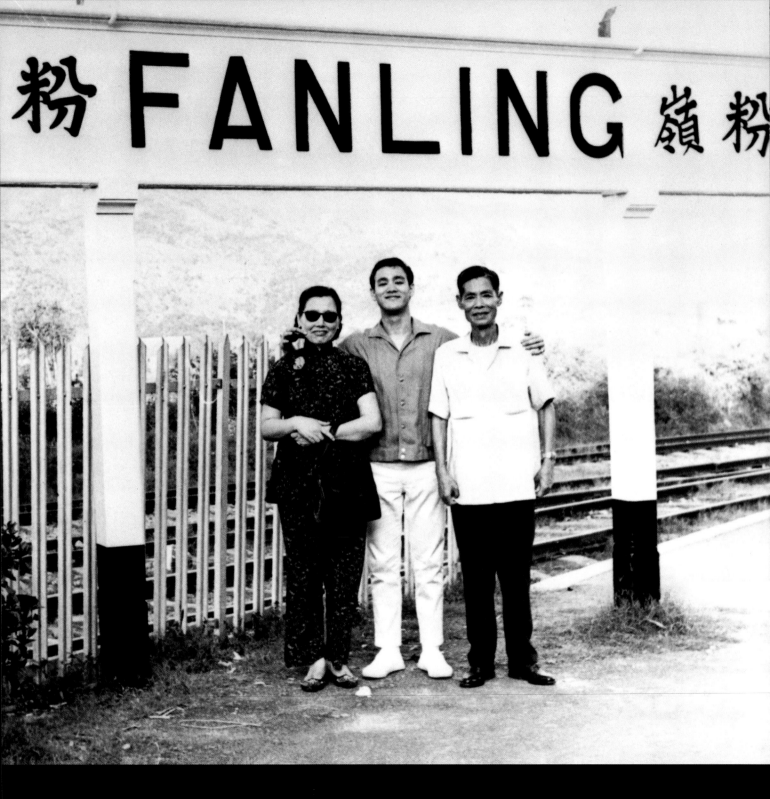

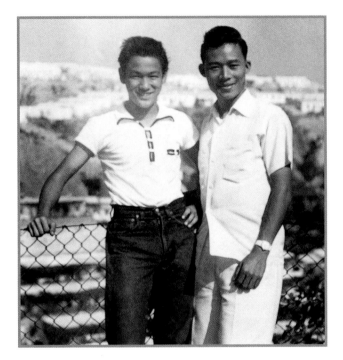

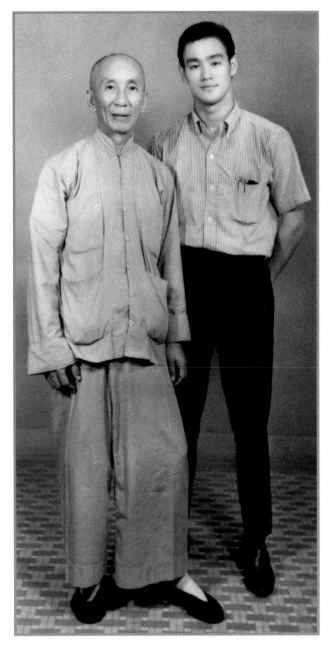

From boyhood to adolescence, I was a bit of a troublemaker and was greatly disapproved of by my elders. I was extremely mischievous and aggressive.

Then, when I was thirteen, I wondered one day what would happen if I didn't have my gang behind me if I got into a fight. I decided to learn how to protect myself and I began to study gung fu. I studied under Yip Man. He was my instructor in a Chinese martial art. It was from Mr. Yip that I took up the style of wing chun.

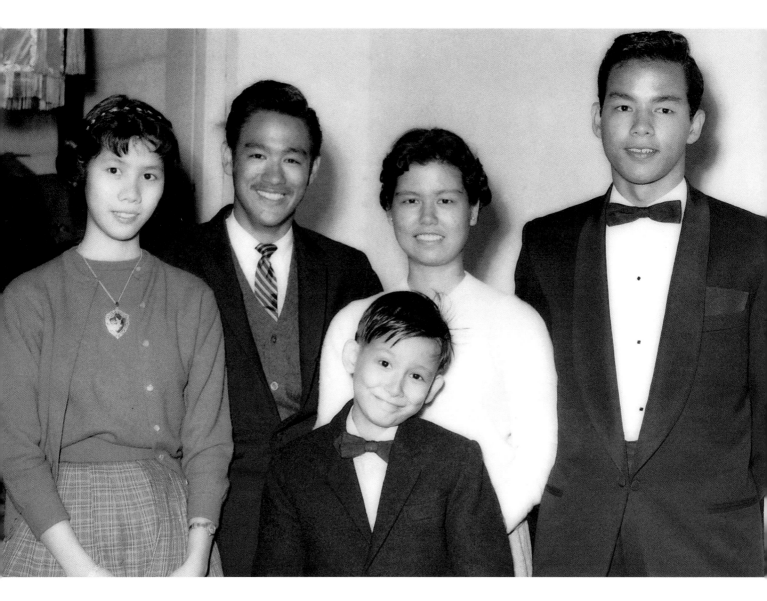

A Chinese boy growing up in Hong Kong knows that if he disgraces himself, he brings disgrace upon all his kin—upon a great circle of people. And I think this is good. [Bruce, 2nd from left, with his siblings—from left to right— Phoebe, Agnes, Peter. Younger brother, Robert, is in front.]

There was a time when a Chinese son could never—never—contradict his father, but that's no longer true except in the very rigid, old families. Things are a little more relaxed than that in most households. [Right: Bruce with his father, Lee Hoi Chuen.]

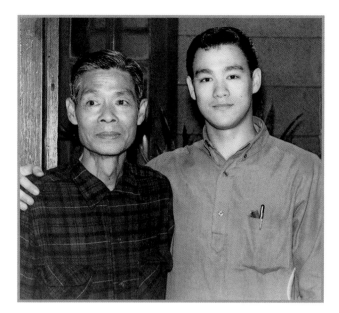

After four years of training in gung fu, I began to understand and feel the principle of gentleness—the art of neutralizing an opponent's effort and minimizing the expenditure of one's energy. All this must be done in calmness and without striving. It sounded simple, but in actual application it was difficult.

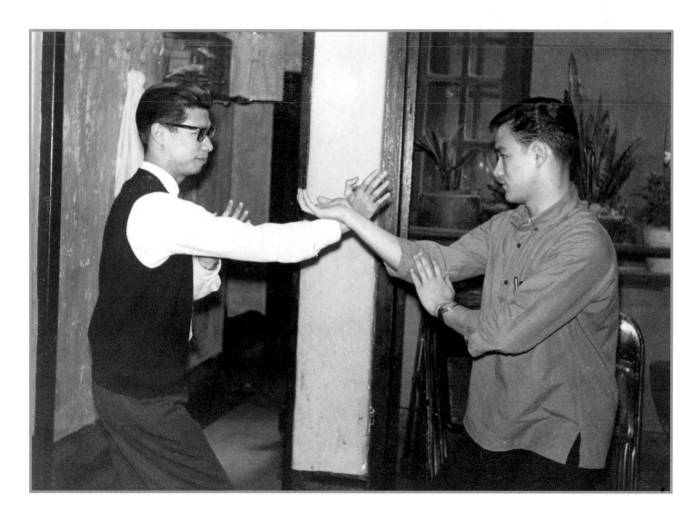

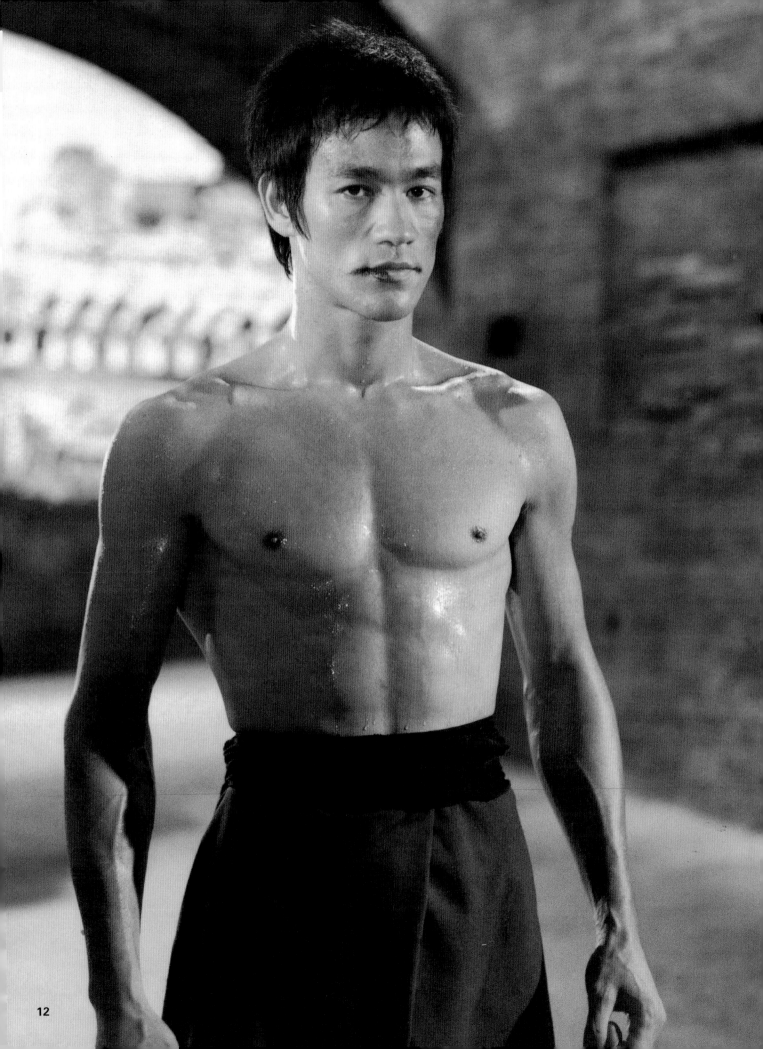

Definitely in the beginning I had no intention—whatsoever—that what I was practicing, and what I'm still practicing now, would lead to this.

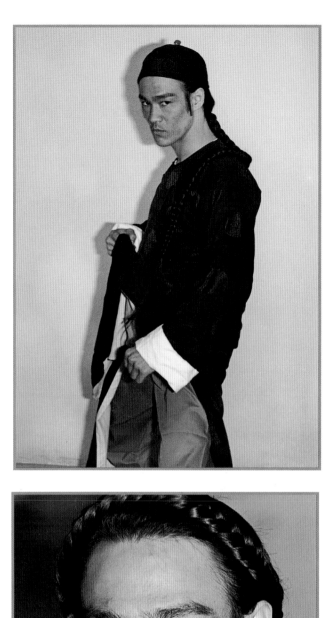

But martial art has a very deep meaning as far as my life is concerned.

Because as an actor, as a martial artist, as a human being—all these—I have learned from martial art.

I came back to the United States in 1959. I wanted to further my education, so I went to Seattle to study philosophy at the University of Washington.

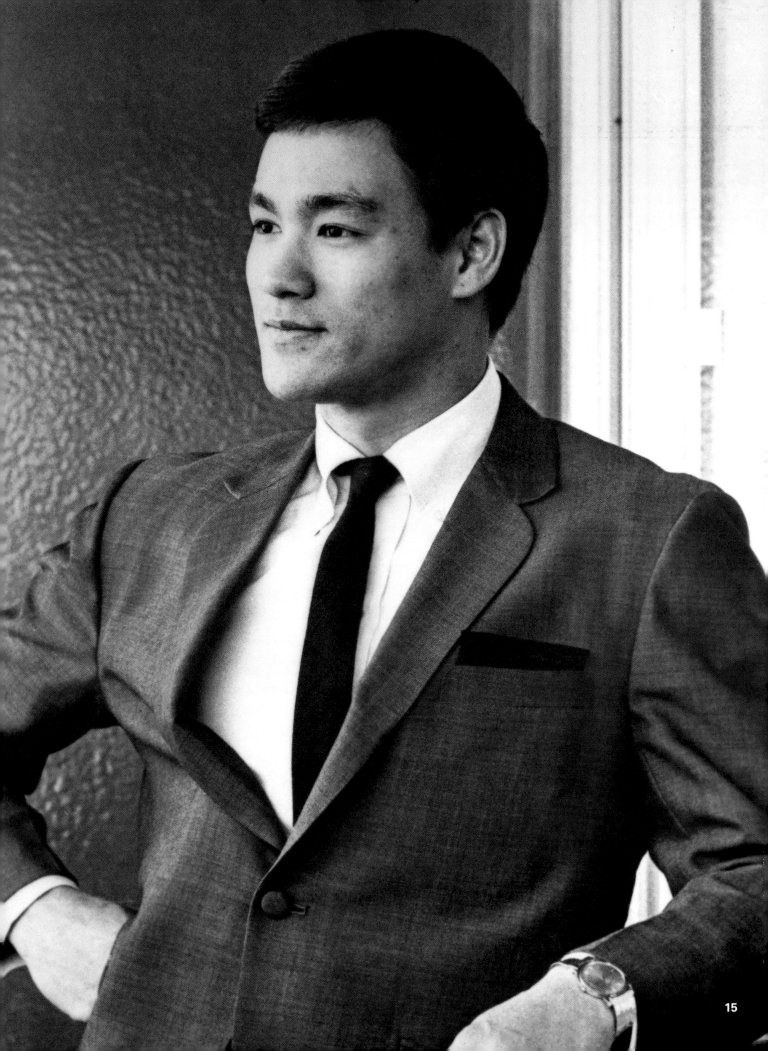

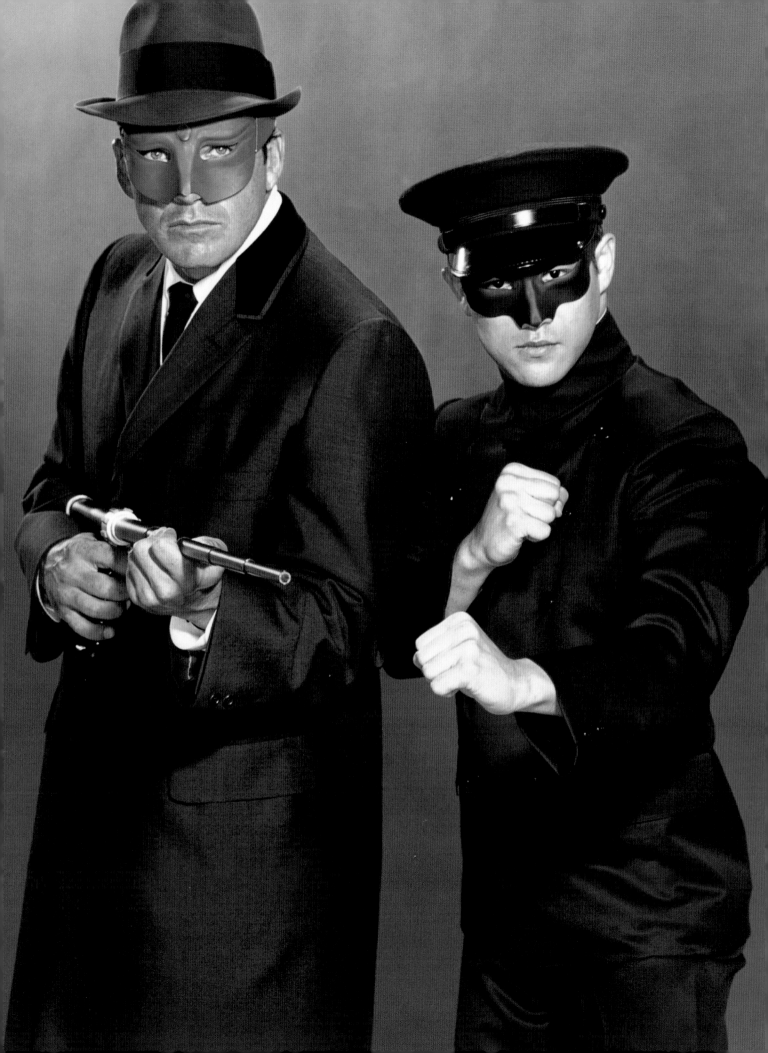

Hollywood

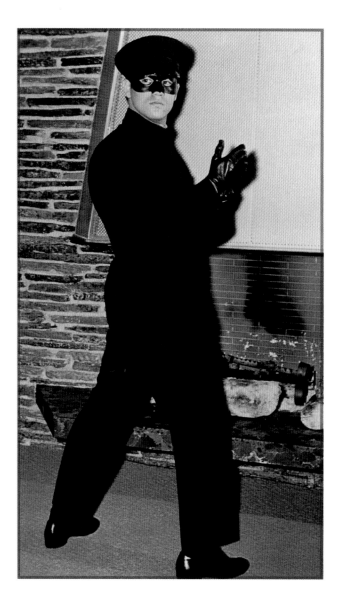

You know why I got that Green Hornet *job? I'll tell you why I got that* Green Hornet *job. Because the hero's name was "Britt Reid," and I was the only Chinese in all of California who could pronounce "Britt Reid," that's why!*

In 1964, just about the time I discovered that I really didn't want to teach self-defense for the rest of my life, I went to the Long Beach International Karate Tournament [where] I gave a demonstration. A Hollywood producer, William Dozier, just happened to be in the audience. That night I received a phone call at my hotel for a tryout. Early next morning, I stopped by 20th Century Fox and was hired to be Charlie Chan's "Number One Son." They were going to make it into a new "Chinese James Bond" type of a thing. Now that, you know, the old man, Chan, is dead, Charlie is dead, and his son is carrying on.

Anyway, the Charlie Chan movie never got made because, while I was attending a one-month private crash course on acting, *Batman* came along and everything started to be going into that kind of a thing [so] the producer changed his mind and decided that I would be Kato instead. It sounded at first like typical houseboy stuff. A producer said he wanted me to play "a Chinese." You know, I mean, here I am a Chinese—and, not being prejudiced or anything but thinking realistically, how many times in film is a Chinese required? And when he is required, I immediately could see the part—pigtails, chopsticks and "ah-sos," shuffling obediently behind the master who has saved my life.

I wanted to make sure before I signed that there wouldn't be any "ah-sos" and "chop-chops" in the dialogue and that I would not be required to go bouncing around with a pigtail. I told Dozier, "Look if you sign me up with all that pigtail and hopping around jazz, forget it." In the past, the typical casting has been that kind of stereotype. Like with the Indians. You never see a human-being Indian on television. But it turned out to be better. So, you know, he signed me up and I did *The Green Hornet.*

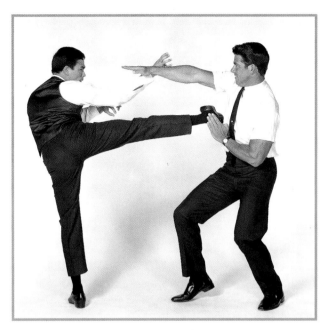

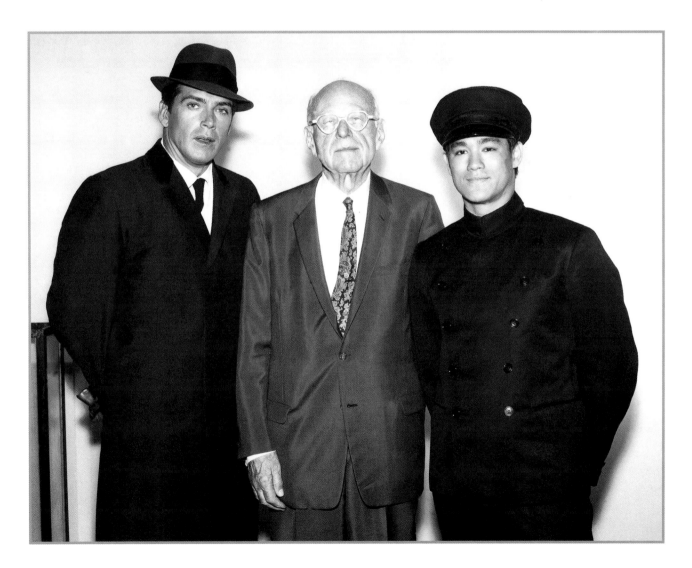

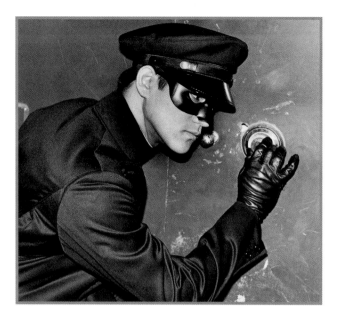

Perhaps when I was hired to play Kato in The Green Hornet *it was an accident.*

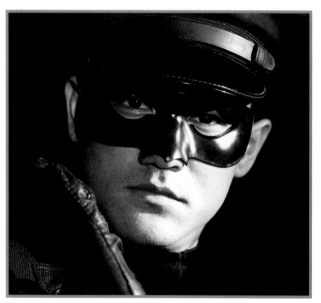

I had acted in Chinese films since I was a child but had not in U.S. films. I had no contacts in Hollywood.

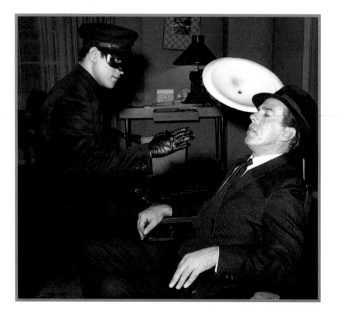

Anyway, it was fun. I was even approached by several businessmen to open a franchise of "Kato's Self-Defense Schools" throughout the U.S., but I refused. I think I could have made a fortune if money was what I wanted then. I felt then and still feel today that I'm not going to prostitute my art for the sake of money.

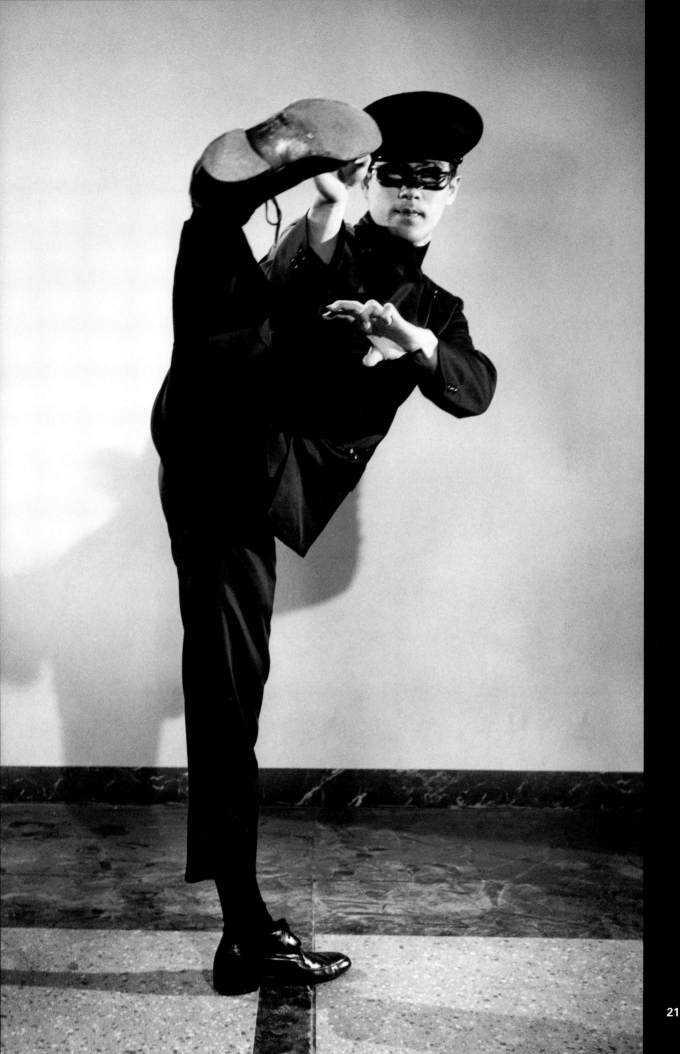

The Green Hornet lasted for one season. [A network producer] wrote to say that although the show had not been renewed, this did not mean it was going off the air. Then he added that he "had enjoyed working with" me. A little later, I got a note from the executive producer, Bill Dozier, that said: "Confucius say, *Green Hornet* to buzz no more."

In the first place it was not far enough out, not *Batman*-ish enough to please the viewers. Second, it should have been an hour-length show. Besides, the scripts were lousy and I did a really terrible job in it, I must say.

[But] in a way, it established me in Hong Kong and it put my foot in a lot of important doorways in Hollywood. When the series ended I asked myself, "What the hell do I do now?"

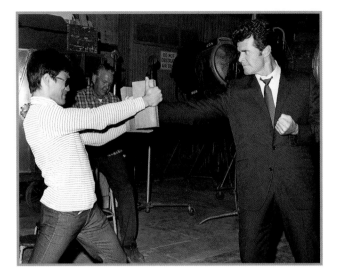

[One of William Dozier's] assistants [called one day and] wanted to know what I was doing. I told the guy I was teaching again and he asked me what I was charging. Man, when I told him he said I was crazy. He said I should be charging $50 an hour. I thought about it and decided, why not $50 an hour? And then eventually I started teaching actors. I used to make very good bread doing that. I started charging

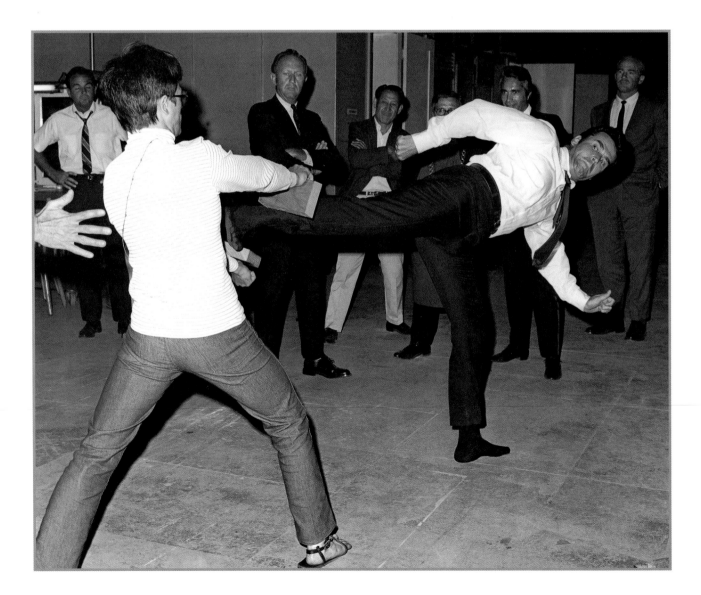

US $500 for a 10-hour course and wound up doubling it. Steve McQueen was one of my students. So was James Coburn.

Later, the producers in Hollywood, thinking that my martial art could be an attraction, invited me to play a role in their films [a villian in *Marlowe*, which starred James Garner. And then later I went on and did this really beautiful television thing for a series called *Longstreet*. James Franciscus played a blind dude who was out for revenge, and I played a guy who was getting him ready for a fight. Stirling Silliphant—one of my students—and I sat down and we wrote that episode together. That was the premiere episode.

The title of that particular episode of *Longstreet* is *The Way of the Intercepting Fist* and I think the successful ingredient in it was because I was being myself—Bruce Lee. And in doing that part I was able to just express myself. Like I say, I "honestly expressed myself" at that time. And, because of that, I received favorable mention in *The New York Times*, which said something like: "Bruce Lee, a Chinaman, who, incidentally, came off quite convincingly enough to earn himself a television series" and so on and so forth. [It was the] first time in my life that I had any kind of review for my acting. I'm glad they were favorable.

The people at Paramount asked me to go back and do a television series. And Warner Bros. was committed to working out a TV series for me as well. I mean they were offering me 25 grand—simply to hold me to do a television series, called *Kung Fu*, which is a really freaky adventure series. It's about a Chinese guy who has to leave China because he managed to kill the wrong person, and winds up in the American West in 1860. Can you dig that? All these cowboys on horses with guns and me with a long, green hunk of bamboo, right? Far out.

I was supposed to do it—but the network decided against it. They think that business-wise it's a risk. And I don't blame them. I don't blame them. It's the same way in Hong Kong: if a foreigner came and became a star, if I were

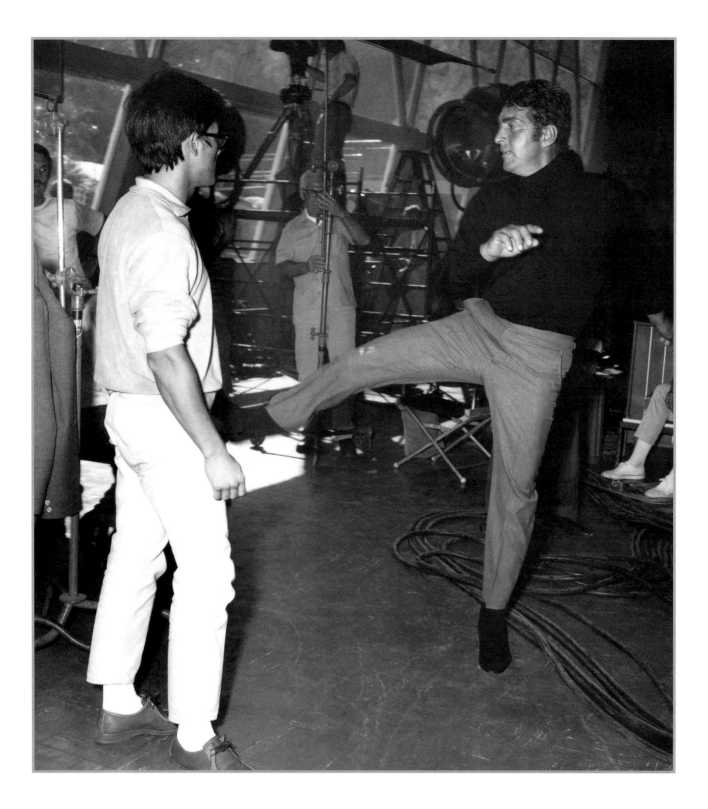

the man with the money, I probably would have my own worry of whether or not the acceptance would be there. I'm glad they decided against it, you know? Look at all of the television series—I mean all of them are gimmicks; shallowly treated; it's all "fast money," you know what I mean? Unlike a film where you can put a few months in it and work on it. But not television. Man, you've got to finish an episode in one week. And how can you keep up the quality every week?

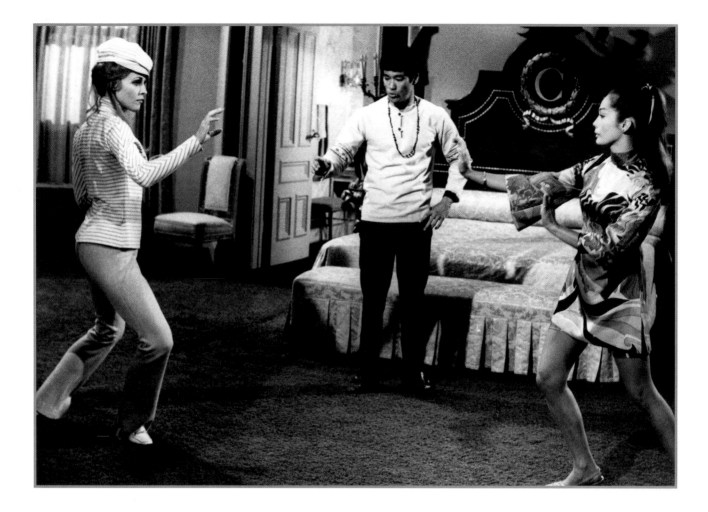

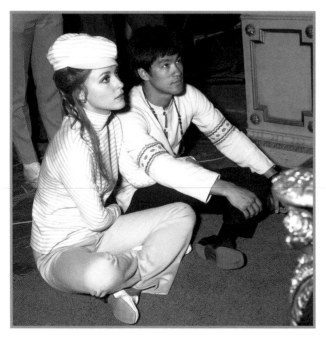

Bruce Lee with Sharon Tate and Nancy Kwan on the set of *The Wrecking Crew*, which also featured Dean Martin.

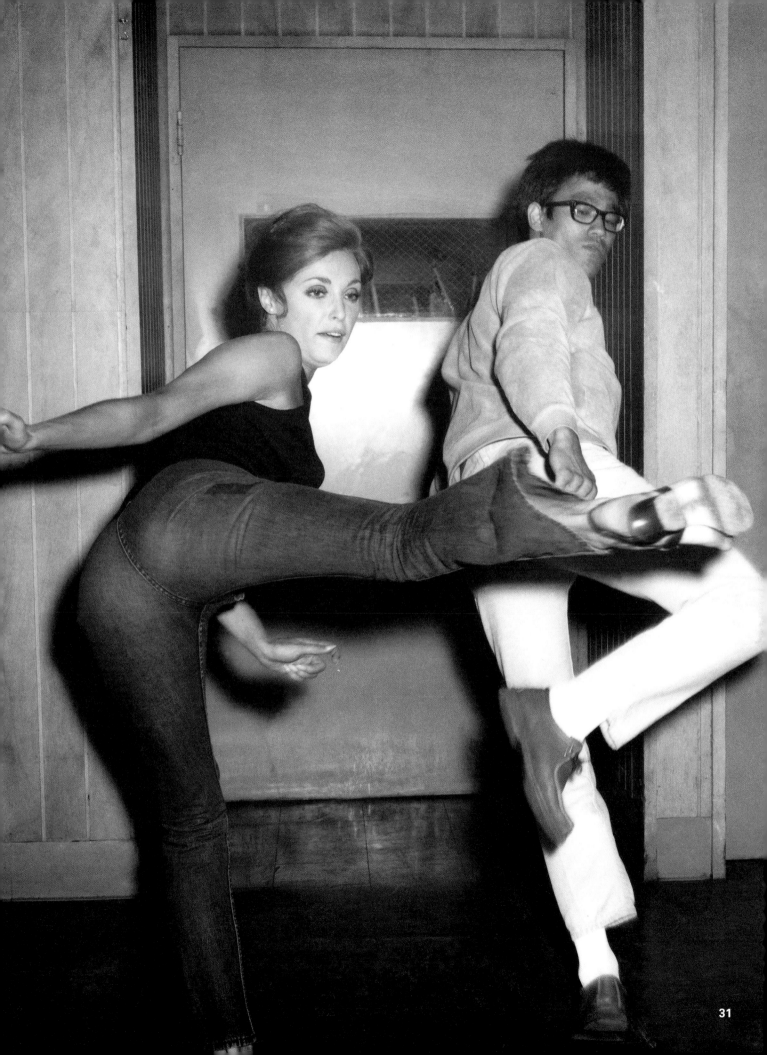

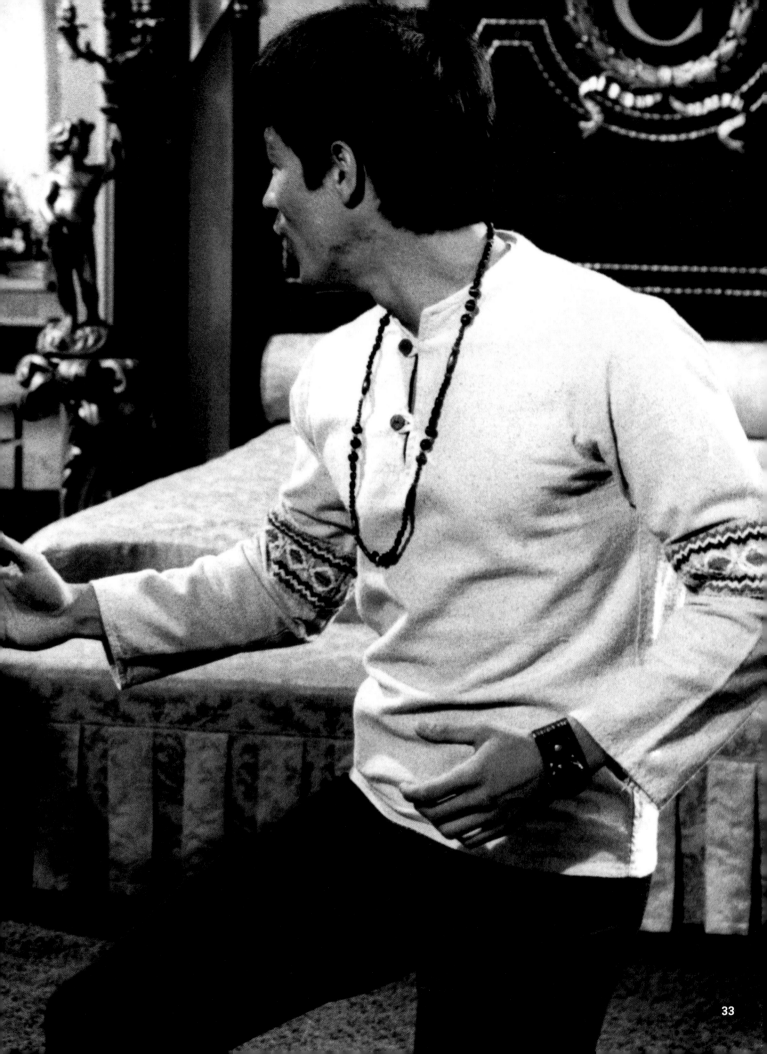

When you get into a fight, everybody reacts differently.

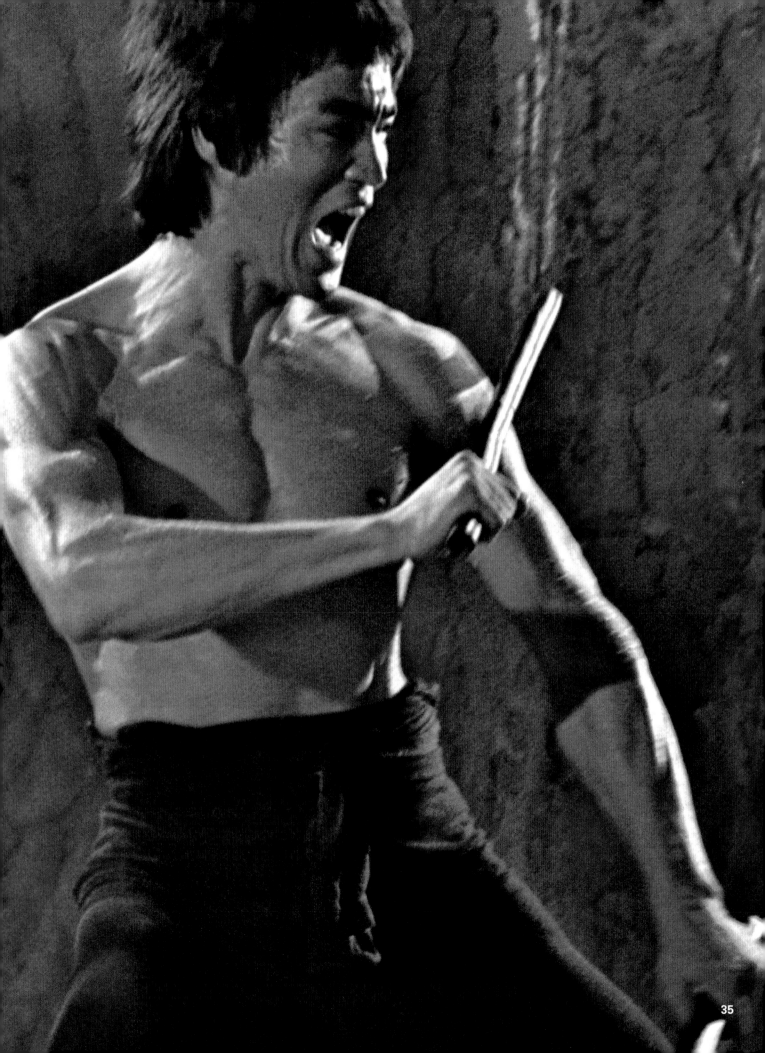

When I decided to come back to Hong Kong and do the film for Raymond Chow, I prepared by going to see a whole bunch of Mandarin movies. They were awful. For one thing, everybody fights all the time, and what really bothered me was that they all fought exactly the same way. Wow, nobody's really like that! When you get into a fight, everybody reacts differently. And it is possible to act *and* fight at the same time. I began to get calls from producers in Hong Kong and Taiwan. Offers to do a movie varied from $2,000 to $10,000.

Afterwards, a contract was made between a representative of Golden Harvest Films and me. I agreed to act in two films, the one being *The Big Boss* and the other being *Fist of Fury*. Mr. Raymond Chow appeared to me a man of insight and his Golden Harvest Ltd. a promising enterprise. They were, as a company, utilizing practical and efficient methods to promote the ideal of a better film industry: like encouraging independent productions, giving freedom to directors and actors to explore and manifest their talents.

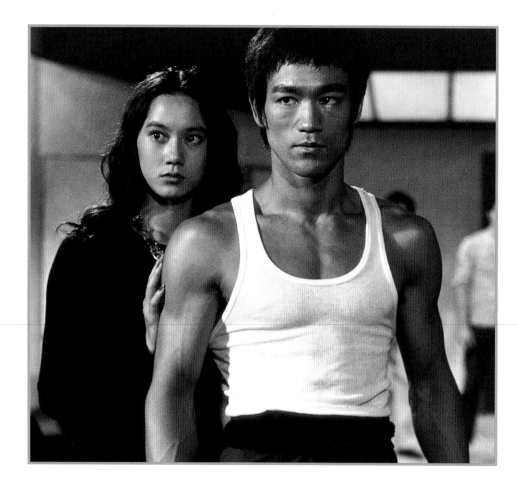

I do not believe in playing up violence in films. I think it is unhealthy to play up violence.

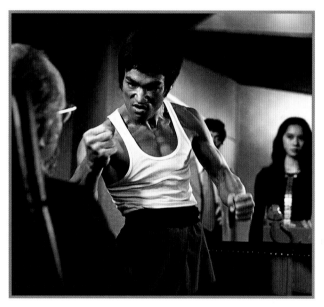

But it should be remembered that violence and aggression is part of everyday life now. You see it over the TV and in Vietnam. You can't just pretend that it does not exist.

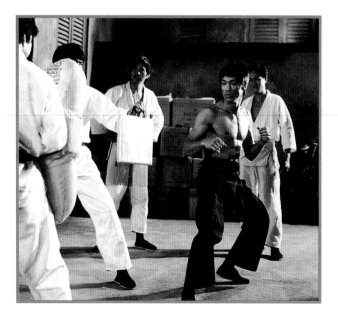

On the other hand, I don't think one should use violence and aggression as themes of movies.

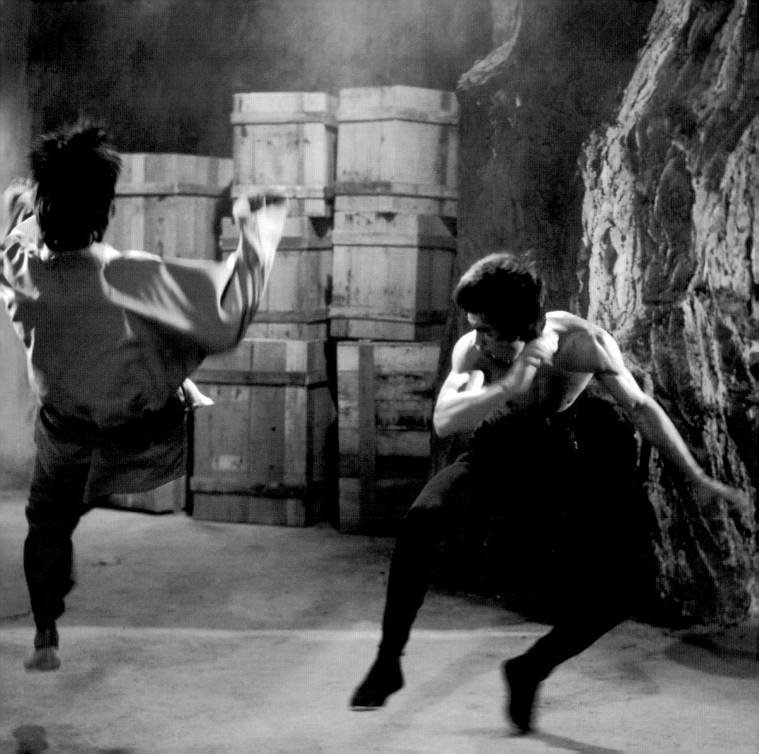

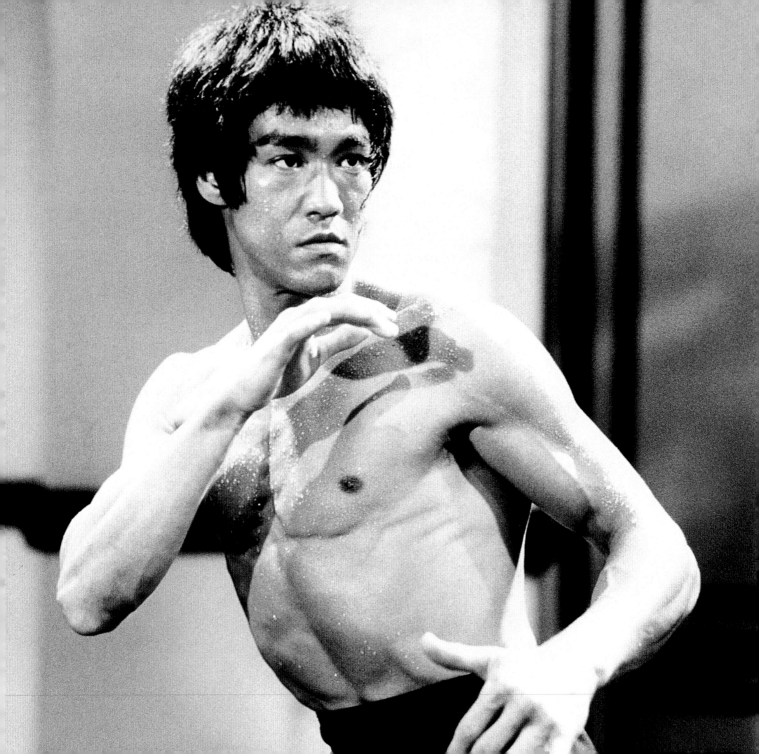

My more than twenty years experience as an actor have caused me to look at it thusly: an actor is a dedicated being who works very hard—so damn hard—that his level of understanding makes him a qualified artist in self-expression, physically, psychologically, as well as spiritually. Depending on one's level of understanding, the movie industry nowadays is basically a co-existence of practical business sense and creative talent, each being the cause and the effect of the other.

To the administrators up in their administrative offices, an actor is a "commodity," a product— a matter of money, money, money. "Whether or not it sells" is their chief concern. The important thing is the box-office appeal. Though cinema is in fact a marriage of practical business and creative talent, to regard an actor—a human being—as a *product*, is somewhat emotionally aggravating to me.

An actor, a good actor, not the cliché type, is in reality a "competent deliverer," one who is not just ready but artistically harmonizes this invisible duality of business and art into a successful appropriate unity. Mediocre actors, or cliché actors, are plentiful, but to settle down to train a "competent" actor mentally and physically is definitely not an easy task. Just as no two human beings are alike, so, too, with actors.

A really trained, good actor is a rarity nowadays— that demands the actor to be real, to be himself. The audiences are not dumb today, an actor is not simply demonstrating what one wants others to believe he is expressing. That is mere *imitation* or illustration—but it is not *creating*— even though this superficial demonstration can be "performed" with remarkable expertise.

Some martial artists are now going to Hong Kong to be in movies, they think they can be lucky, too. Well, I don't believe in pure luck. You have to create your own luck. You have to aware of the opportunities around you and take advantage of them. Some guys may not believe it, but I spent hours perfecting whatever I did. [Bruce Lee in action from The Way of the Dragon.*]*

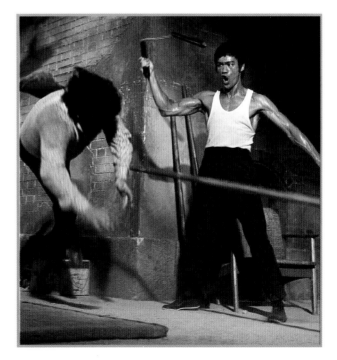

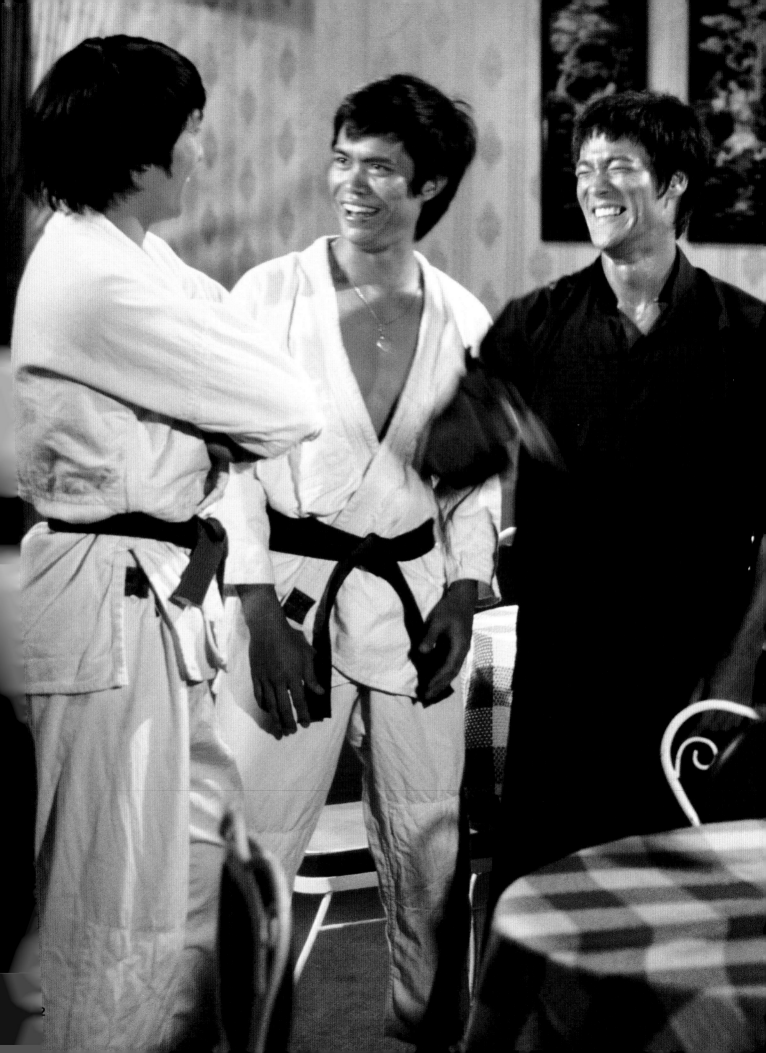

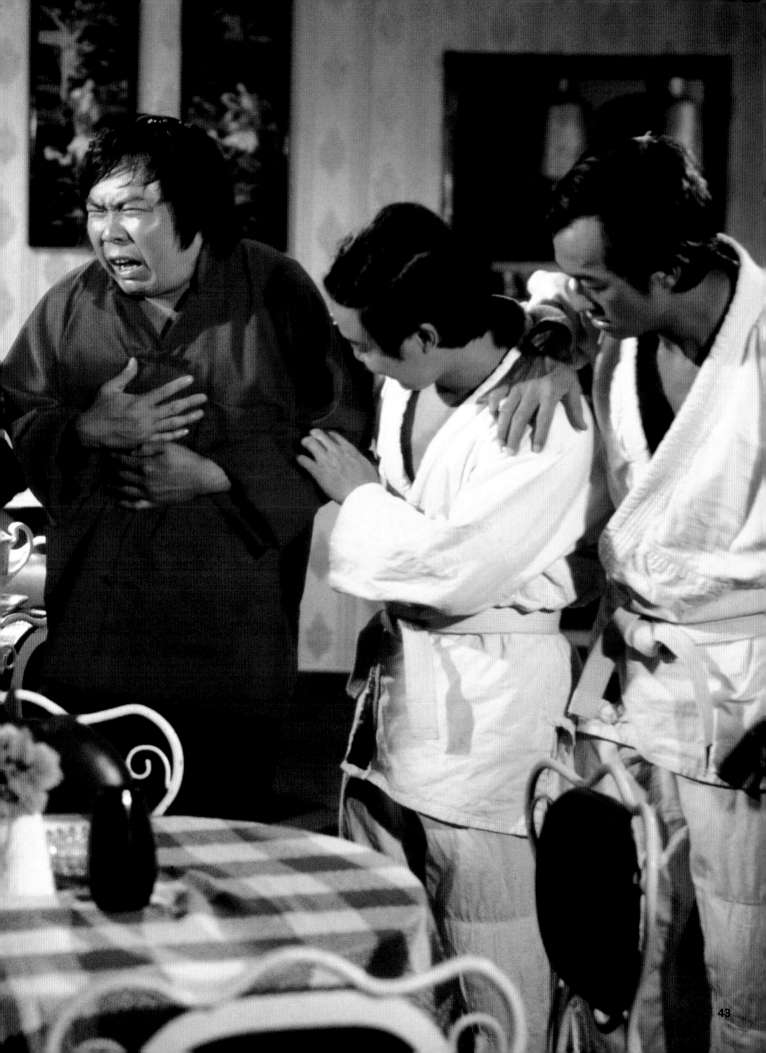

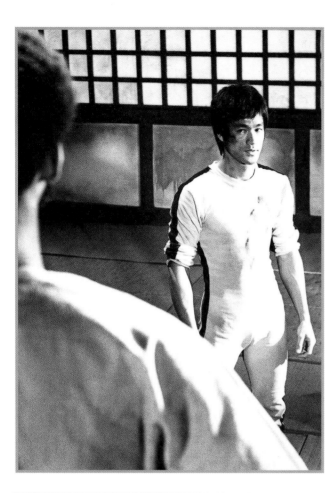

Just what then is an actor of quality? To begin with, he is no "movie star," which is nothing but an abstract word given by the people and a symbol. There are more people who want to become "movie stars" than actors. To me, an actor is the sum total of all that he is—his high level of understanding of life, his appropriate good taste, his experience of happiness and adversity, his intensity, his educational background and much, much more—like I said, the sum total of all that he is.

One more ingredient is that an actor has to be real in expressing himself as he would honestly in a given situation. An actor's problem, though, is not to be egotistical and to keep his cool and to learn more through discoveries and much deep soul-searching.

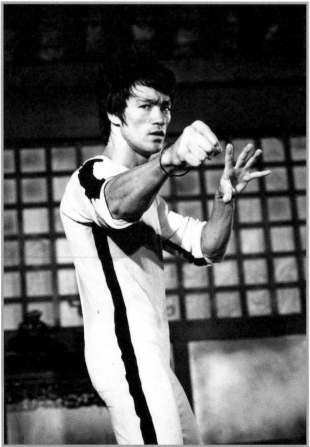

Dedication, absolute dedication is what keeps one ahead.

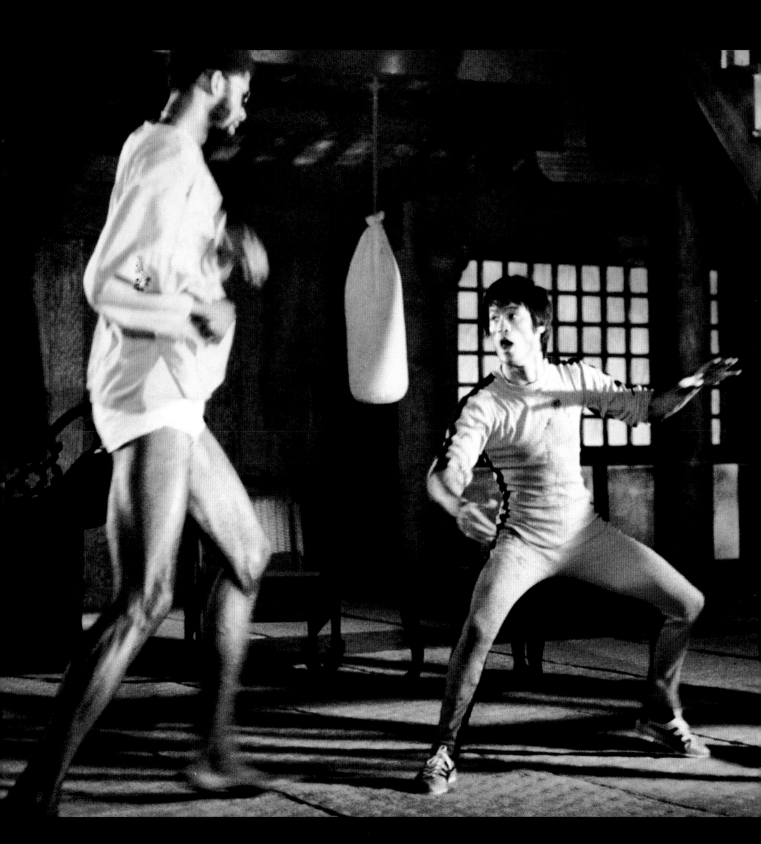

Believe me that in every big thing or achievement there are always obstacles—big or small—and the reaction one shows to such obstacles is what counts, not the obstacle itself. [Bruce Lee takes on Kareem Abdul-Jabbar during the climactic battle scene in The Game of Death.*]*

Yes, there is a difference between self-actualization and self-image actualization.

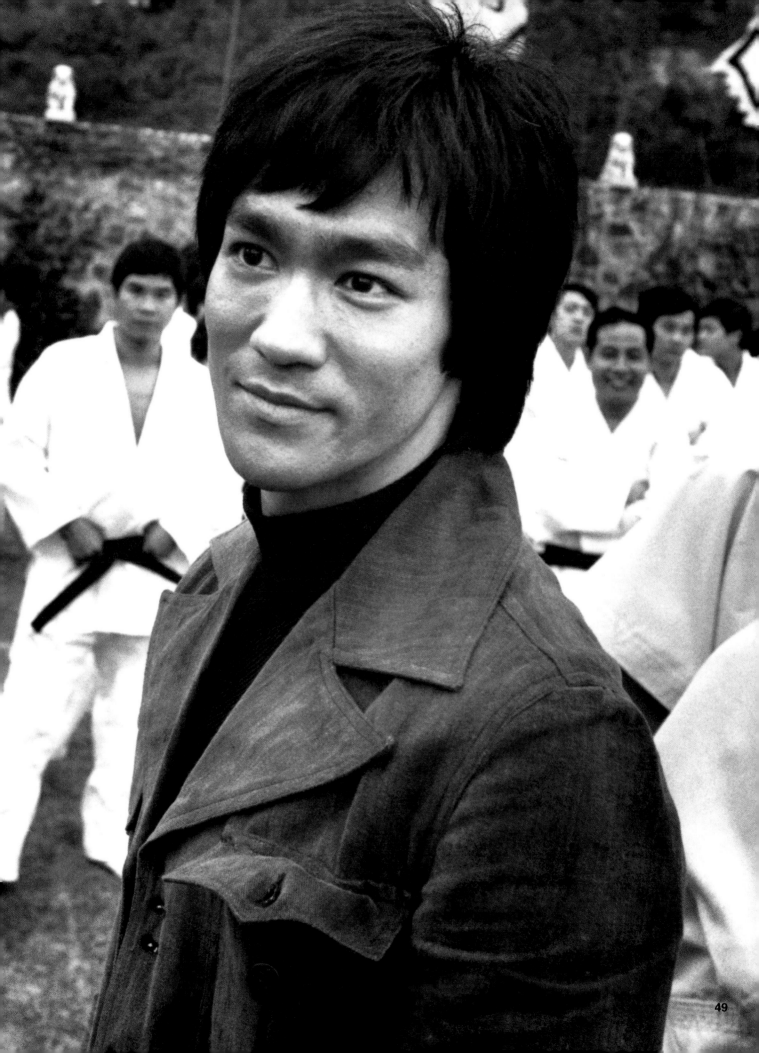

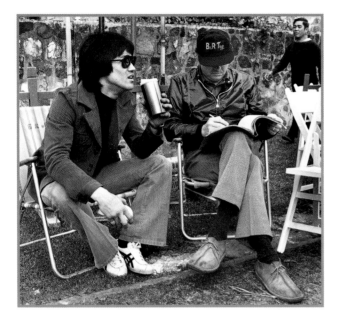

*I know we all admit that we are
intelligent beings; yet, I wonder
how many of us have gone
through some sort of self-inquiries
and/or self-examining of all these
ready-made facts or truths that
are crammed down our throats
ever since we acquired the
capacity and the sensibility
to learn?*

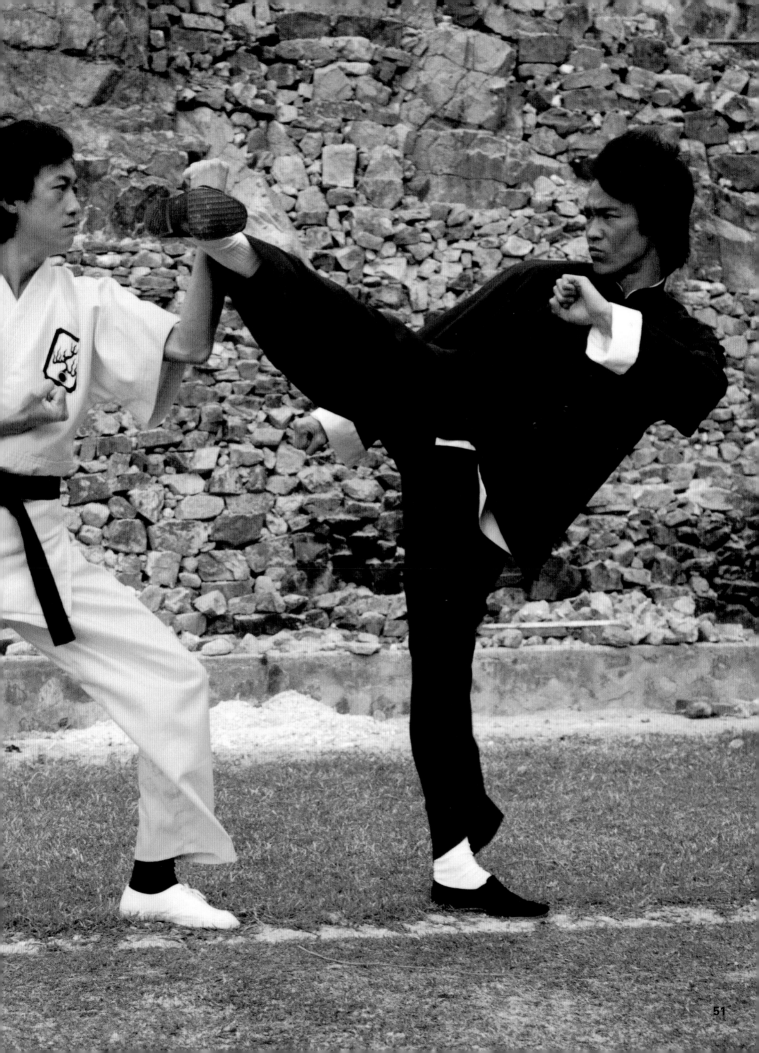

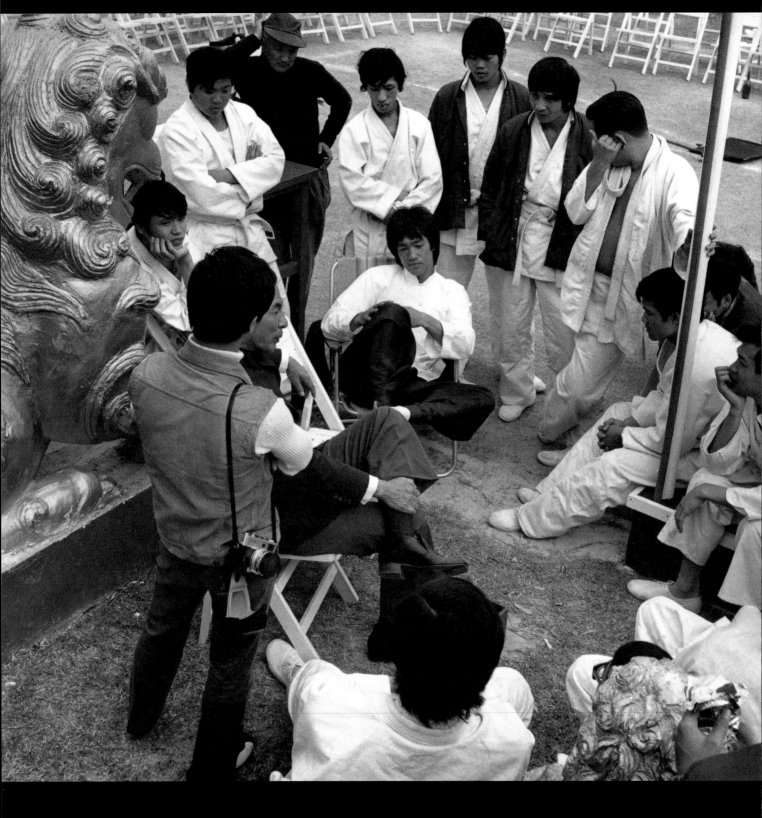

Though we possess a pair of eyes, most of us do not really "see" in the true sense of the word.

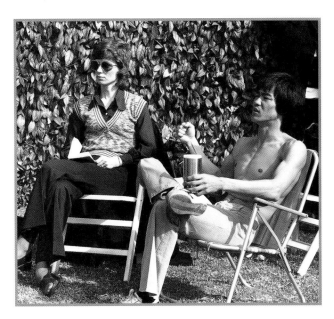

True seeing, in the sense of choiceless awareness, leads to new discovery, and discovery is one of the means to uncovering our potentiality.

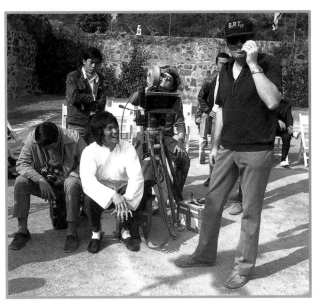

However, when these same eyes are used in observing or discovering other people's faults, we are quick with readily-equipped condemnation.

For it is easy to criticize and break down the spirit of others, but to know yourself takes a lifetime.

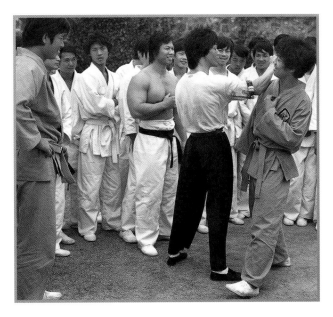

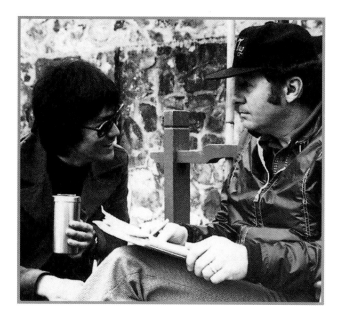

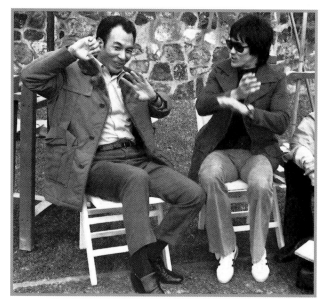

Most people only live for their image, that is why where some have a self, a starting point, most people have a void, because they are so busy projecting themselves as this or that. Wasting, dissipating all their energy in projection and conjuring up of facade, rather than centering our energy on expanding and broadening their potential or expressing and relaying this unified energy for efficient communication, etc. When another human being sees a self-actualizing person walk past, he cannot help but say, "hey, now there is someone real!"

In *Enter the Dragon*, I tried to present a sort of spiritual and physical expression of a dedicated artistic athlete, who in this case, [happens to be] a Chinese martial artist, as set apart from the ordinary, because he can "deliver" and communicates with the audience and is capable to get across to the audience that which is considered the ultimate value of a martial artist (which I will apply with a total sum of my level of understanding and experience).

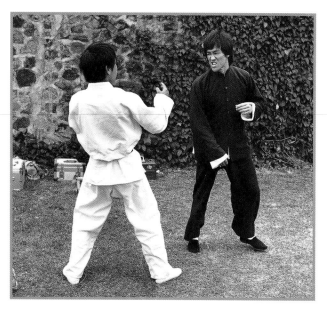

The important thing is that I am personally satisfied with my work. If it is a piece of junk, I will only regret it.

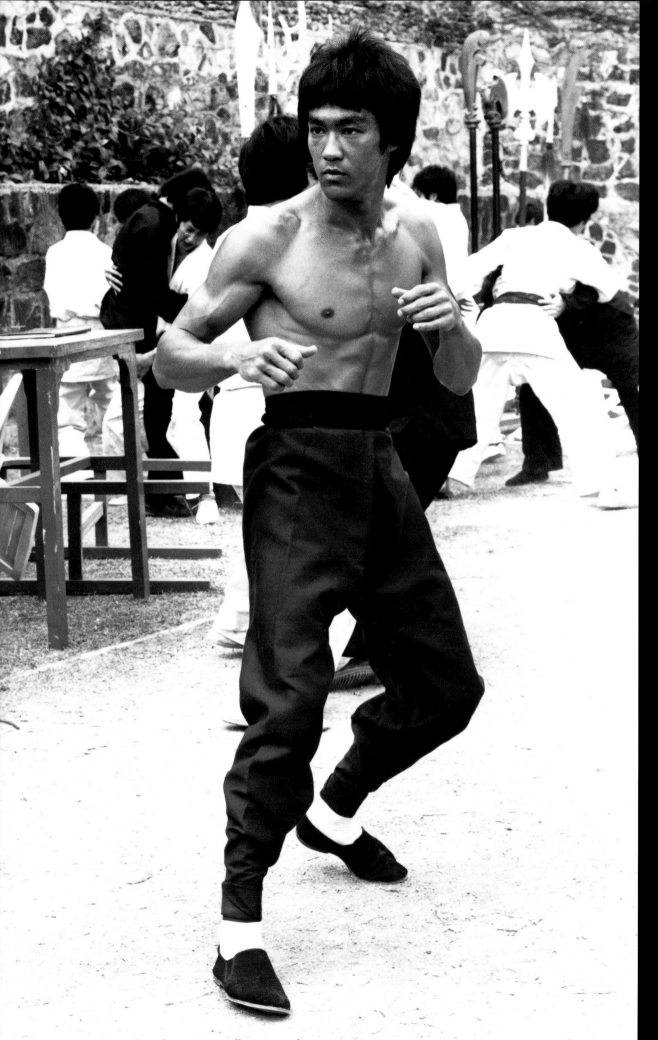

I would like to evolve into different roles, but I cannot do so in Southeast Asia. I am already typecast. I am supposed to be the good guy. I can't even be a bit gray, because no producer would let me. Besides, I can't even express myself fully on film here, or the audience wouldn't understand what I am talking about half the time. That's why I can't stay in Southeast Asia all the time. I plan to stay half a year here and half a year in Hollywood.

I also want to direct more films. Directing, I feel, is more creative. You really get a chance to produce the result you want. An actor is restricted. He can only do as the director instructs. I will be doing different types of films in the future: some serious, some philosophical, and some pure entertainment. But I will *never* prostitute myself in any way that I do what I don't believe in. I am confident that my talent will expand internationally. I am improving and making new discoveries every day. If you don't you are already crystallized and that's it.

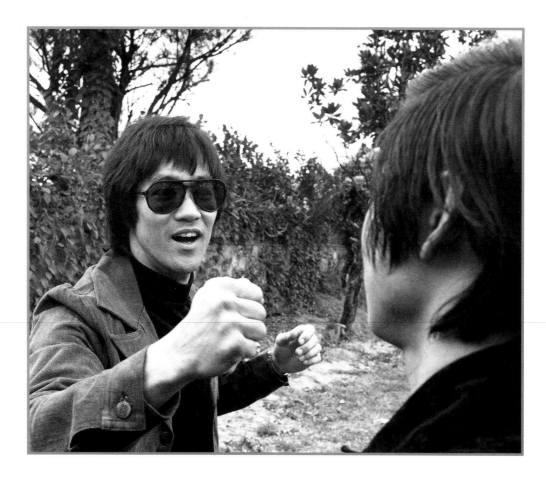

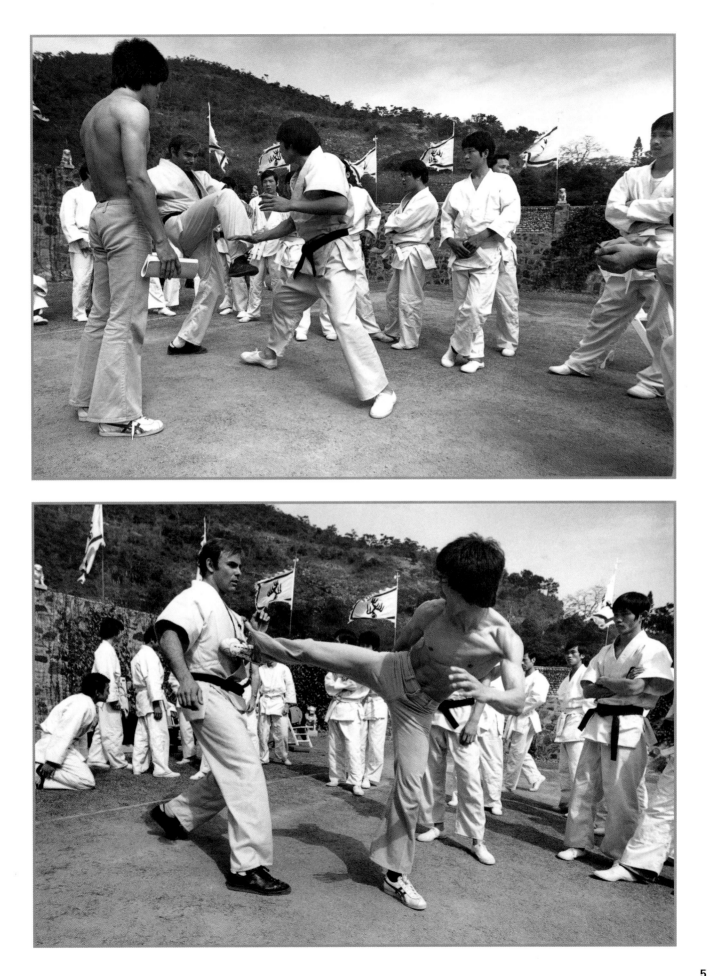

The past is history and only the future can give you happiness. So, everybody must prepare for their future and create their own future.

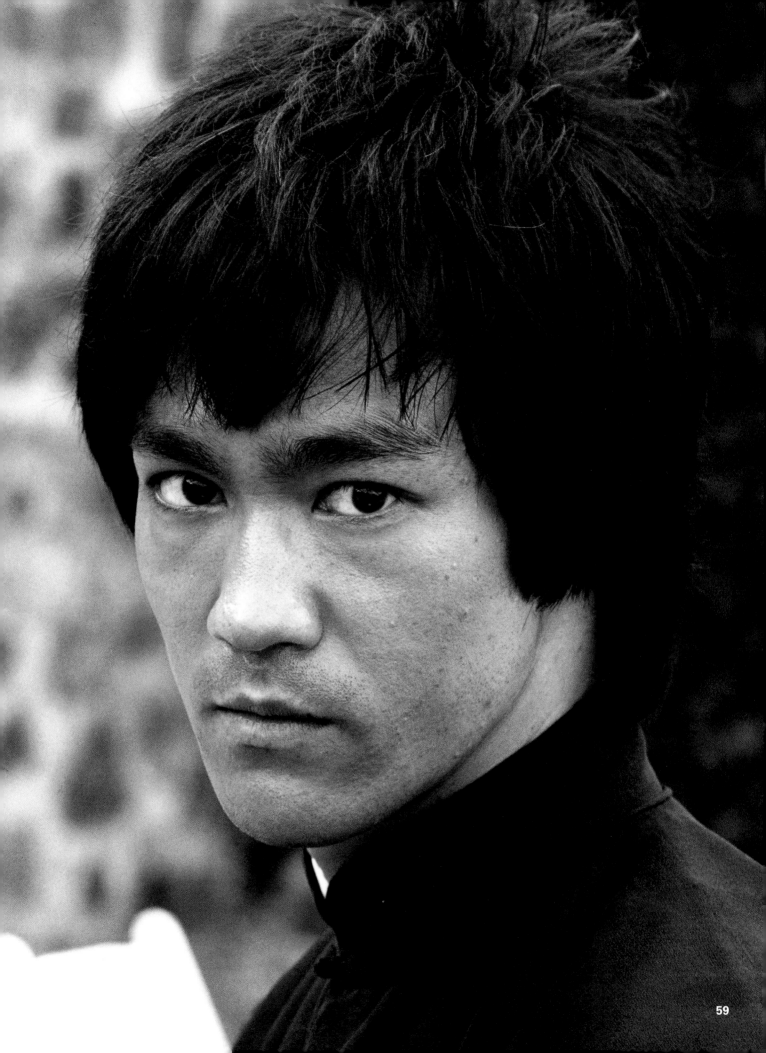

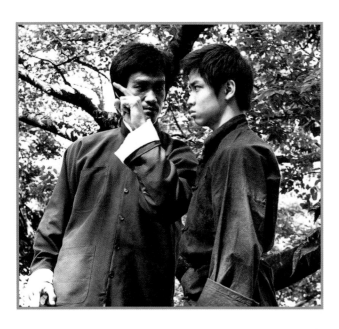

[Some Bruce Lee philosophy from Warner Bros.' Enter The Dragon:*] "It is like a finger..."*

"pointing a way to the moon."

"Don't concentrate on the finger, or you will miss all that heavenly glory."

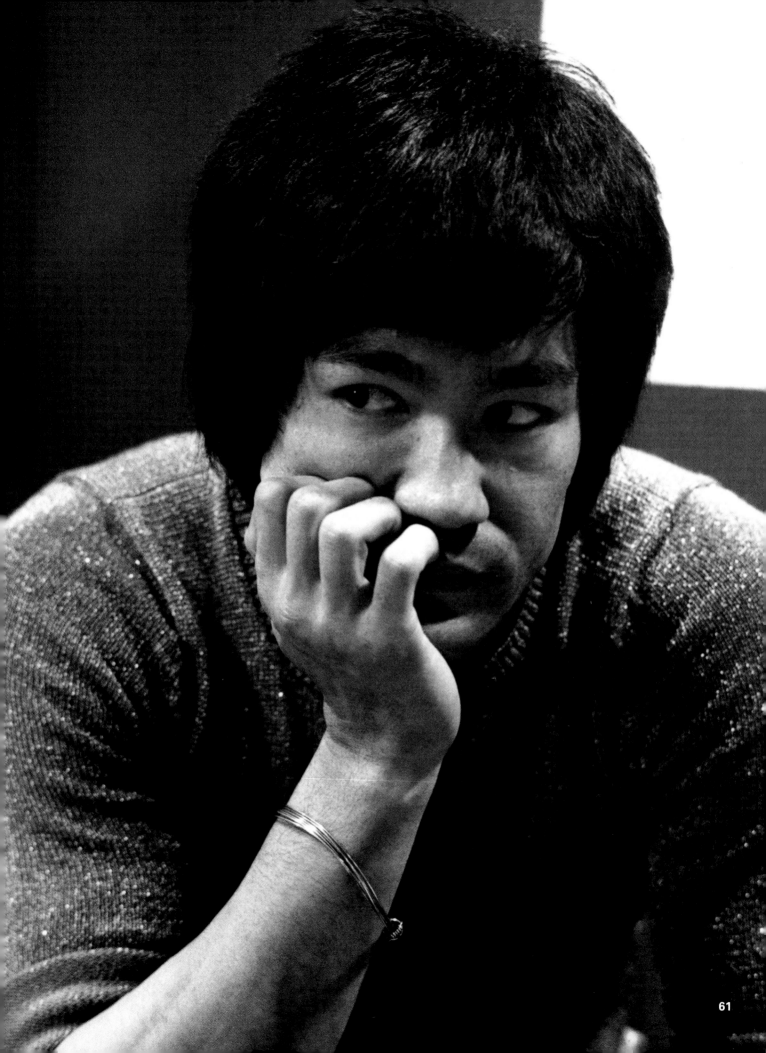

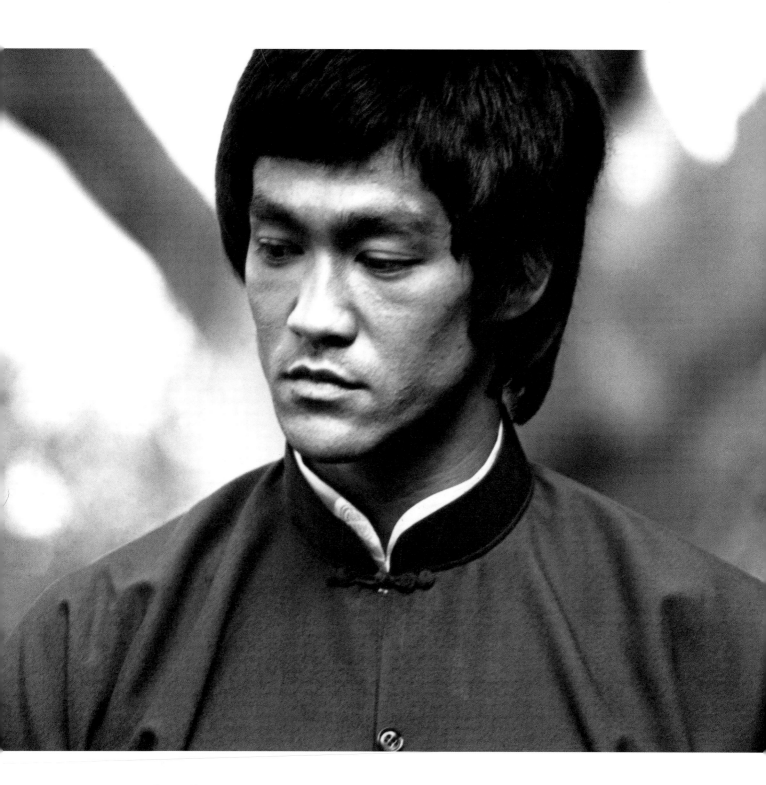

Success [only] means doing something sincerely and wholeheartedly. I think life is a process. Through the ages, the end of heroes is the same as ordinary men. They all died and gradually faded away in the memory of man. But when we are still alive, we have to understand ourselves, discover ourselves and express ourselves. In this way, we can progress, but we may not be successful.

A learned man once went to a Zen master to inquire about Zen. As the Zen master talked, the learned man would frequently interrupt with remarks like, "Oh yes, we have that, too," and so forth. Finally the Zen master stopped talking and began to serve tea to the learned man; however, he kept on pouring and the tea cup overflowed. "Enough! No more can go into the cup!" the learned man interrupted. "Indeed, I see," answered the Zen master. "If you do not first empty your cup, how can you taste my cup of tea?"

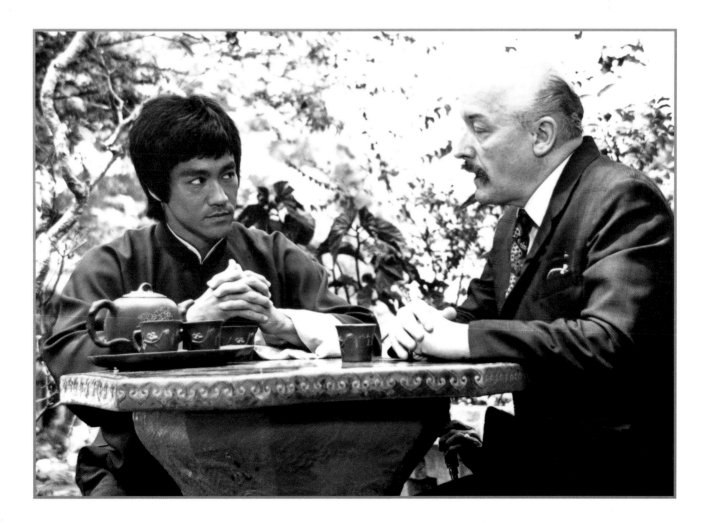

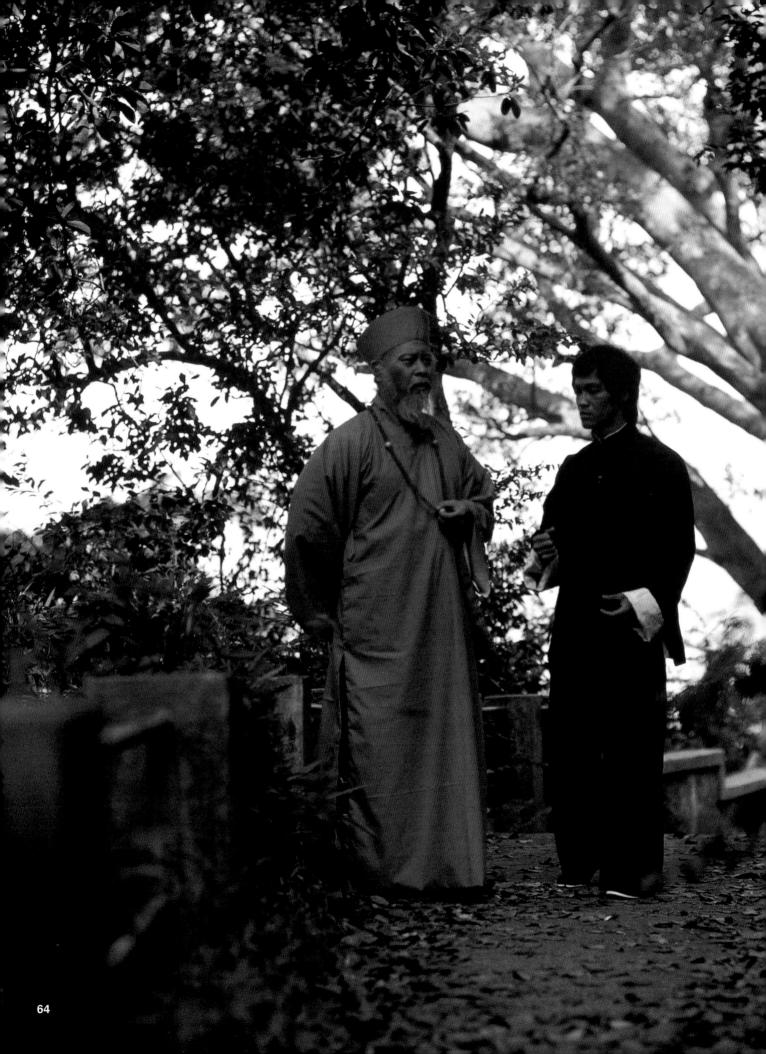

When my tutor assisted me in choosing my courses, he advised me to take up philosophy because of my inquisitiveness. He said, "philosophy will tell you what man lives for." When I told my friends and relatives that I had picked up philosophy, they were all amazed.

My majoring in philosophy was closely related to the pugnacity of my childhood. I often ask myself these questions: What comes after victory? Why do people value victory so much? What is "glory"? What kind of victory is "glorious"?

Everybody thought I had better go into physical education, since the only extracurricular activity that I was interested in, from my childhood until I graduated from my secondary school, was Chinese martial arts.

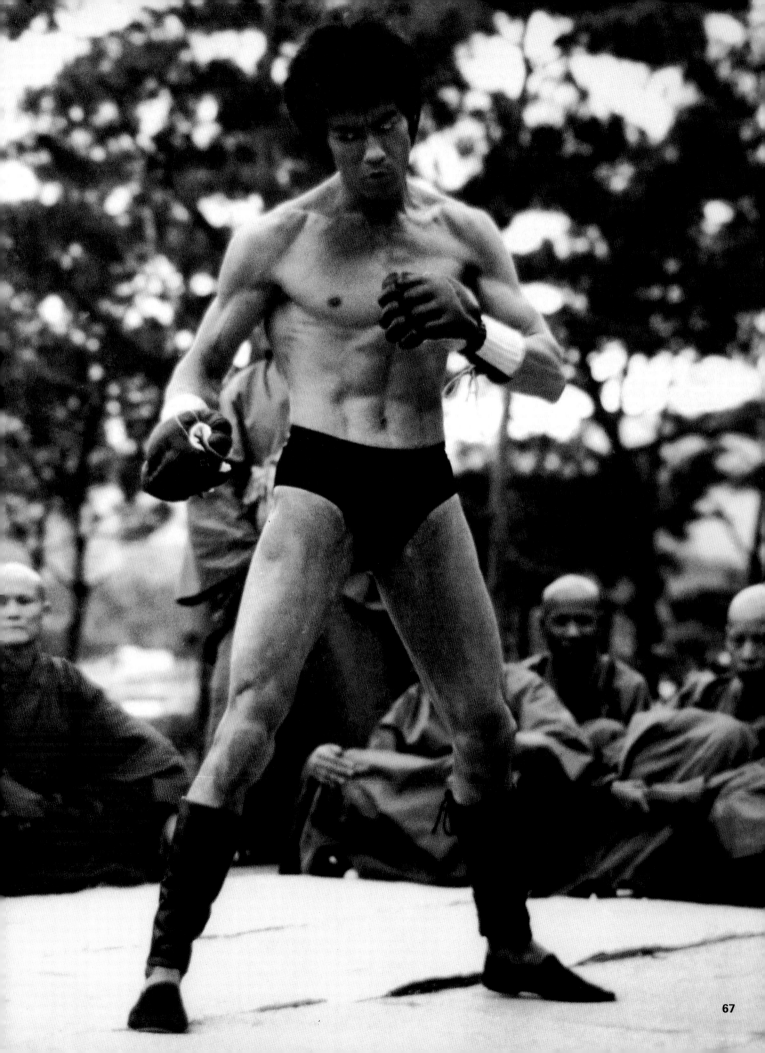

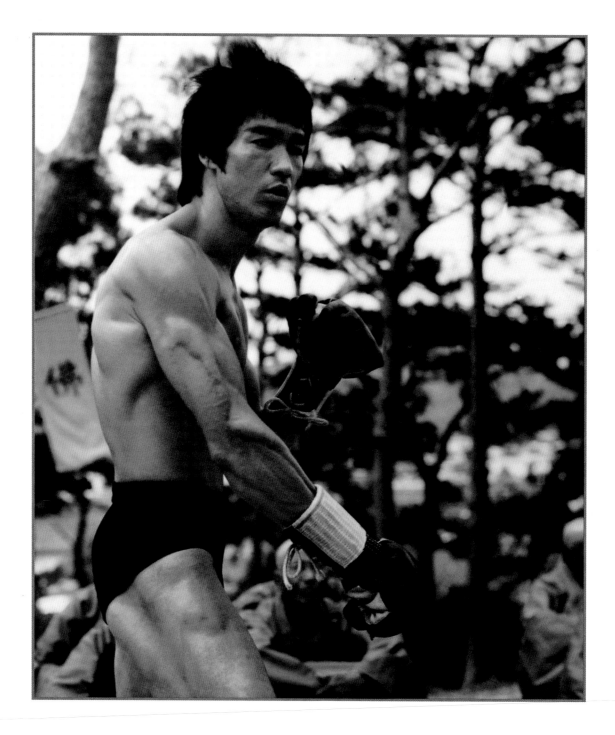

However, I began to lose faith in the Chinese classical arts because, basically, all styles are products of dry-land swimming, so my line of training [moved] more toward efficient street fighting with everything goes; wearing headgear, gloves, chest guard, shin/knee guards, etc. I changed the name of the gist of my study to Jeet Kune Do—"the way of the intercepting fist."

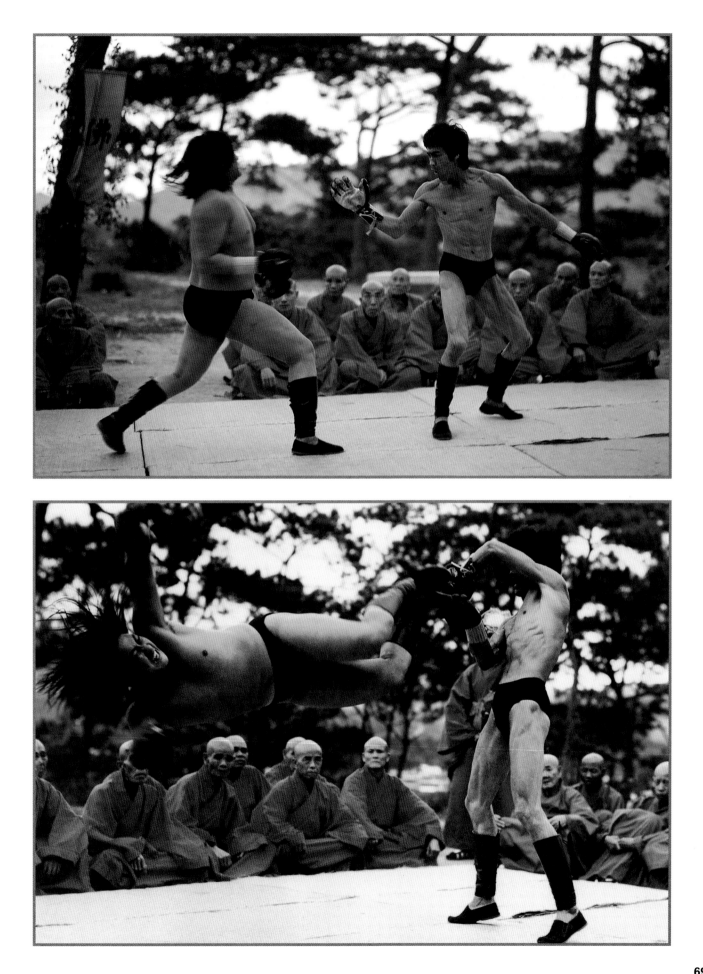

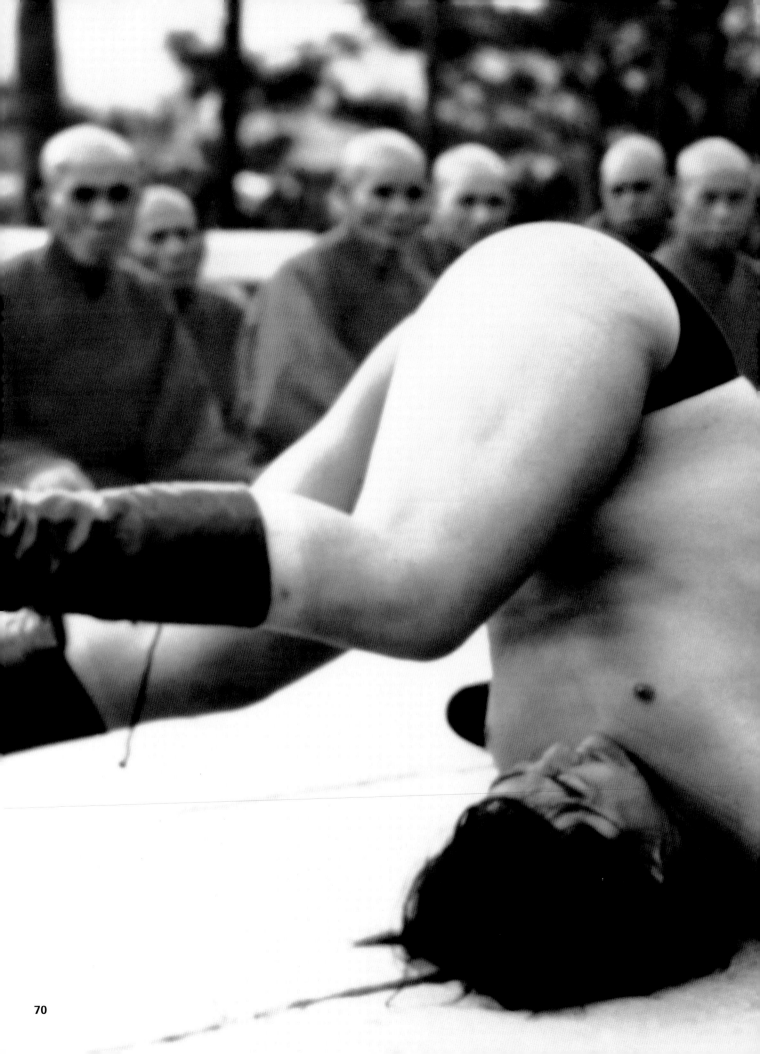

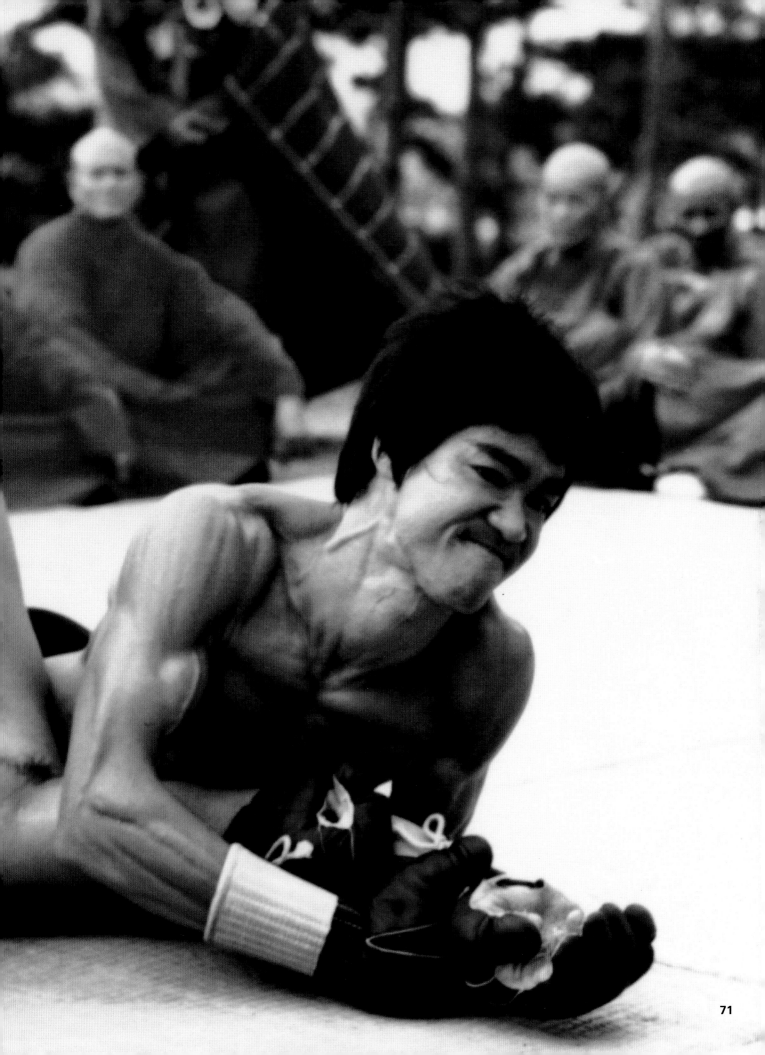

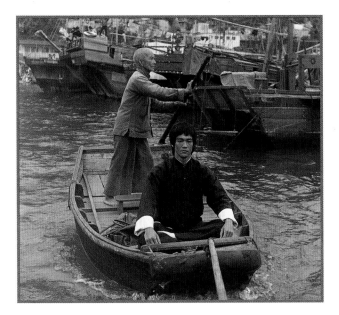

Random Notes on Character Lee: The "cool" (because it is real) and "hip" way of showing the charisma of what exactly is a "quality" martial artist as well as a human being, like you and me. [A note Bruce Lee wrote within his personal copy of the script for Warner Bros.' Enter the Dragon.]

What more can I say but that I am ready for action and hopefully let the outside world in on some of our Chinese culture. I have a hell of a responsibility because Americans really do not have first-hand information on the Chinese. *Enter the Dragon* should make it—this is the movie that I'm proud of because it has been made for the U.S. audience as well as for the European and the Oriental. But I am happy to say that, unlike the past, the deal was made on a fair and square basis; truly a co-production.

I hope that the character of "Lee" in Warner Bros.' *Enter the Dragon* comes across as one who is endowed with the capacity of generating such intensified enthusiastic popular support in the leadership or symbolic unification or direction of human affairs, or what is so elusively called "this ingredient." In short, baby, he is what constitutes a "quality" and "cool" martial artist. This man knows and, most important of all, this audience knows as well!

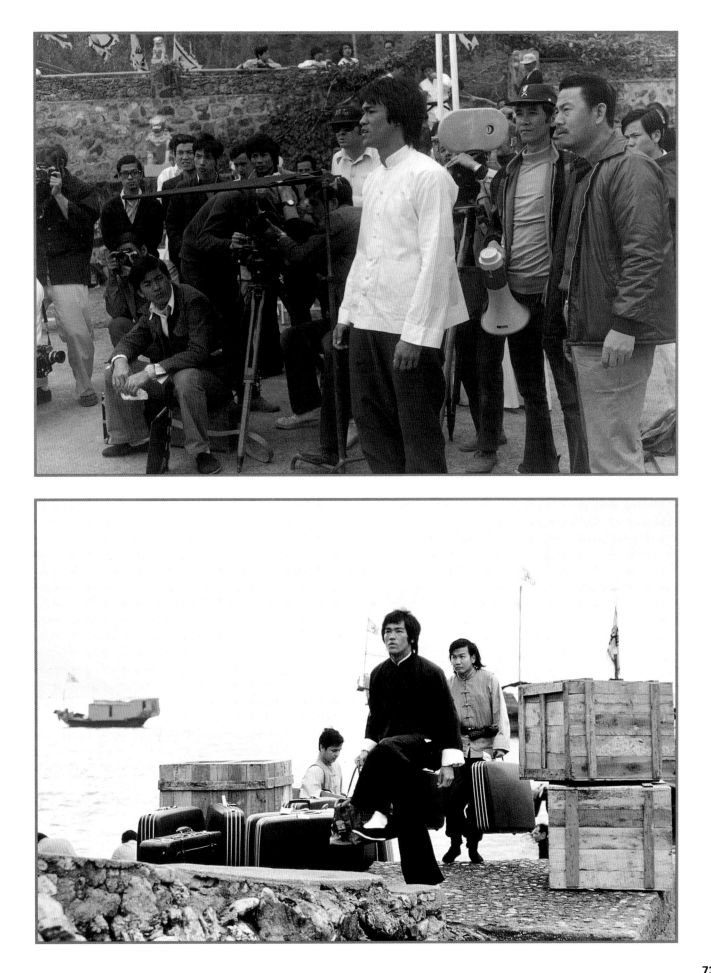

I am responsible for a good part
of the script, in collaboration
with the director, Bob Clouse.
The script has turned out to be
a beauty, and artistic, too.

This is definitely the biggest
movie I ever made. I'm excited to
see what will happen.

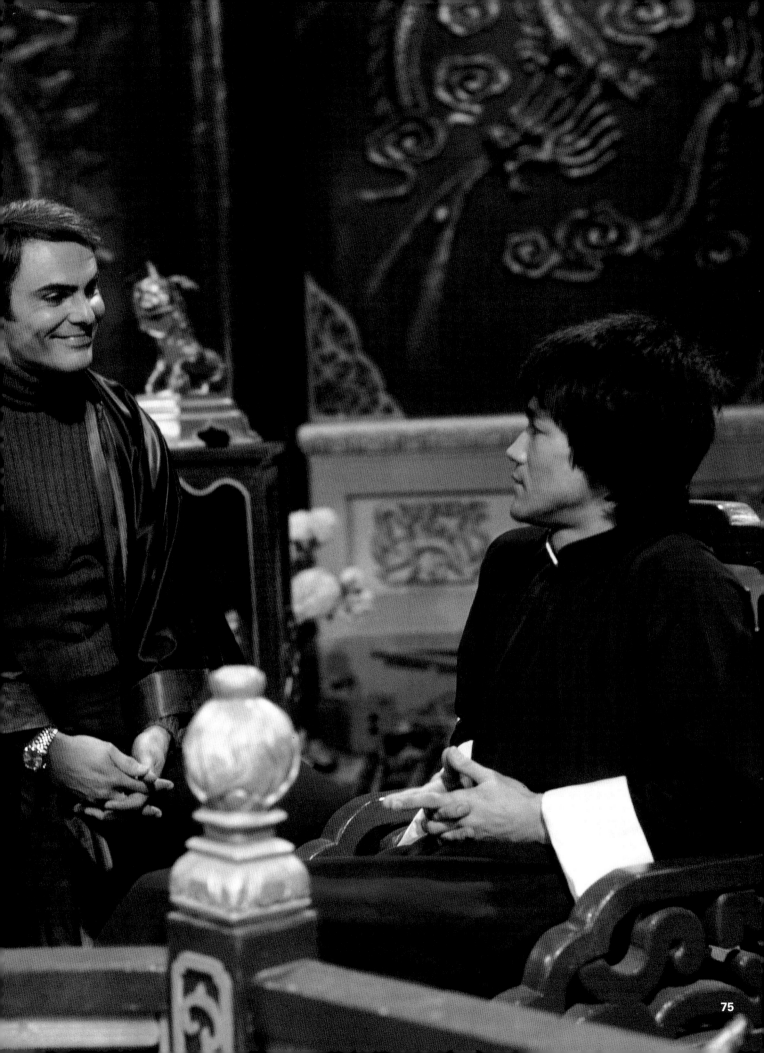

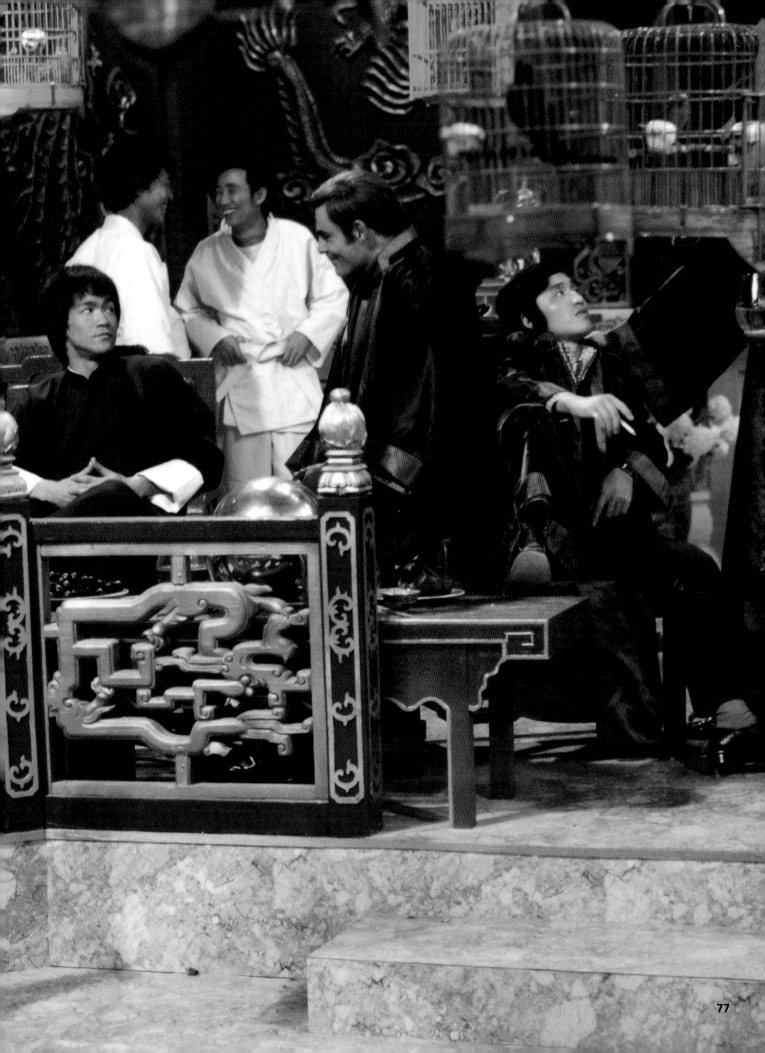

To bring the mind into sharp focus and to make it alert so that it can immediately intuit truth, which is everywhere, the mind must be emancipated from old habits, prejudices, restrictive thought process, and even ordinary thought itself.

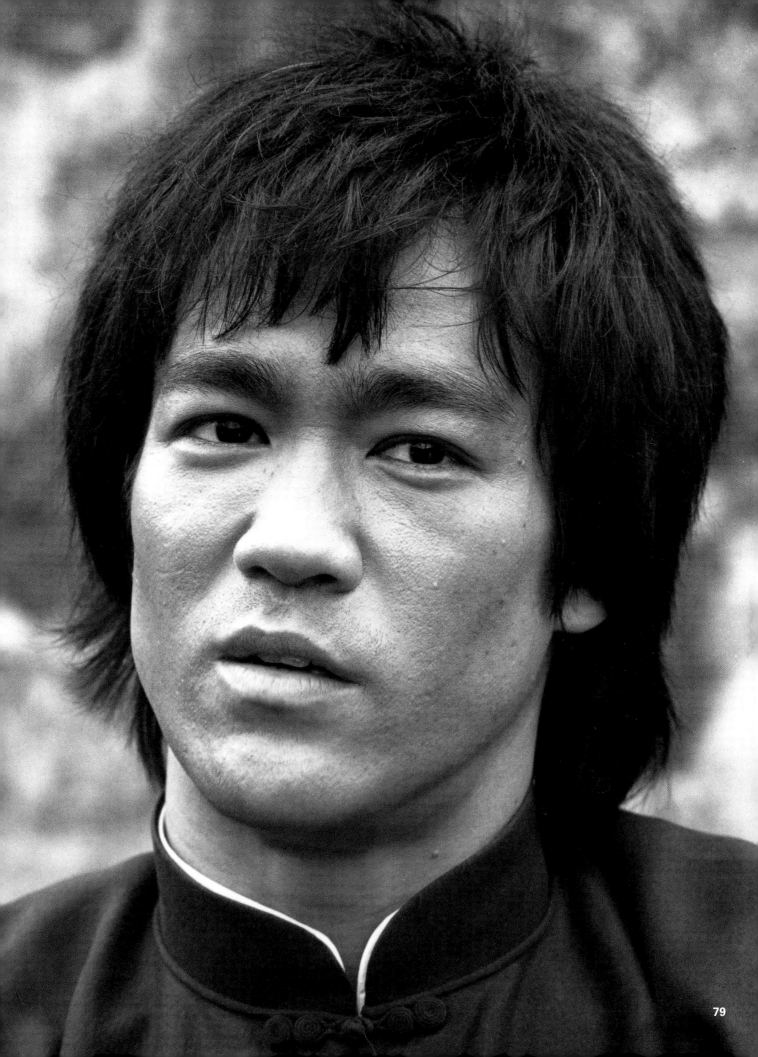

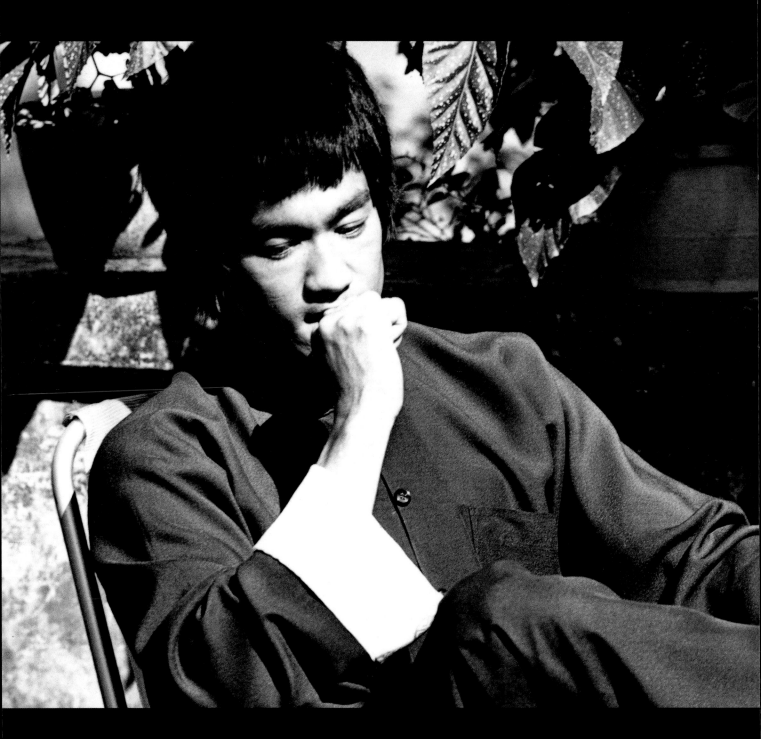

[On Jeet Kune Do:] *Anytime other writers write about Jeet Kune Do, they write it according to their knowledge. One cannot see a fight "as is," say from the point of view of a boxer, a wrestler, or anyone who is trained in a particular method, because he will see the fight according to the limits of his particular conditioning.*

One cannot "express" fully—the important word here is *fully*—when one is imposed by a partial structure or style. For how can one be truly aware when there is a screen of one's set pattern as opposed to "what is." What is is total (including what is and what is not), without boundaries, etc., etc. From drilling on such organized "land swimming" pattern, the practitioner's margin of freedom of expression grows narrower and narrower. He becomes paralyzed within the framework of the pattern and accepts the pattern as the real thing. He no longer "listens" to circumstances, he "recites" his circumstances. He is merely performing his methodical routine as [a] response rather than responding to what is. He is an insensitized patternized robot, listening to his own screams and yells. He is those classical blocks; he is those organized forms; in short, he is the result of thousands of years of conditioning.

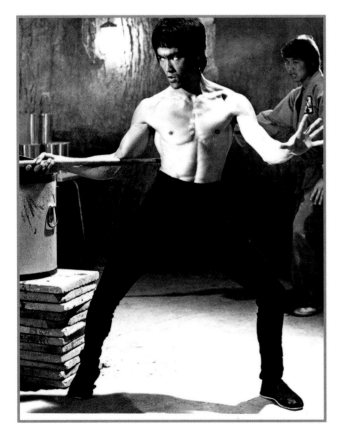

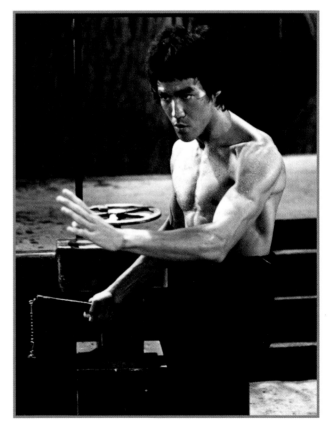

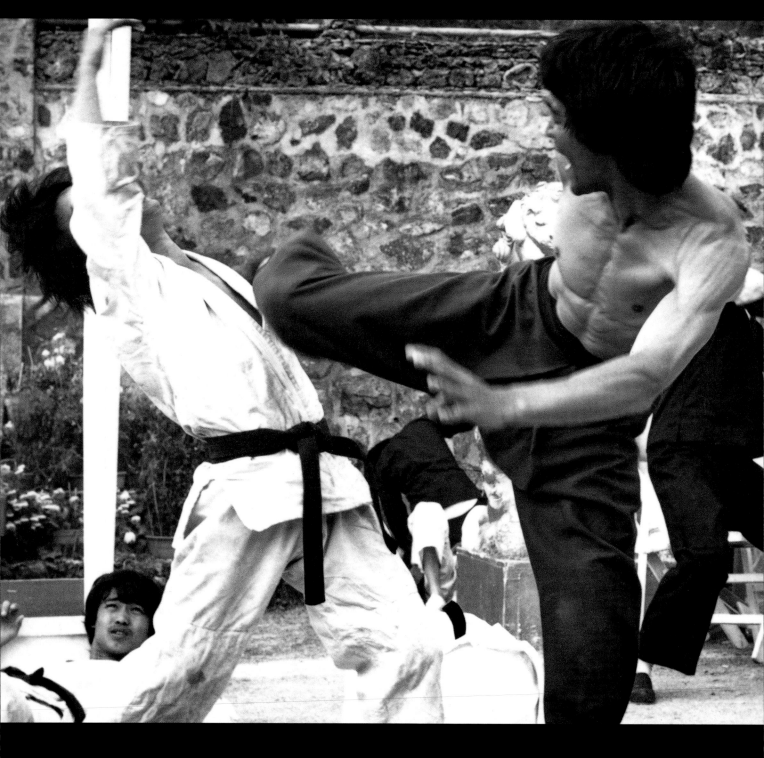

Fighting is not something dictated by your conditioning as a Chinese martial artist, a Japanese martial artist, etc., etc.

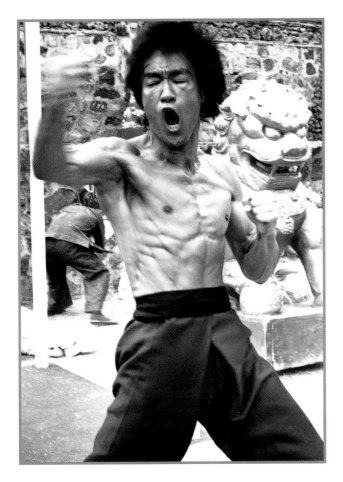 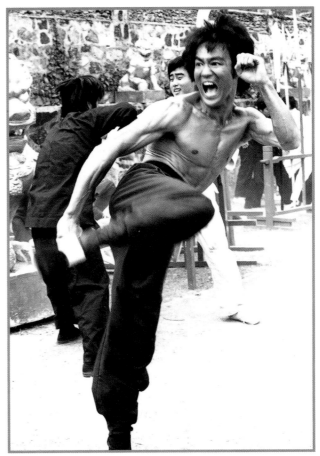

Take for instance the boxer: he will probably criticize the fact the two fighters are too close to allow crispy punching room. On the other hand, the wrestler will complain that one of the fighters should crowd and smother the other's "crispiness," and thus be close enough to apply grappling tactics. So a split second between the above two statements, the boxer could have switched into grappling tactics when there is no crispy punching room. The wrestler, when out of distance, could have kicked or punched as a means to bridge the gap for his specialty.

True observation begins when devoid of set patterns, and freedom of expression occurs when one is beyond systems.

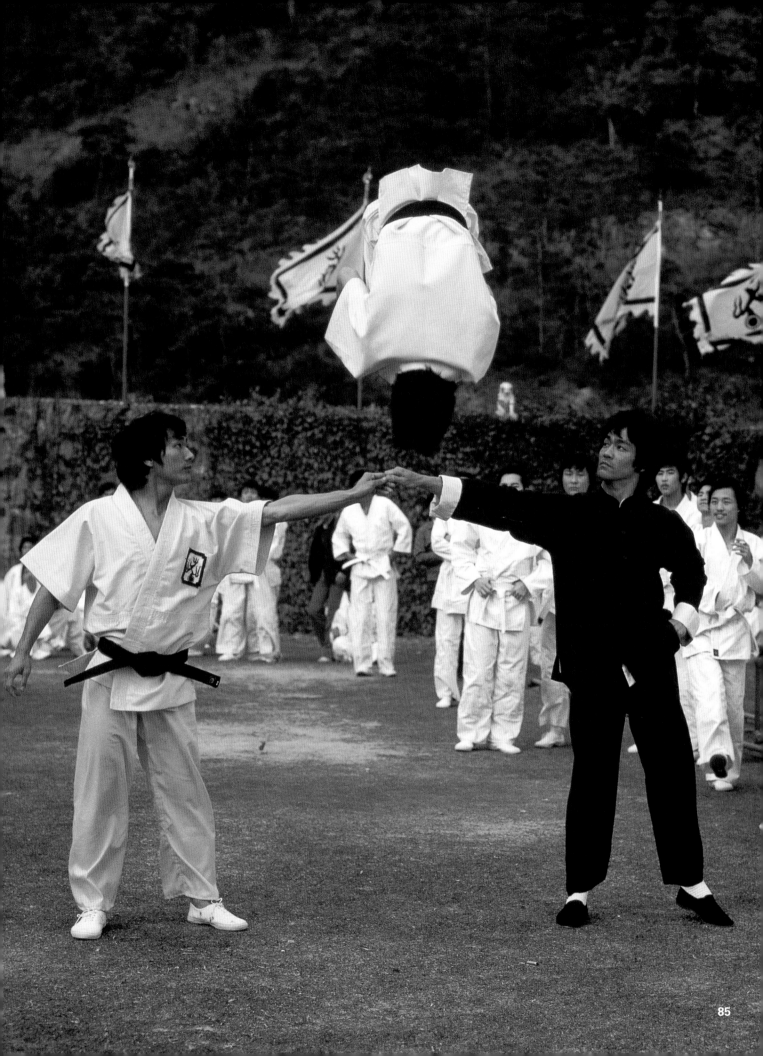

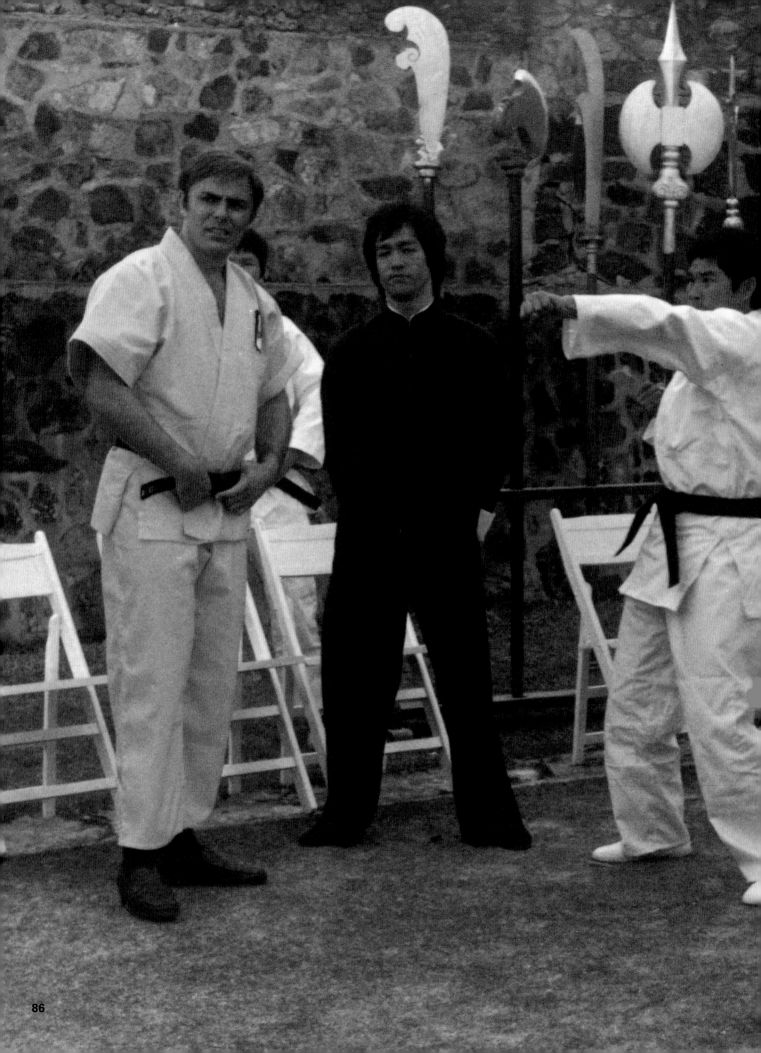

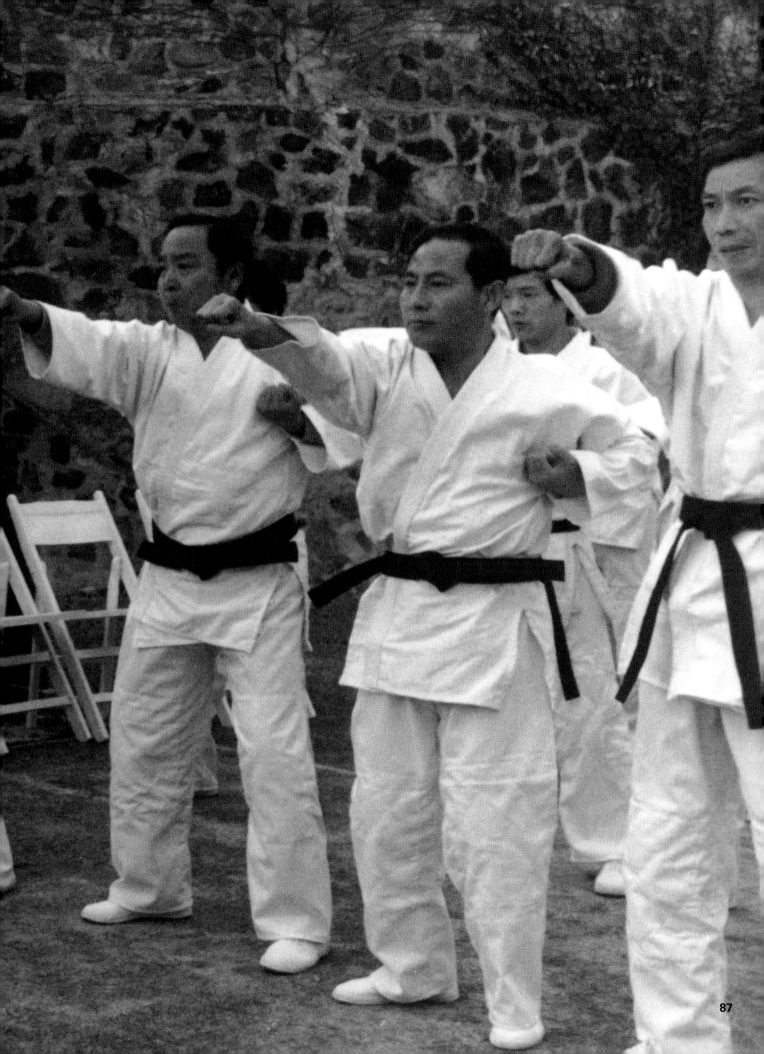

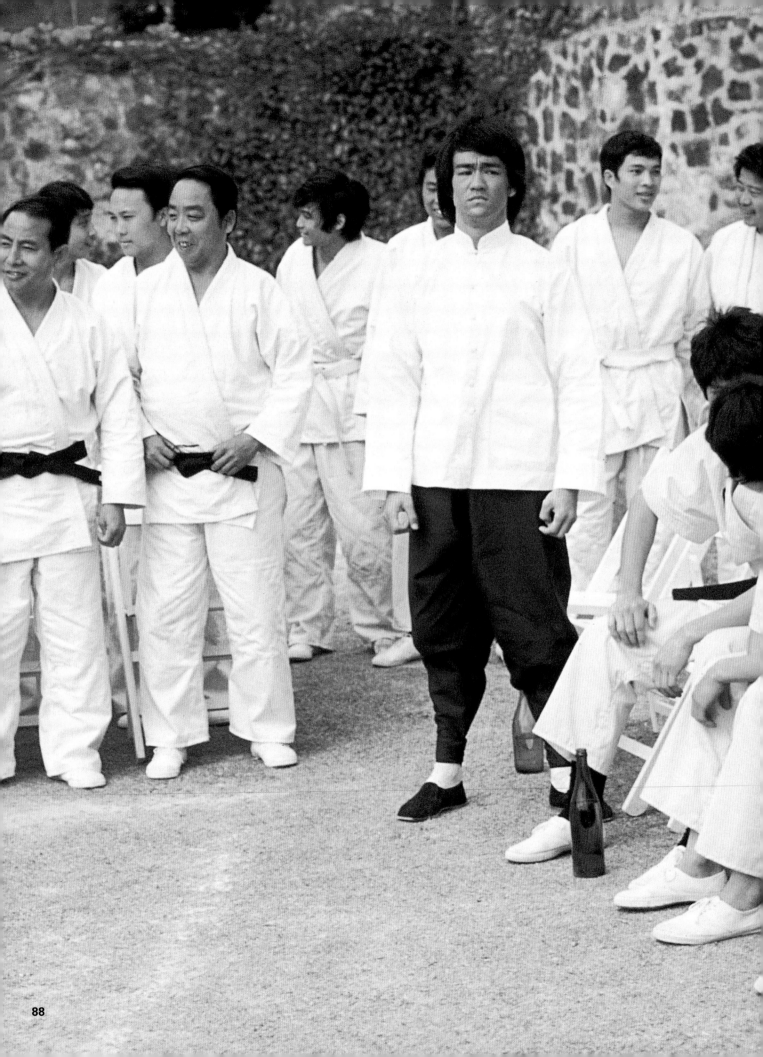

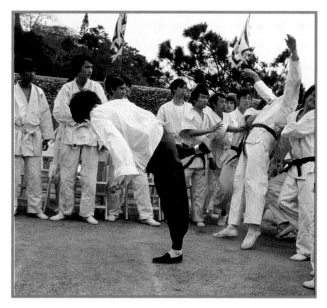

As I've mentioned, styles "set" and "trap" reality into a choice mold. Freedom just cannot be preconceived, and where there is freedom, there is neither good nor its reaction, bad. My only concerns are for those who are conditioned and solidified by a partialized structure, with only routine efficiency, rather than freedom of individual expression.

To set the record straight, I have not invented a new style, that is, set within distinct form as apart from "this" style or "that" style. On the contrary, I hope to free my followers from styles.

Jeet Kune Do (JKD) does not look at combat from a certain angle but from all possible angles. It utilizes all ways and means to serve its end, but, and that is a very important "but," it is bound by none; in other words, JKD, though possessed of all angles, is itself not possessed. This is because of the fact that any structure, however intelligently designed, becomes a cage if the practitioner is obsessed with it. This is where the value lies: the freedom both to use technique and to dispense with it.

Therefore, to define JKD as a particular system (gung fu, karate, etc.) is to miss it completely. It is outside of all particular structures and distinct forms. However, do not mistake JKD as a composite style or being neutral or indifference; for it is both at once "this" and "not this." It is neither opposed to styles nor not opposed to them. To understand one must transcend the duality of "for" and "against" into one organic whole. A good JKD man rests in direct intuition.

Truth is a pathless road. It is total expression that has no before or after. Similarly, JKD is not an organized institution that one can be a member of. Either you understand or you don't, and that is that. (There was a Jun Fan Gung Fu Institute, there was a method of wing chun, but there is no such organization or method existing now.)

In most cases, a practitioner of the martial art is what I term a second-hand artist, a conformer. To be sure, he seldom learns to depend upon himself for expression; rather, he faithfully follows a pattern. As time passes, he will probably understand some dead routines, and be good according to his particularly set pattern, but he has not come to understand himself.

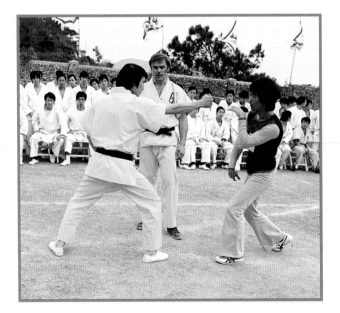

Drilling on routines and set patterns will eventually make a person be good according to the routines and set pattern, but only self-awareness and self-expression can lead to the truth. A live person is not a dead product of "this" style or "that" style, he is an individual, and the individual is always more important than the system.

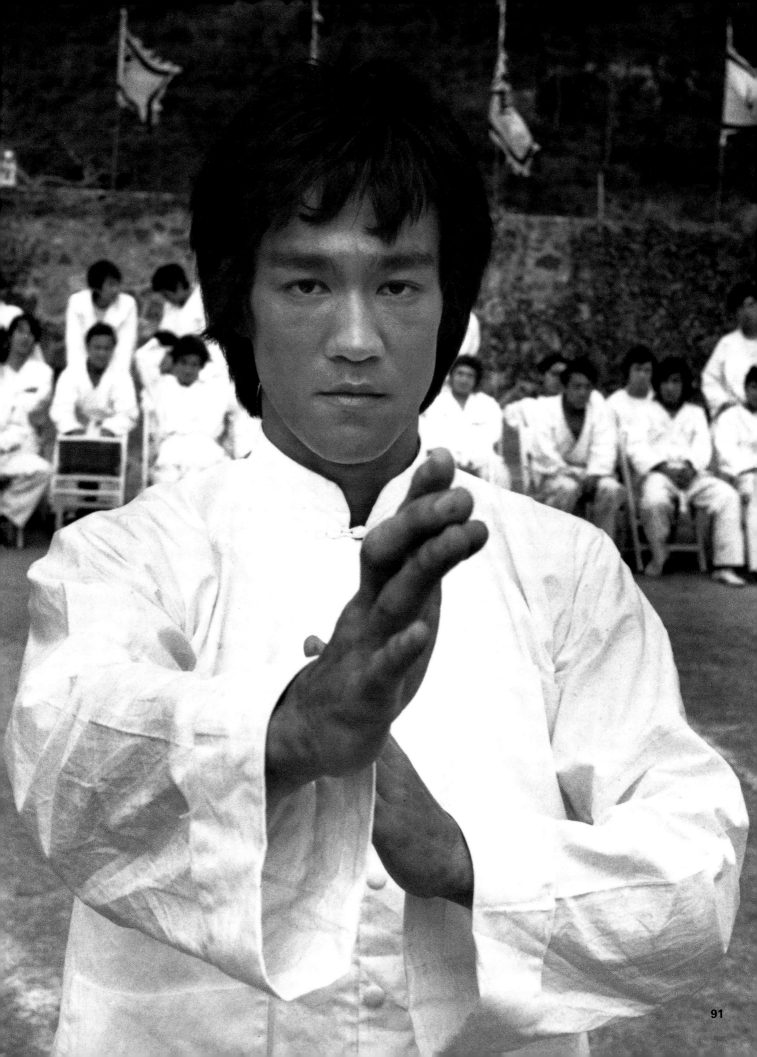

In martial art, many instructors derive their techniques and principles from intellectual theories and not from application.

He can talk about combat, and there are some master talkers, but he cannot really teach it.

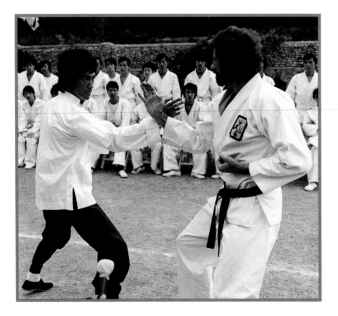

He might create this first law and that kicking principle, but the student will merely be conditioned and controlled rather than freeing himself to blossom into a better martial artist.

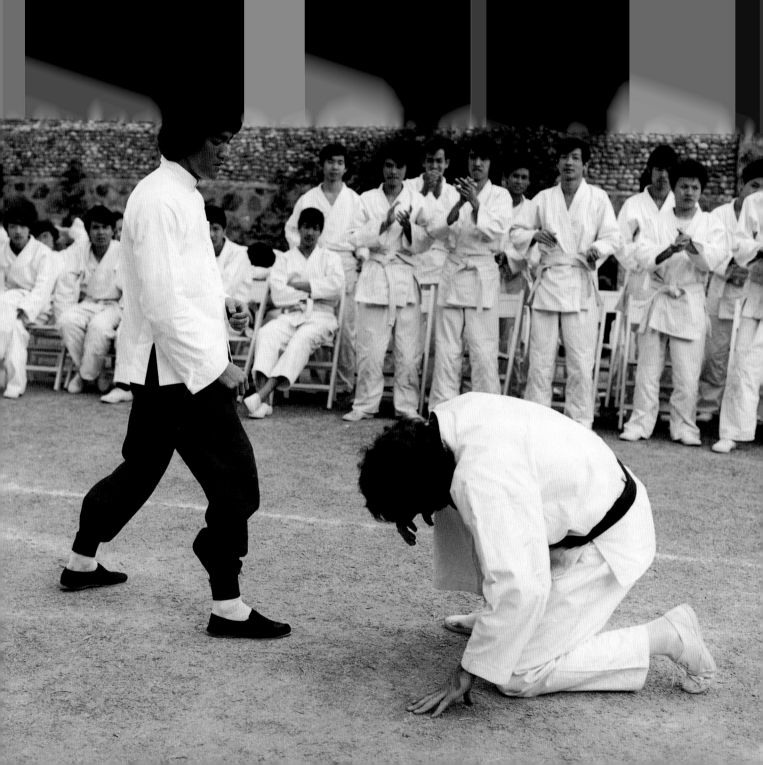

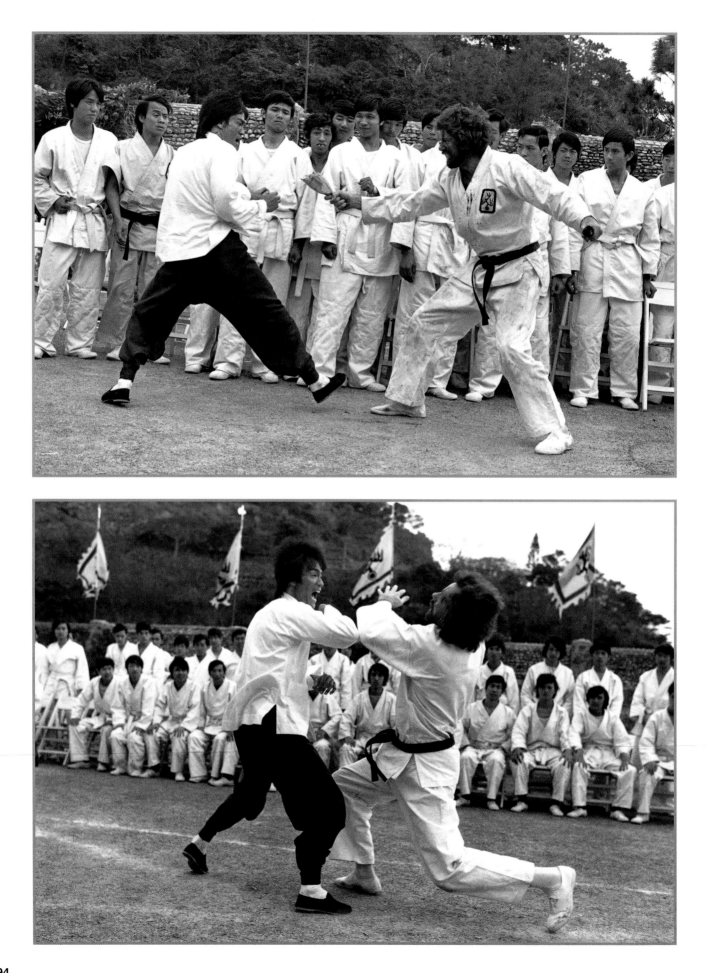

Just as one cannot get a piece of paper to wrap and shape up water, fighting can never be made to conform to any one system, especially forcing it into a highly classical frame. Such a frame only kills and limits the life of the individual as well as the situation. The professed cure of such a frame is itself a disease. In the practice of JKD, there is no set or form, for JKD is not a method of classified techniques, laws, etc., which constitute a system of fighting. It does employ a systematic approach to training but never a method of fighting. To go further, JKD is a process, not a goal; a means but not an end, a constant movement rather than an established static pattern.

The final aim of JKD is toward personal liberation. It points the way to individual freedom and maturity. Mechanical efficiency or manipulatory skill is never as important as inward awareness gained, for to learn a movement without inward awareness results in imitative repetitiousness, a mere product. A true fighter "listens" to circumstances, while a classical man "recites" his circumstances. Remember that a martial art man is not merely a physical exponent of some prowess he may have been gifted with in the first place. As he matures, he will realize that his side kick is really not so much a tool to conquer his opponent, but a tool to explode through his ego and follies. All that training is to round him up to be a complete man.

Of this I am certain: superior performances in martial art will rest in the future development and not on many of the obsolete and outmoded training methods existing.

An excellent instructor is an excellent athlete. True, I am sure as one advances in age he will be at a disadvantage with a good young man, but he has no excuse not to be a first-rate man among his contemporaries, physically, as well as mentally.

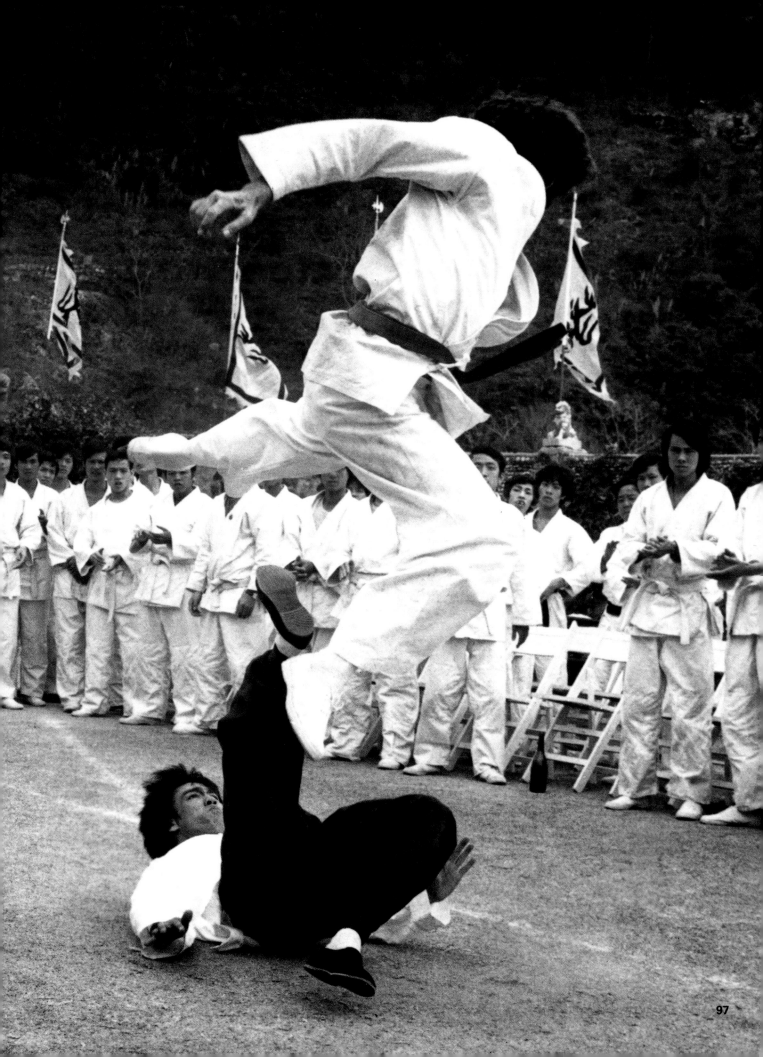

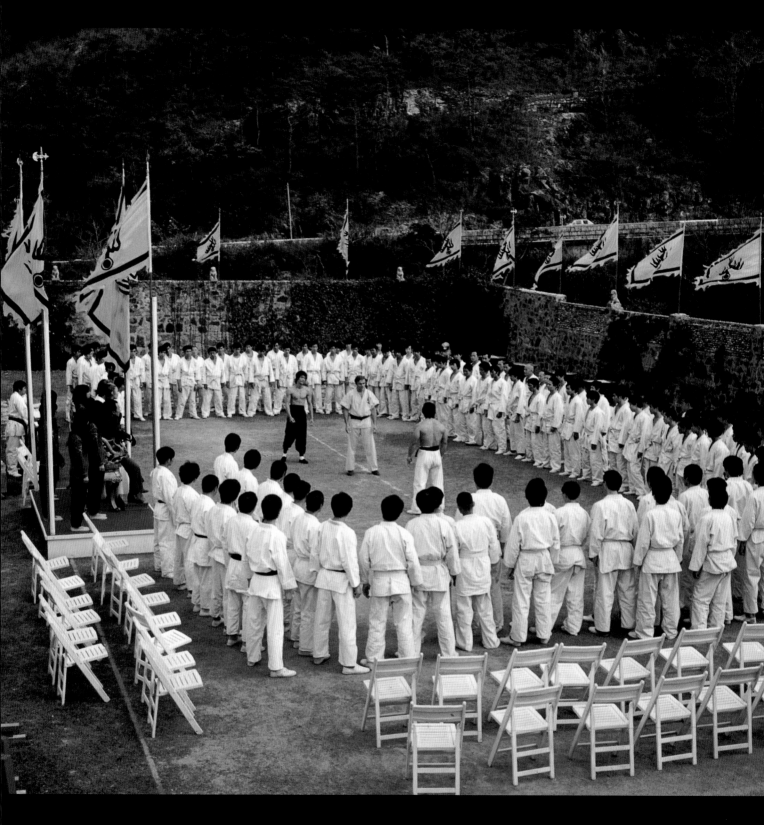

A pliable, choiceless observation without exclusion is the foundation of a JKD man. An "altogether alert awareness" without a center or its circumference; to be in it, but not of it.

In essence, JKD seeks to restore the pupil to his primordial state so that he can "freely" express his own potential. The training consists of minimum of form in the natural development of his tools towards the formless. In short, to be able to enter a mold yet not being caged in it, or to obey the principles without being bound by them.

A JKD member who says JKD is exclusively JKD is simply not in with it. He is still hung up in his self-closing resistance; in this case, anchored down to a reactionary pattern and naturally is still bound by another modified pattern and can move only within its limits. He has not digested the simple fact that truth exists outside of all molds and patterns, and awareness is never exclusive. Jeet Kune Do is merely a name used, a boat to get one across the river, and once across, is to be discarded, and not to be carried on one's back.

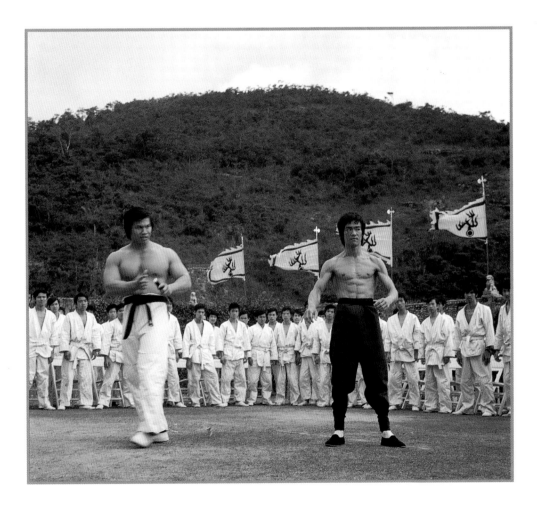

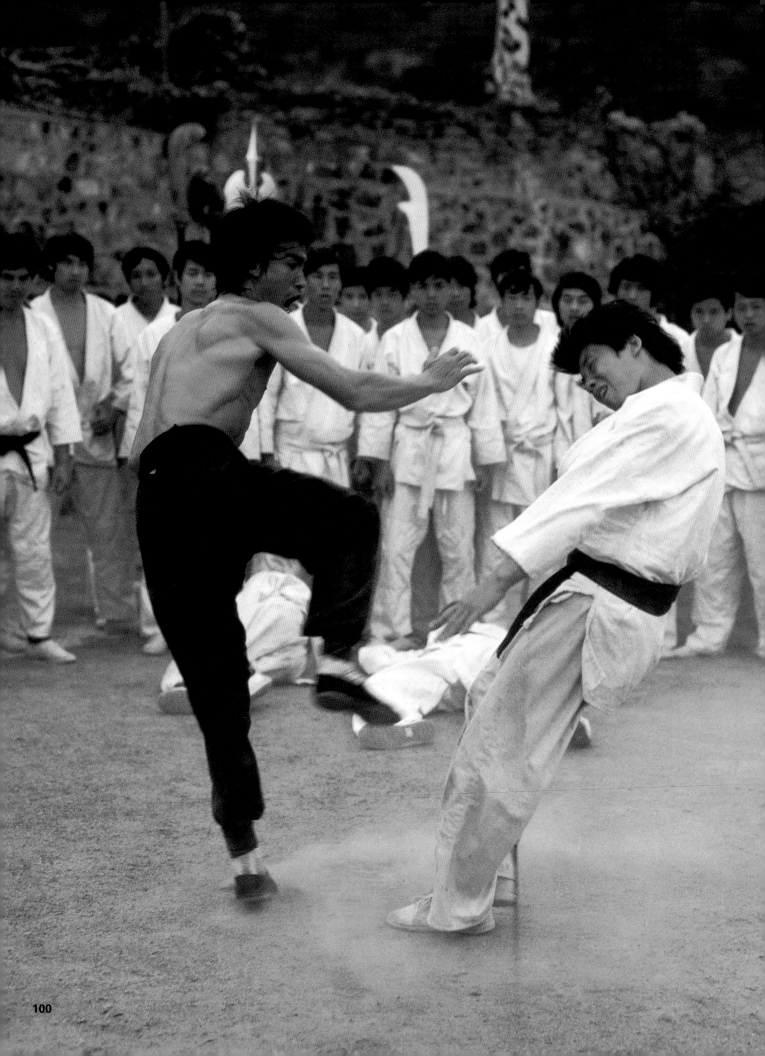

Really, there is no rigid form in Jeet Kune Do. All that there is is this understanding: If the enemy is cool, stay cooler than him. If the enemy moves, move faster than him.

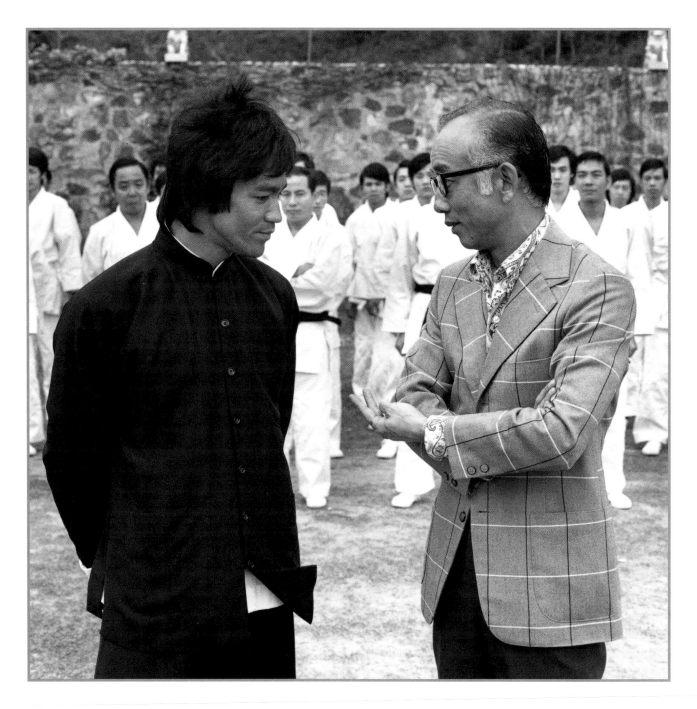

Jeet Kune Do rejects all restrictions imposed by forms and formality and emphasizes the clever use of mind and body to defend and attack.

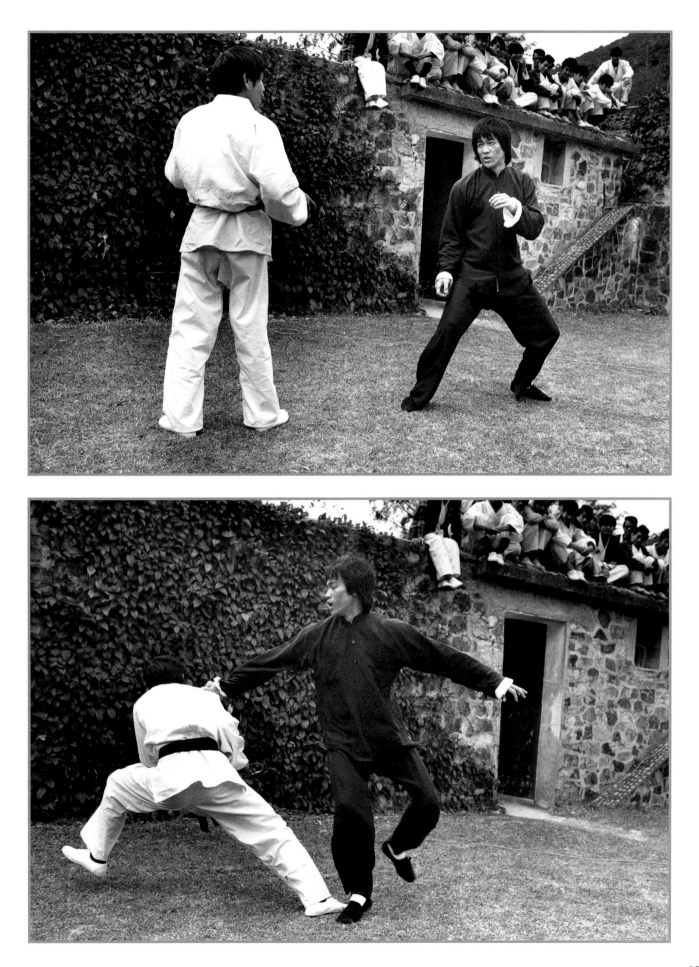

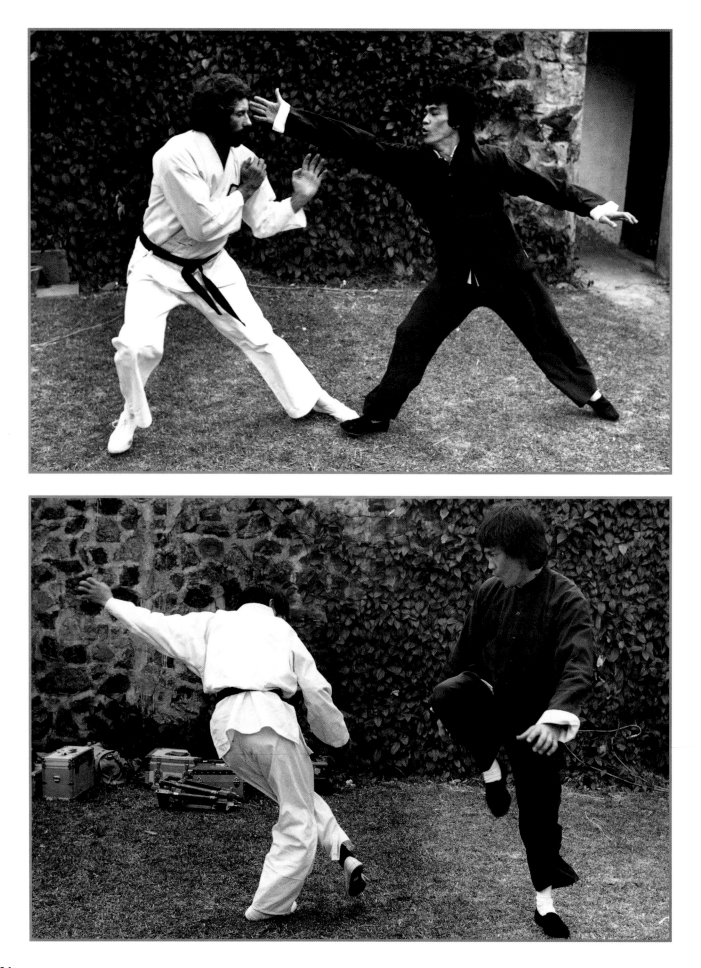

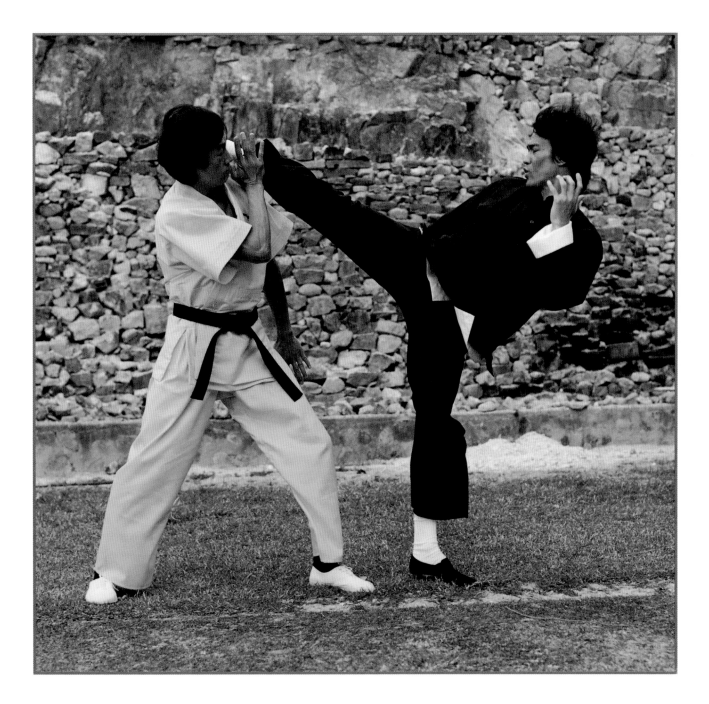

Be concerned with the ends, not the means. Master your own manipulation of force.

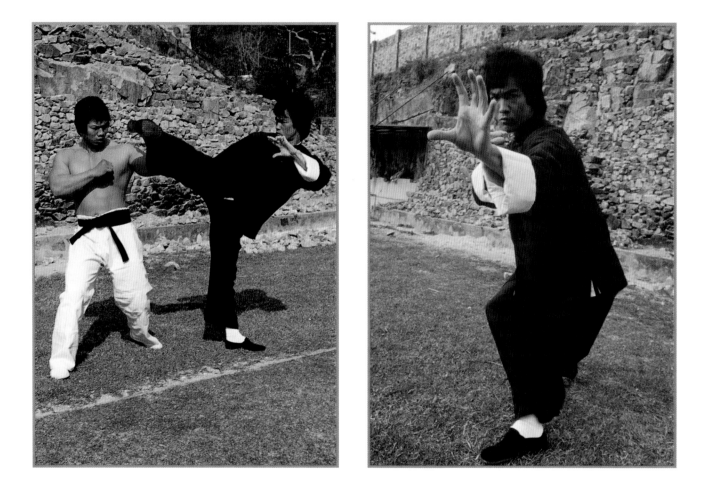

Don't be restricted by your form.

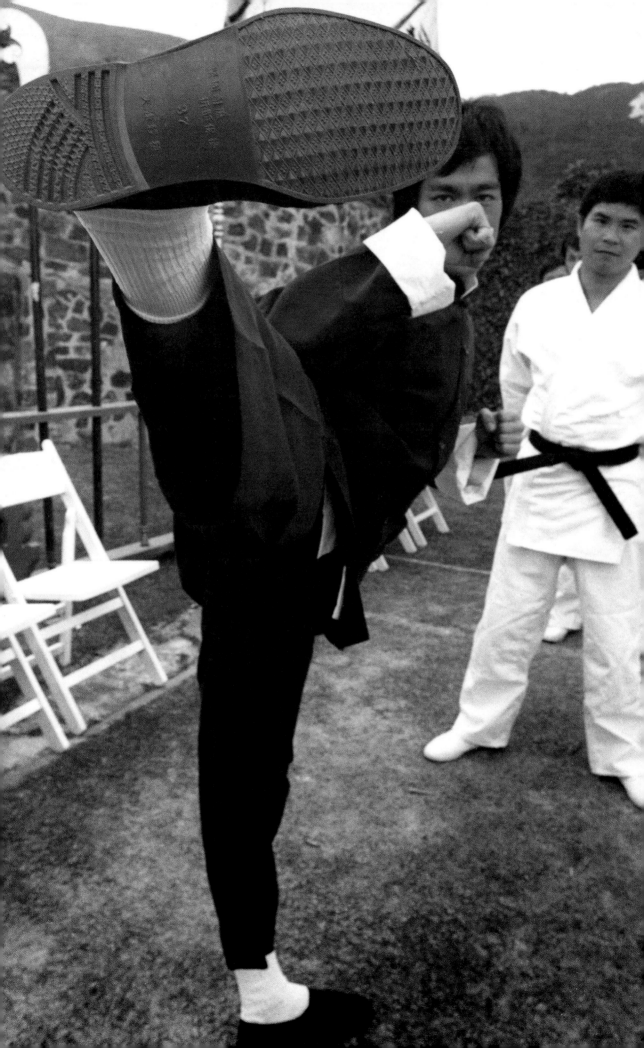

While being trained in Jeet Kune Do, the student is to be active and dynamic in every way. But in actual combat, his mind must be calm and not at all disturbed. He must feel as if nothing critical is happening. When he advances, his steps are light and secure, and his eyes are not glaringly fixed on the enemy as those of an insane man might be. His behavior is not in any way different from his everyday behavior. No change is taking place in his expression. Nothing betrays the fact that he is now engaged in a mortal fight.

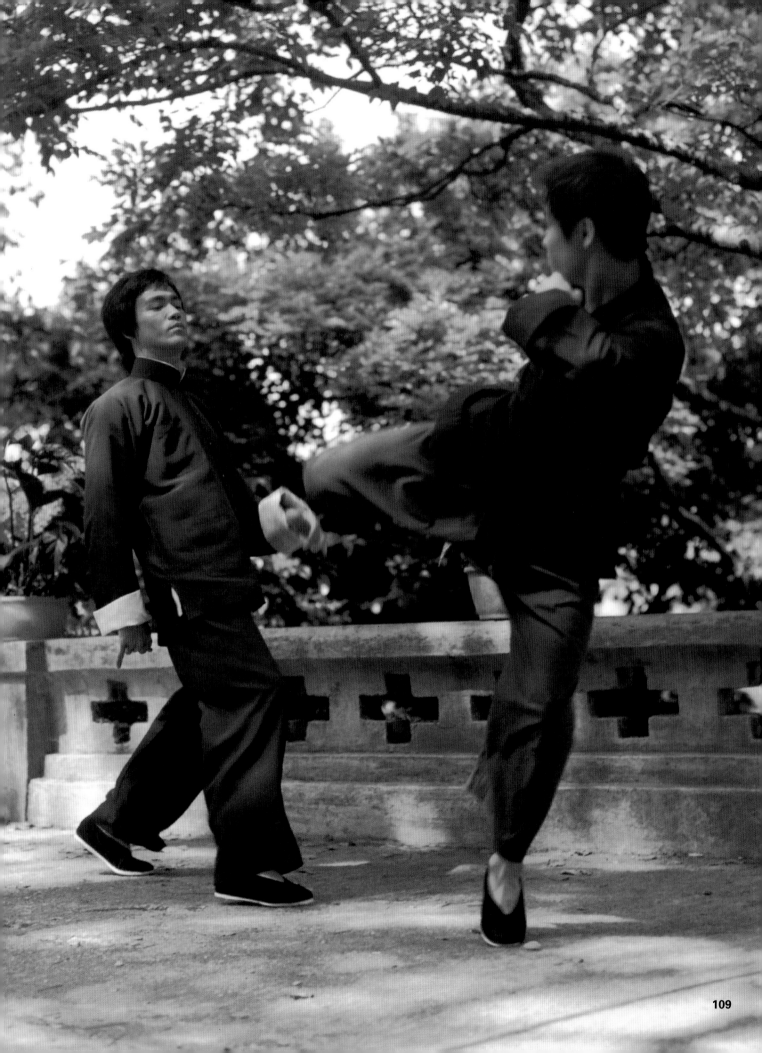

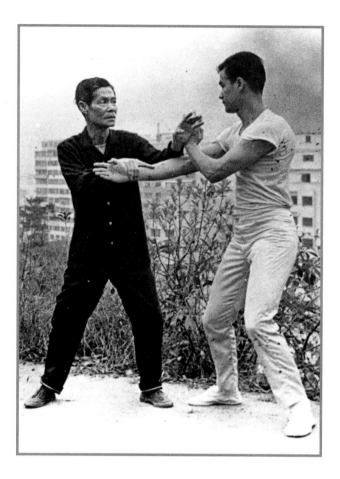 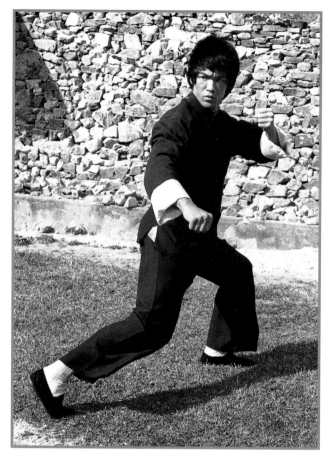

The fighter is to be always single-minded with one object in view; to fight, looking neither backward nor sidewise. Rid obstructions to one's onward movement—emotionally, physically, or intellectually.

A way of life, a system to will power and control, though it ought to be enlightened by intuition.

To approach Jeet Kune Do with the idea of mastering the will.

Forget about winning and losing, forget about pride and pain: let your opponent graze your skin and you smash into his flesh; let him smash into your flesh and you fracture his bones; let him fracture your bones and you take his life! Do not be concerned with your escaping safely—lay down your life before him!

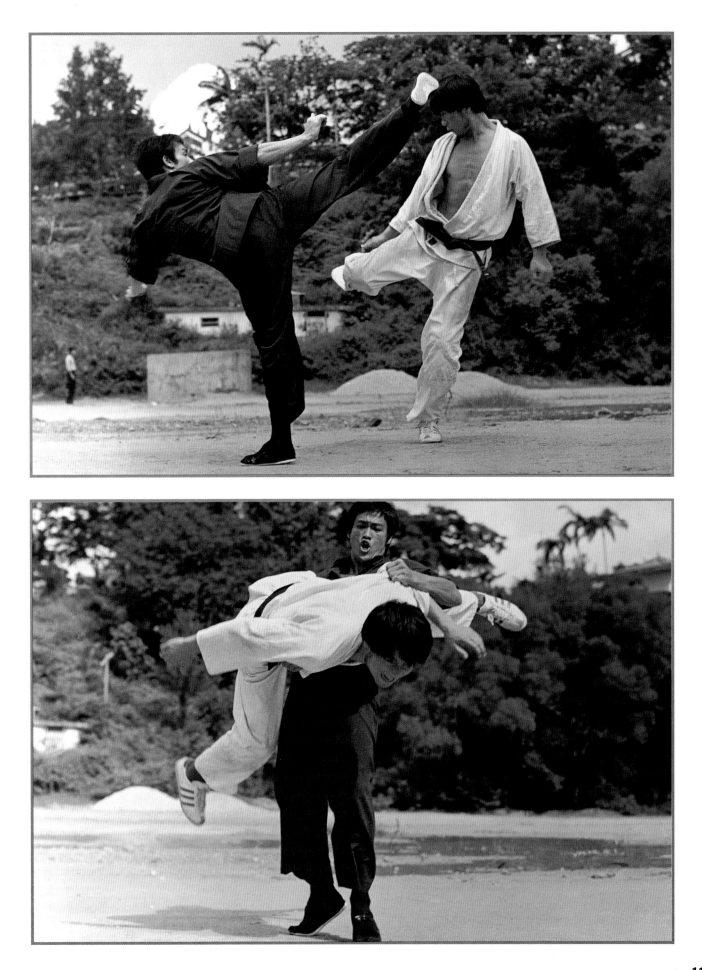

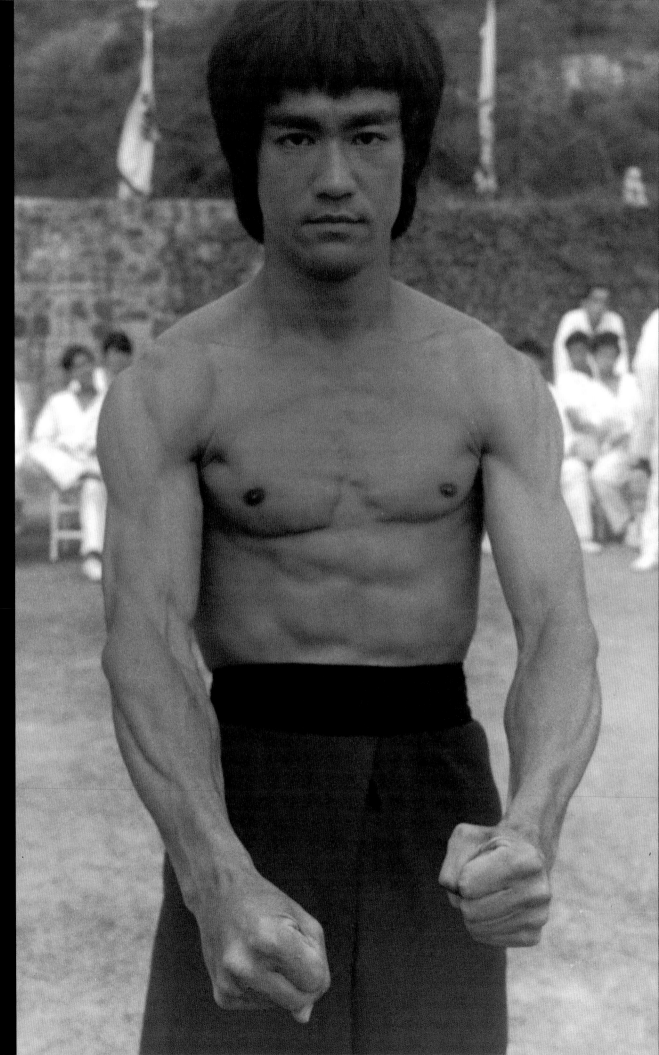

The tools (your natural weapons) have a double purpose:

a) To destroy the opponent in front of you— annihilation of things that stand in the way of peace, justice, and humanity.

b) To destroy your own impulses from the instinct of self-preservation (anything that is bothering your mind)—not to hurt or maim anyone but one's own greed, anger, and folly. In this respect, Jeet Kune Do is directed toward oneself.

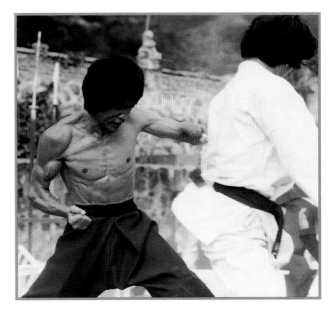

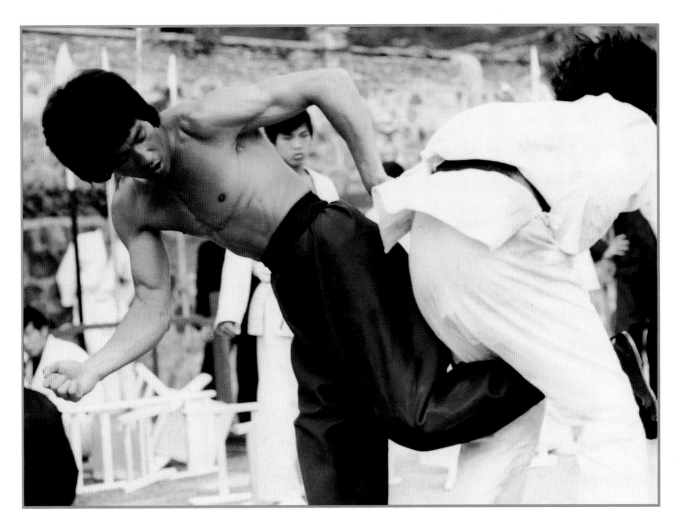

Learning gained is learning lost.

The knowledge and skill you have achieved are after all meant to be "forgotten" so you can float in emptiness without obstruction and comfortably. Learning is important but do not become its slave. Above all, do not harbor anything external and superfluous, the mind is the primary. One can never be the master of his technical knowledge unless all his psychic hindrances are removed and he can keep the mind in the state of emptiness (fluidity), even purged of whatever technique he has obtained—with no conscious effort.

With all the training thrown to the wind, with a mind perfectly unaware of its own workings, with the self vanishing nowhere anybody knows, the art of Jeet Kune Do attains perfection. Learning of the techniques corresponds to an intellectual apprehension in Zen of its philosophy, and in both Zen and Jeet Kune Do a proficiency in this does not cover the whole ground of the discipline. Both require us to come to the attainment of ultimate reality, which is the emptiness or the absolute. The latter transcends all modes of relativity.

In Jeet Kune Do, all the technique is to be forgotten and the unconscious is to be left alone to handle the situation, when the technique will assure its wonders automatically or spontaneously—to float in totality, to have no technique is to have all technique.

I do not believe in styles anymore. I mean, I do not believe that there is such a thing as, like, "the Chinese way of fighting" or "the Japanese way of fighting," or any other "way" of fighting, because unless human beings have three arms and four legs, we will not have a different form of fighting.

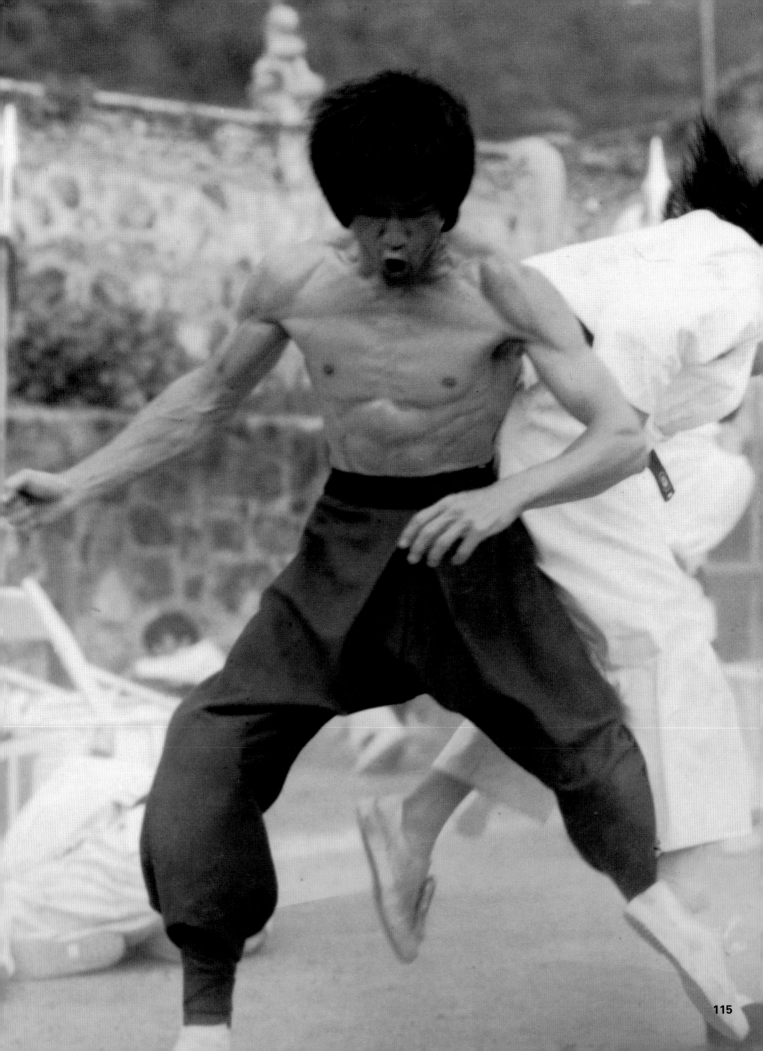

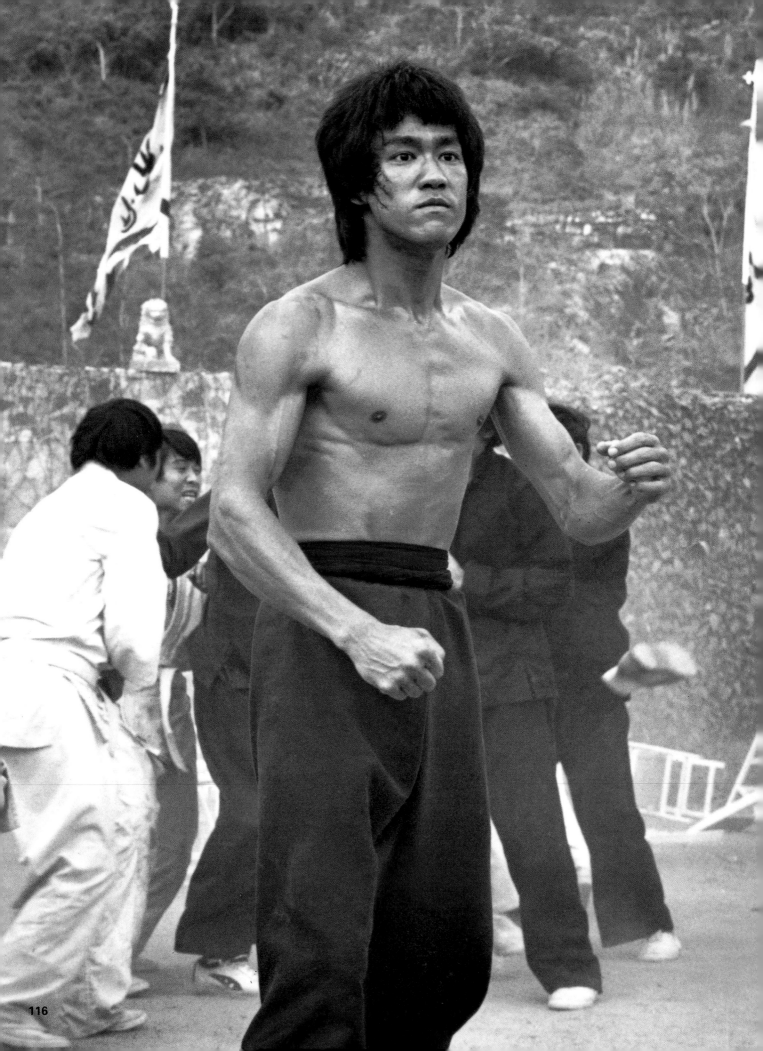

116

I mean it is easy for me to put on a show and be cocky and be flooded with a cocky feeling and then feel pretty cool and all that. Or I can make all kinds of phony things—you see what I mean?—and be blinded [to the truth of combat] by it. Or I can show you some really fancy movement. But to express oneself honestly, not lying to oneself, and to express myself honestly, now that, my friend, is very hard to do.

And you have to train. You have to keep your reflexes, so that when you want *it,* it's there! When you want to move, you are moving. And when you move, you are determined to move.

Not taking one inch—not anything less than that! If I want to punch, I'm going to do it, man, and I'm going to do it, you see? So that is the type of thing you have to train yourself into: to become one with the punch—whether it travels in a straight line, curved line, upwards, downwards, etc. That might be slow but, depending on the circumstances, sometimes that might not be slow. And, in terms of legs you can kick up, straight—same thing, right? And, after all that, then you ask yourself, how can you honestly express yourself—at that moment?

To me, ultimately, martial art means honestly expressing yourself.

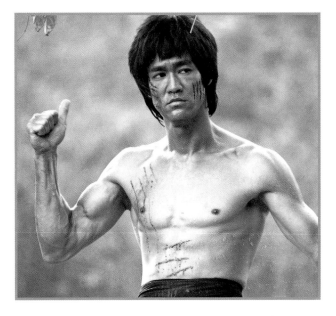

A good martial artist does not become tense—but ready. Not thinking, yet not dreaming. Ready for whatever may come.

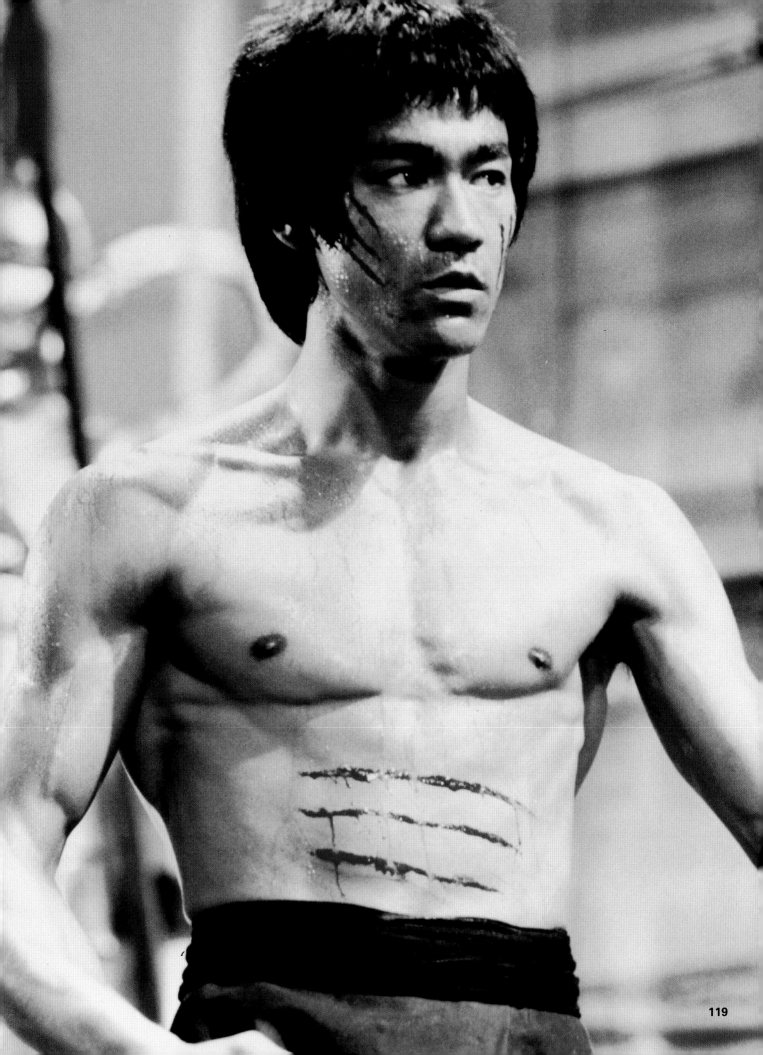

Because of styles, people are separated. They are not united together because styles became laws. But the original founder of the style started out with hypothesis. But now it has become the gospel truth. And people that go into it, man, become the product of it. It doesn't matter how you are, who you are, how you are structured, how you are built, how you are made—it doesn't matter. You just go in there and be that product. And that—to me—is not right.

But, if you do not have styles; if you just say: "Here I am as a human being, how can I express myself totally and completely?" Now that way, you won't create a style because style is a crystallization, this way is a process of continuing growth.

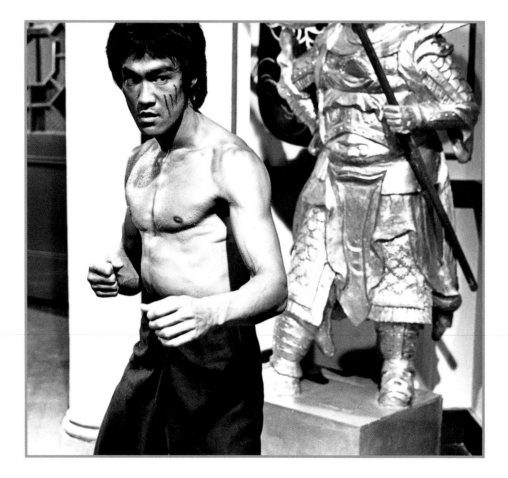

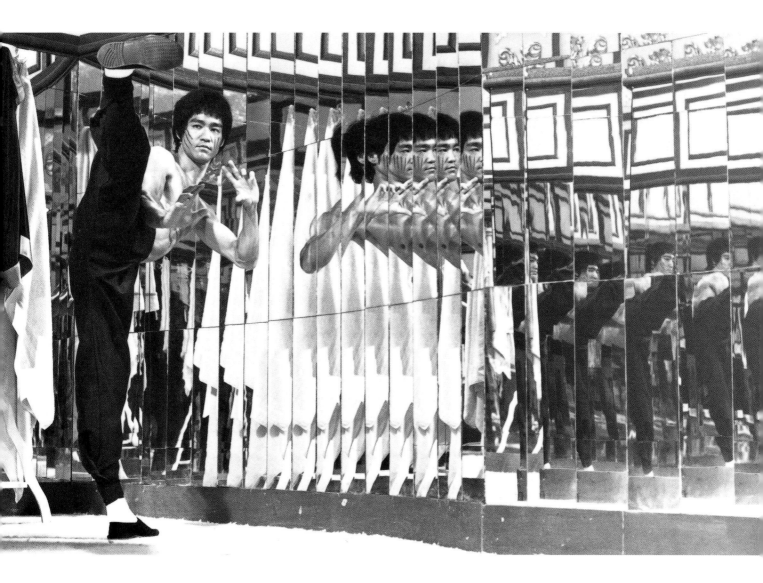

Jeet Kune Do's aggressive mental training is not a mere philosophical contemplation on the effervescence of life or a frozen type of mold, but an entrance into the realm of non-relativity—and it is real.

The point is to utilize the art as a means to advance in the study of the Way. To be on the alert means to be deadly serious, to be deadly serious means to be sincere to oneself, and it is sincerity that finally leads to the Way.

The undifferentiated center of a circle that has no circumference: The Jeet Kune Do man should be on the alert to meet the interchangeability of the opposites. But as soon as his mind "stops" with either of them, it loses its own fluidity. A

Jeet Kune Do man should keep his mind always in the state of emptiness so that his freedom in action will never be obstructed.

When there is no obstruction of whatever kind, the Jeet Kune Do man's movements are like flashed lightning or like the mirror reflecting images.

The spirit is no doubt the controlling agent of our existence (as to its whereabouts we can never tell), though altogether beyond the realm of corporeality. This invisible seat controls every movement in whatever external situation it may happen to find itself. It is thus to be extremely mobile, no "stopping" in any place at any moment.

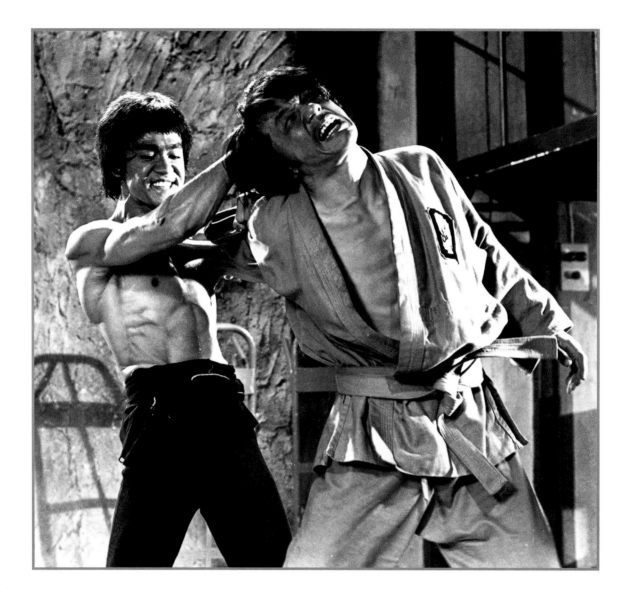

Martial art is ultimately an athletic expression of the dynamic human body. More important yet is the person who is there expressing his own soul.

Martial art, then, like any art, is an expression of the human being. Some expressions have taste, some are logical (maybe under certain required situations), but most are mere performing, sort of a mechanical repetition of a fixed pattern.

This is most unhealthy because to live is to express and to express you have to create. Creation is never something old and definitely not merely repetition. Remember well my friend that all styles are man-made and the man is always more important than any style. Style concludes. Man grows.

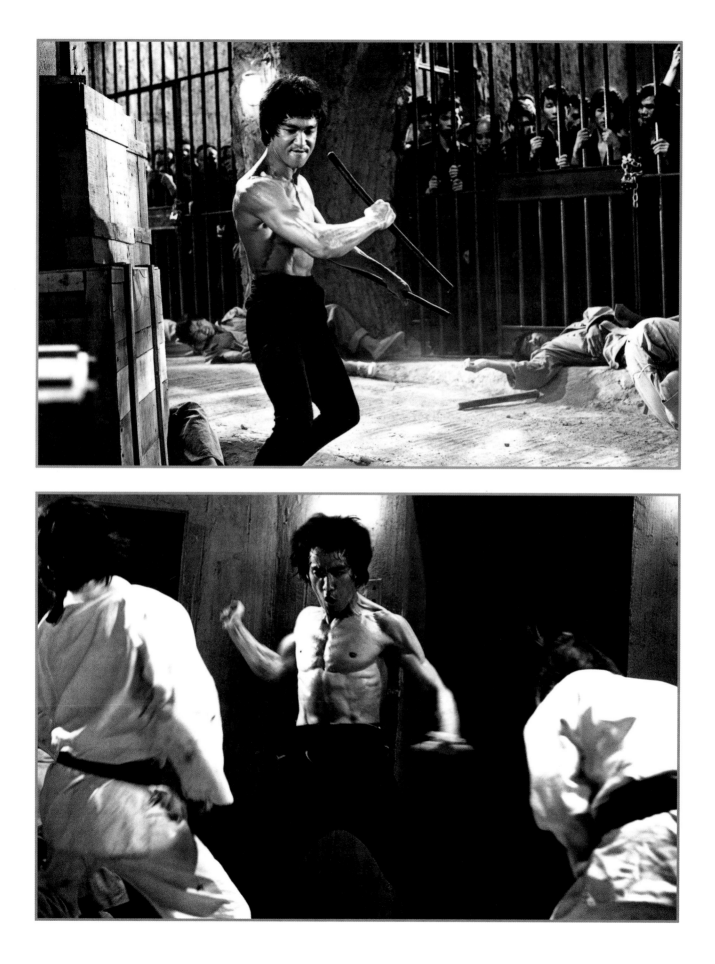

Yes, martial art is an unfolding of what one is; his anger, his fears, and yet under all these natural human tendencies, which we all experience, after all, a "quality" martial artist can—in the midst of all these commotions—still be himself.

And it is not a question of winning or losing but it is a question of being what *is* at that moment and being wholeheartedly involved with that particular moment and doing one's best. The consequence is left to whatever will happen.

Therefore to be a martial artist also means to be an artist of life. Since life is an ever-going process, one should flow in this process and discover how to actualize and expand oneself.

In case you have missed the recent news, Bruce Lee's Jeet Kune Do—of which he is the founder—has been elected and accepted into the "Black Belt Hall of Fame" in America. This marks the first time a recently developed form of martial art is nationally accepted. No, Jeet Kune Do is not thousands, or even hundreds of years old. It was started in around 1965 by a dedicated and intensified man called Bruce Lee. And his martial art is something that no serious martial artist can ignore.

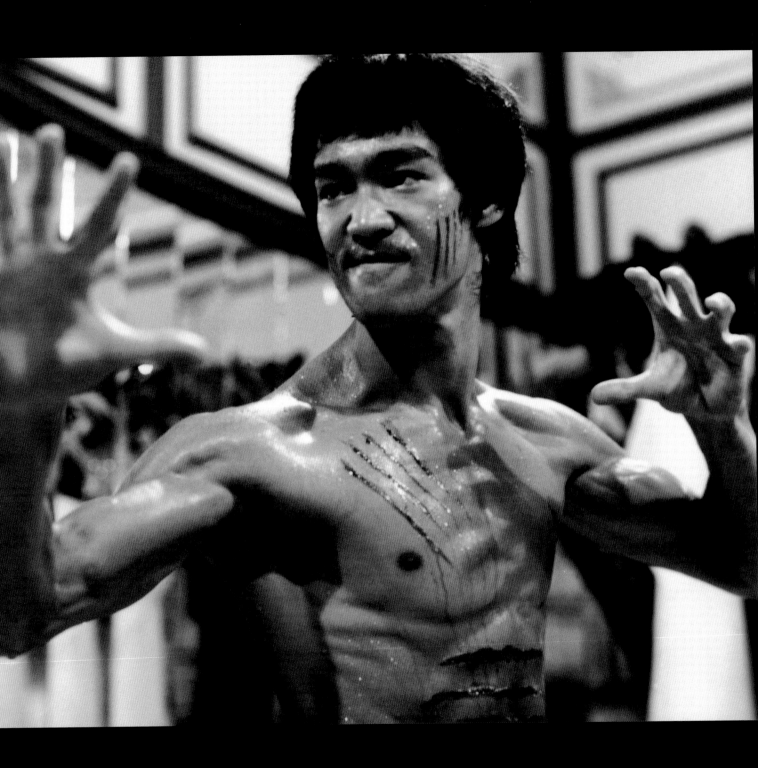

Lee, from Enter the Dragon:
"When the opponent expands, I contract. And when he contracts, I expand."

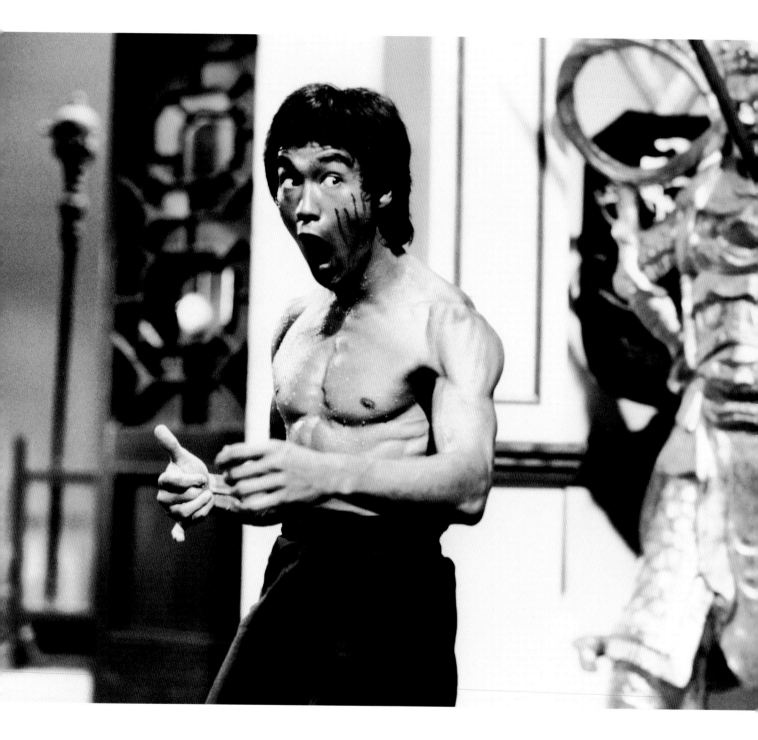

And when there is an opportunity, "I" do not hit; "it" hits—all by itself.

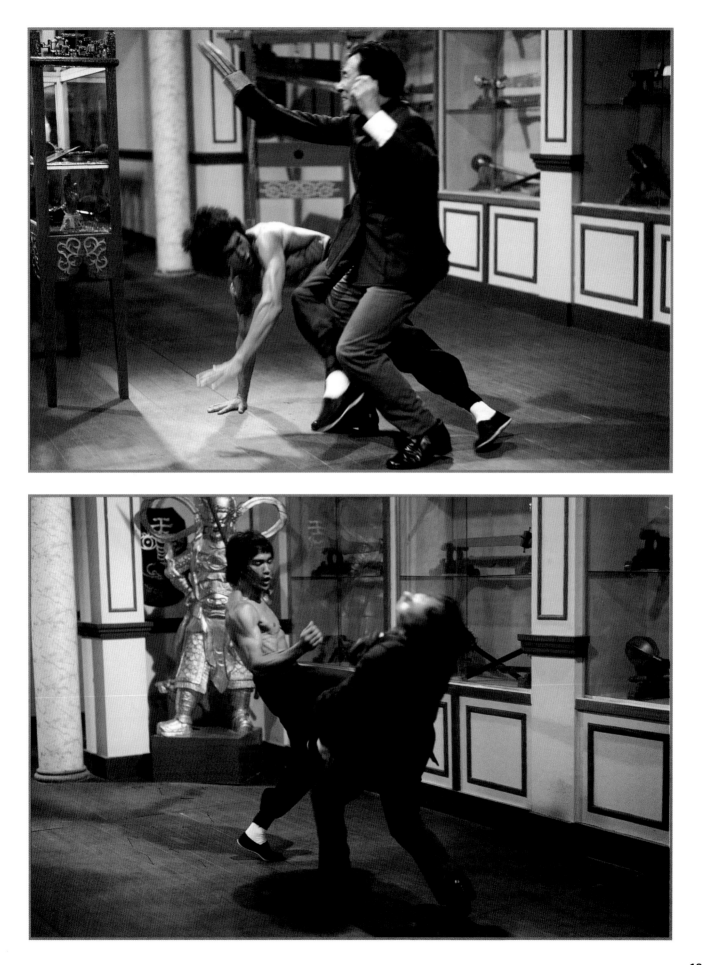

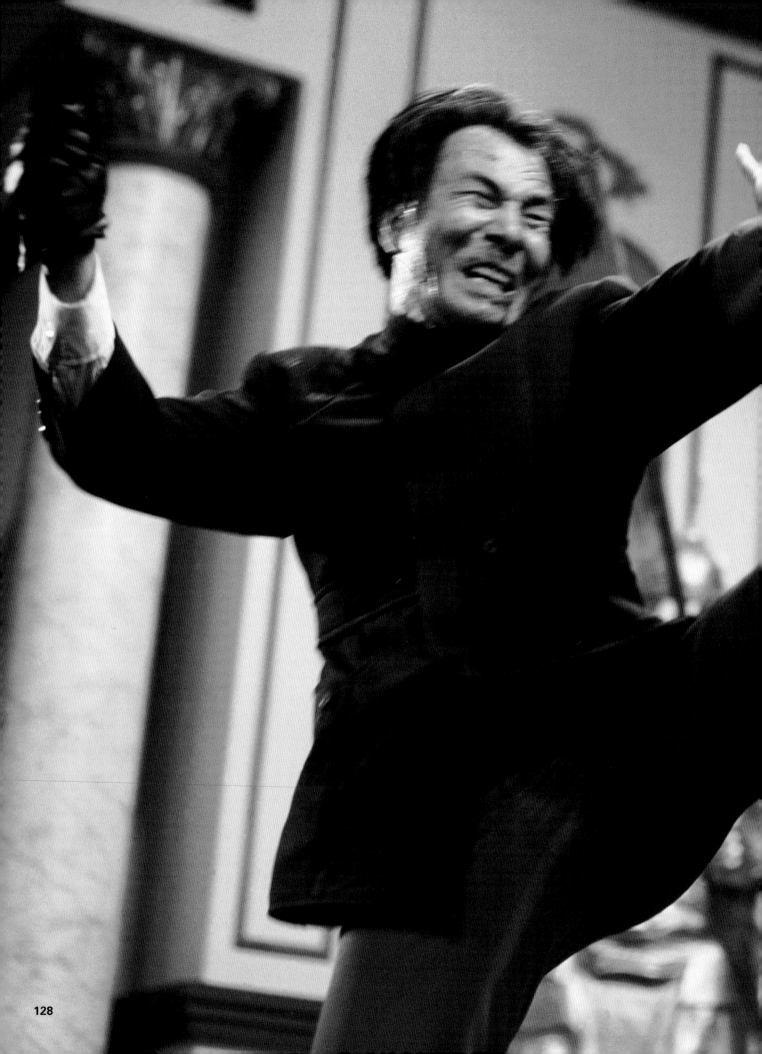

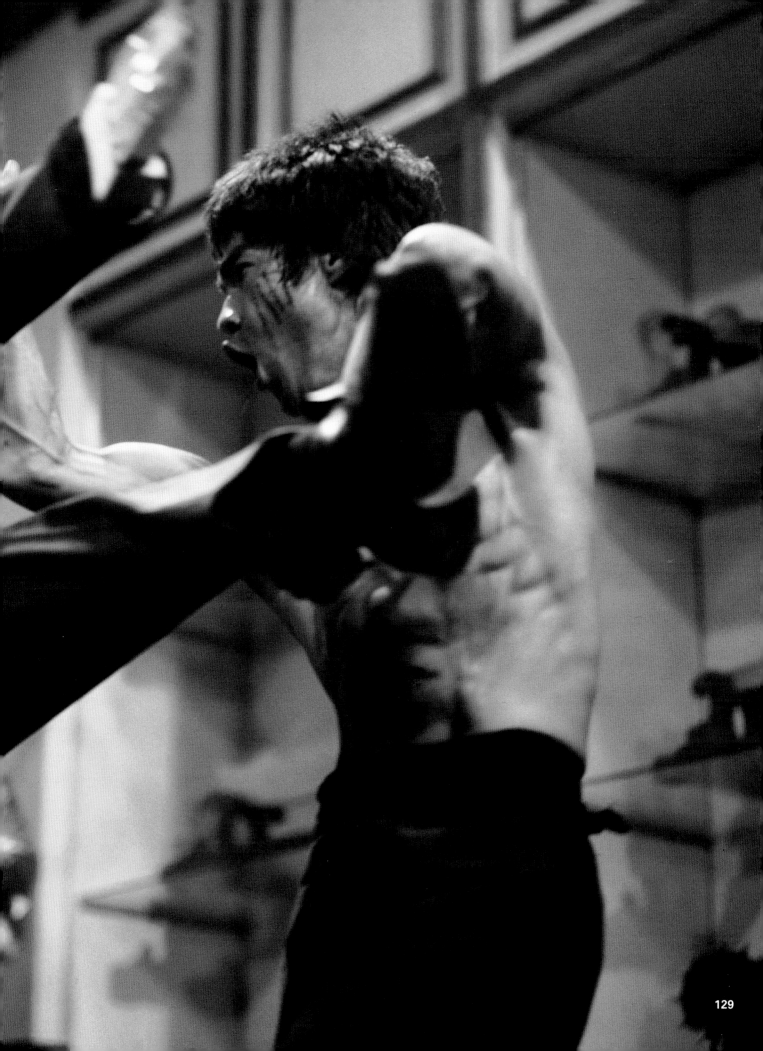

Ever since *The Big Boss* there seems to have been a wave, a hot wave in fact, of finding "another Bruce Lee" among all types of people, particularly martial artists. Ranging from karate men, hapkido men, judo men, etc. Forgetting about whether or not they possess the ability to act, just so long as they can kick or punch halfway decent and know a few tricks or gimmicks, the producers, hopefully, will make them a "star."

Is it that simple to become a star? Well, I can assure you it's not that simple. Also, I can tell you that as more "Bruce Lee films" are shown, the audience will soon see and realize the difference—not only in acting ability, but in physical skill as well.

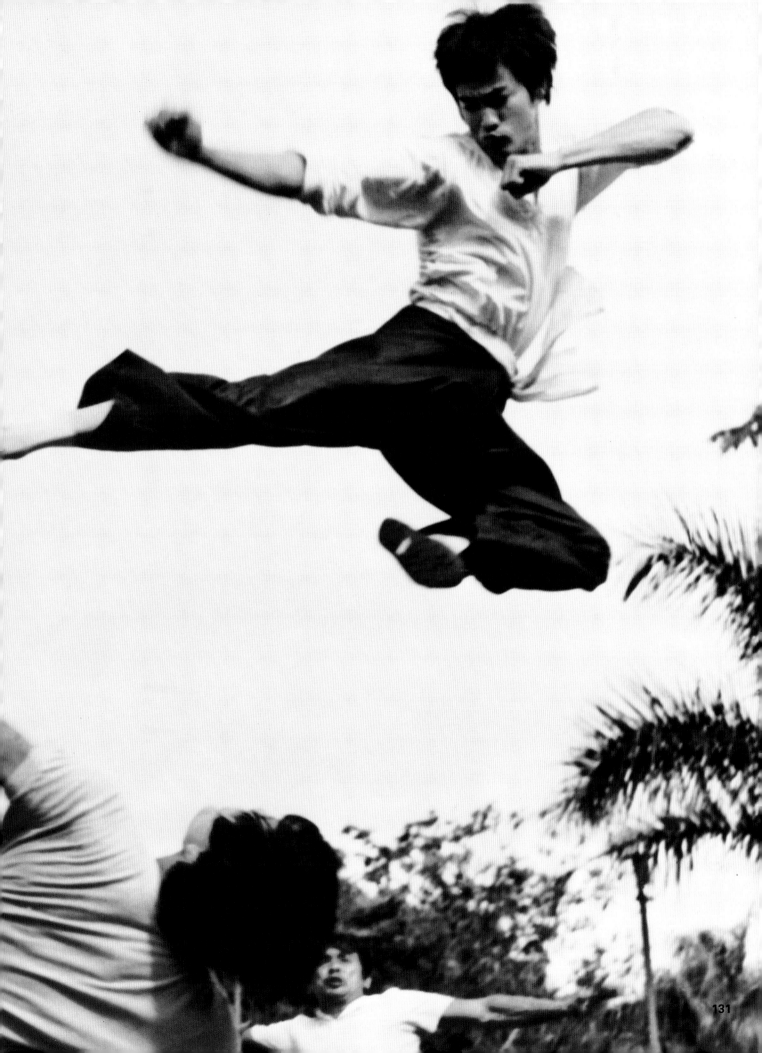

The word "superstar" really turns me off, and I'll tell you why, because the word "star," is an illusion, it is something—what the public calls you. You should look upon [yourself] as an actor. I mean you would be very pleased if somebody said, "Hey man, you're a super actor!" It is much better than "superstar."

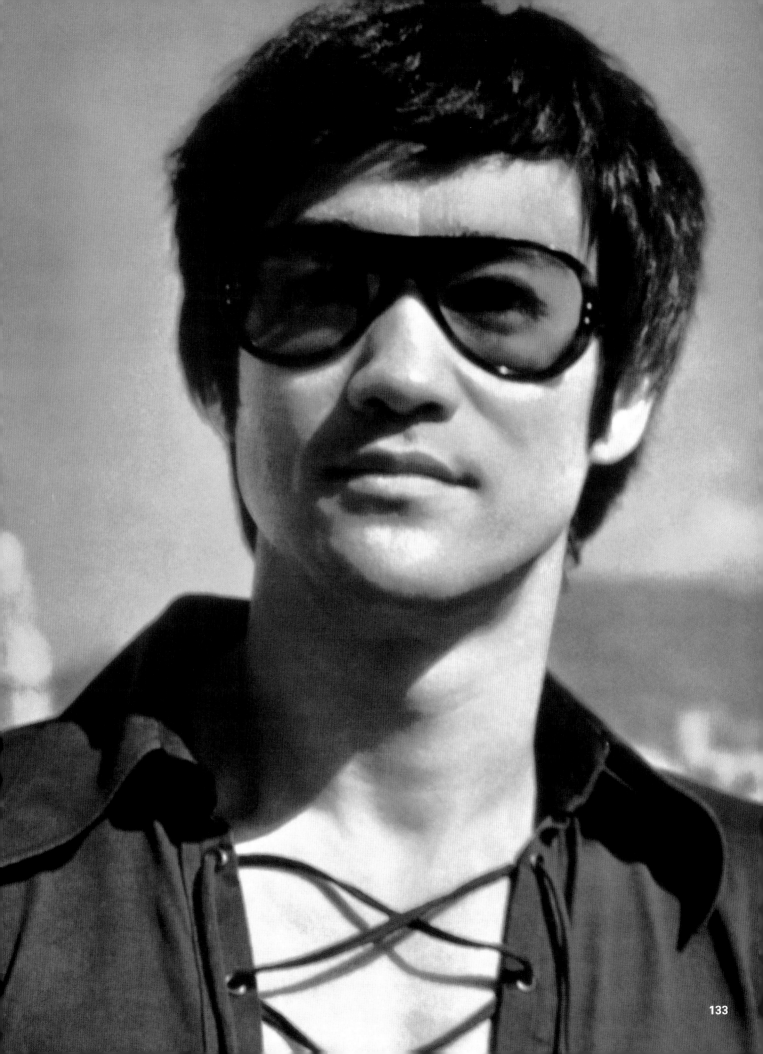

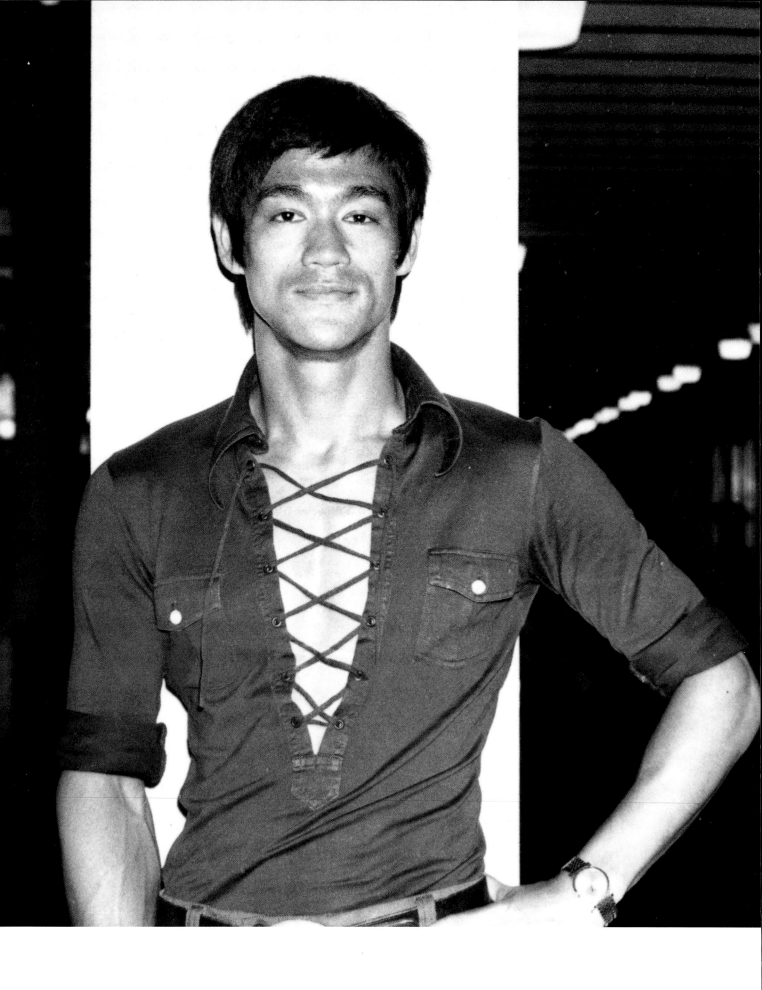

When I make Chinese films, I try my best not to be as "American" as I have been adjusted to for the last twelve years in the States. But when I go back to the States, it seems to be the other way around. I mean it's always that pigtail and bouncing around, "chop-chop," you know, with the eyes slanted and all that. I have already made up my mind that in the United States, I think something about the Oriental—I mean the true Oriental—should be shown.

Before I made my first Chinese film, Chinese flicks were considered kind of unrealistic. I mean there was a lot of over-acting and a lot of jumping around and, anyway, all in all, it didn't look real, you know what I mean?

So, anyway, I came back and I introduced some new elements into it, like when I hit, I really hit.

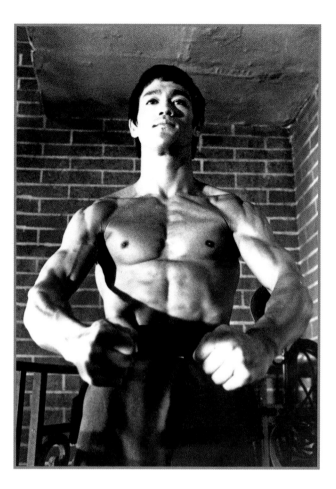

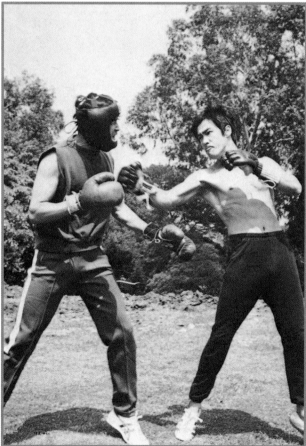

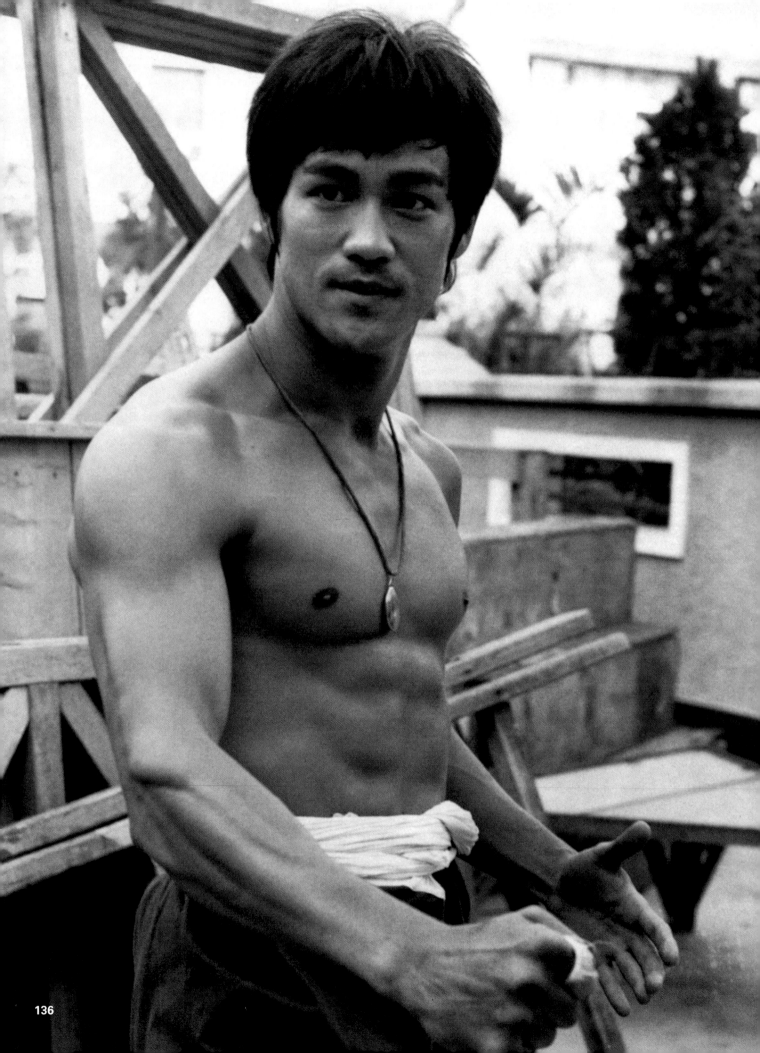

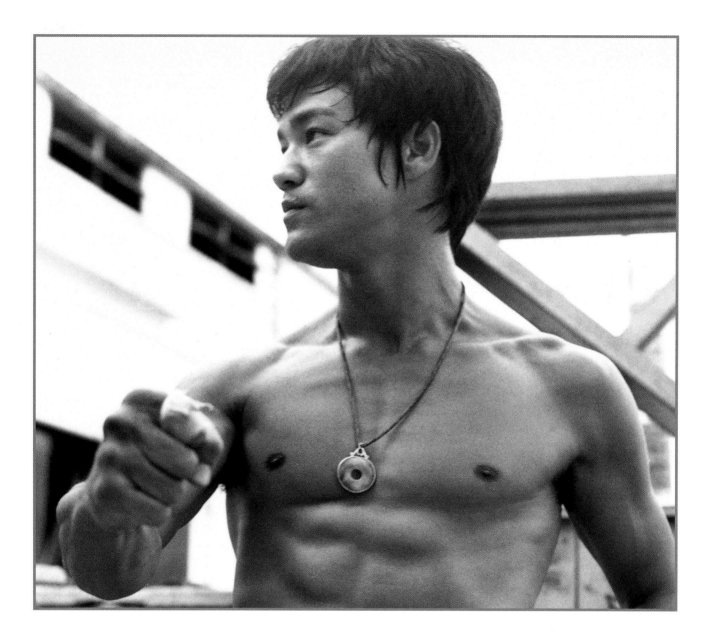

When I signed to do **The Big Boss** *I had a voice in it. Fortunately, I had some background in U.S. filming techniques and with my experience, I was able to help them—especially choreographing the fight scenes.*

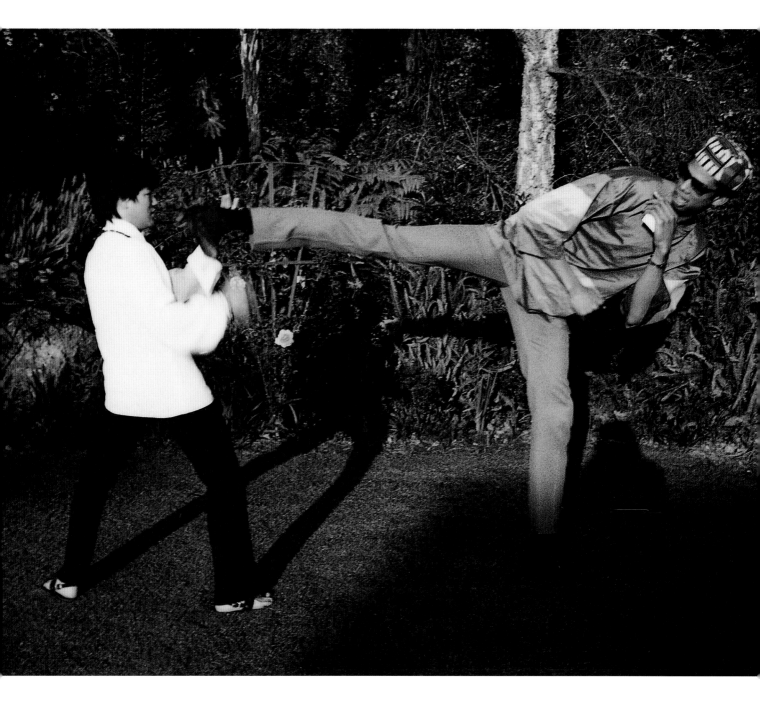

With any luck, I hope to make multi-level films here—the kind of movies where you can just watch the surface story if you want, or you can look deeper into it if you feel like it.

I tried to do that in *The Big Boss.* The character I played was a very simple, straightforward guy. Like, if you told this guy something, he'd believe you. Then, when he finally figures out he's been had, he goes animal.

This isn't a bad character, but I don't want to play him all the time. I'd prefer somebody with a little more depth.

The Big Boss was an important movie for me because I had a starring role for the first time. I felt that I could do a better acting job than in *The Green Hornet* and had more confidence since I just did Paramount's *Longstreet* episode entitled *The Way of the Intercepting Fist.*

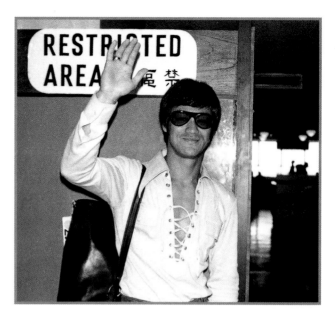

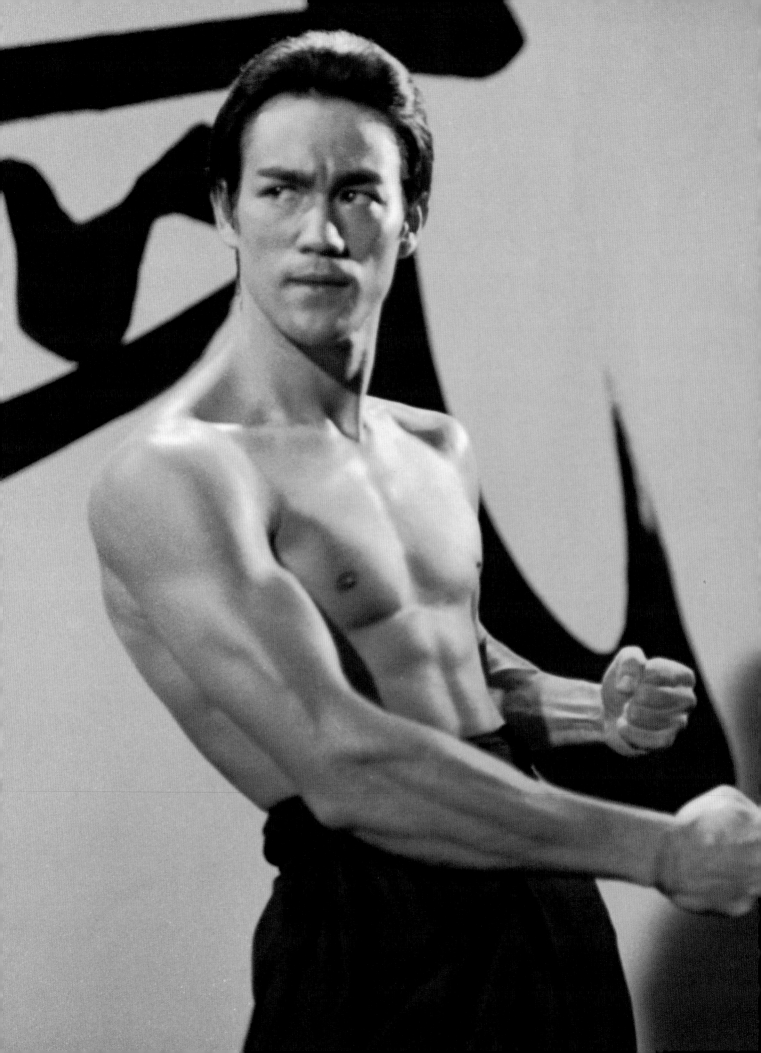

Hong Kong

Paramount wanted me to be a regular for Longstreet *but I refused because I was getting offers from Warner Bros. and MGM. Besides, I still had another commitment with Raymond Chow. We immediately began plans for a second film:* Fist of Fury.

In the movie *Fist of Fury* I am Fok Yuen Gap's student. Fok Yuen Gap was the best gung fu man among his time. His technique was as legendary as it was true. He was the first in the past four thousand years of gung fu history to establish a gung fu institute where many schools of techniques were taught. The Jing Mo Institutes still flourish all over China. He was famous as a patriot, who was ready to defend his country anytime. Many Japanese martial artists had tangled with him; and he, himself, had crossed over Siberia where he killed the Russian wrestlers with a single blow. He was called by foreigners the "Yellow-Faced Tiger."

You see I'm actually portraying his student—not Fok Yuen Gap himself. That is more interesting because Fok Yuen Gap is, you know, sort of limited as a character for a film because you've got to follow how his history goes, you see. But the film is very interesting

because I fought with a Japanese and a Russian and all that—just like Fok Yuen Gap. The Russian fights like karate, boxing, wrestling—everything—all together. And I bite him and everything. Man, all hell breaks loose.

And at the end I died under the gunfire. But it's a very worthwhile death. I walk out and I say "Screw you, man! Here I come!" Boom! And I leap out and leap up in the air, and then they stop the frame and then "ba-ba-ba-ba-ba-bang!"—like *Butch Cassidy and the Sundance Kid*—except they stop the frame so that I'm in the middle of the air, you know?

Fist of Fury cost around eight-hundred-thousand Hong Kong dollars, which is under two-hundred-thousand U.S. dollars [but] it grossed close to one million dollars U.S. in Hong Kong alone and in Thailand and Singapore it did the same.

I insisted that Chen Chen, the role I played in Fist of Fury, *should die in the film. It means the glorification of violence is bad. He had killed many people and he had to pay for it.*

The fight scenes for Fist of Fury *are really tremendous. I mean, I like them myself. So you can imagine if I enjoy them, the regular people should really dig it.*

Ultimately, martial art is the expression of oneself.

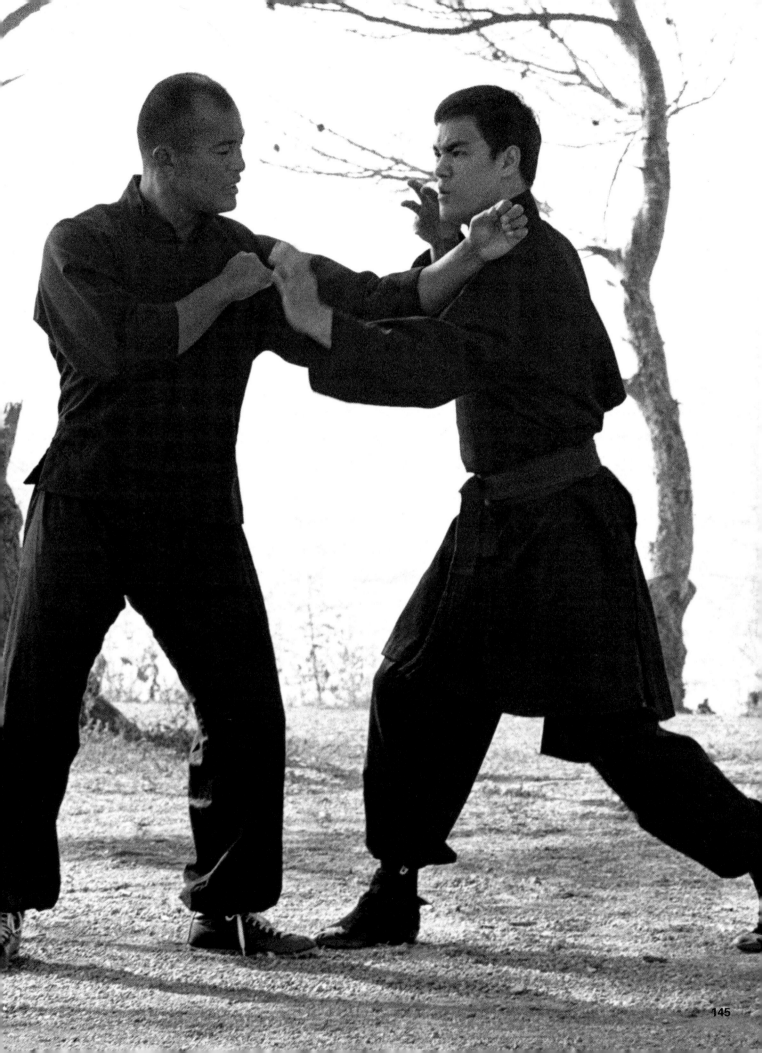

To me, at least, the way that I teach it, all types of knowledge ultimately mean self-knowledge.

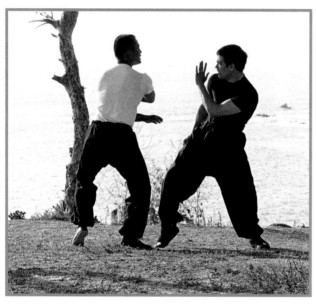

So therefore, my students are coming in and asking me to teach them—not so much how to defend themselves or how to do somebody in—rather, they want to learn to express themselves through some movement; be it anger, be it determination, or whatever.

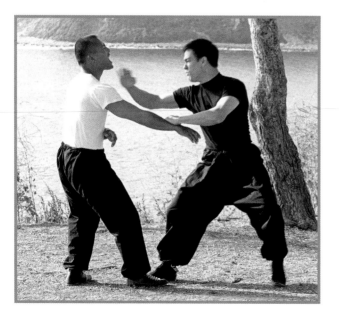

So, in other words, what I'm saying is that the student is paying me to show him, in combative form, the art of expressing the human body.

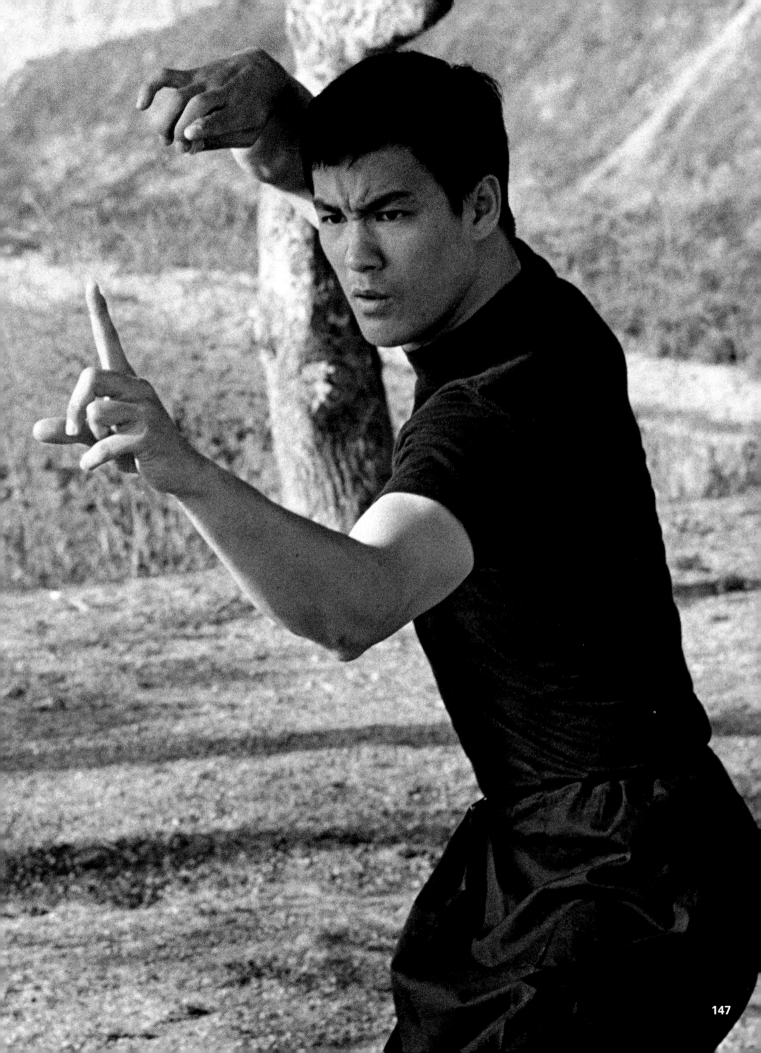

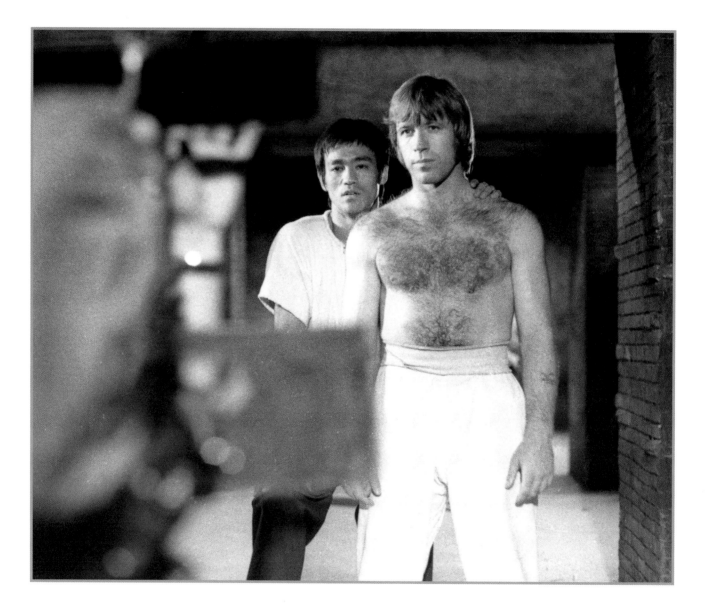

In *The Way of the Dragon,* I wrote the script, had the starring role, directed it, and produced it. I worked almost around the clock for days. I did it because it was fun. It was something I haven't done before but always had an interest in. The climax takes place in the famous Coliseum in Rome, and I have to fight an American, Chuck Norris, who has won the karate championship in the States seven times! The fight scenes between Chuck Norris and me were held in the Coliseum.

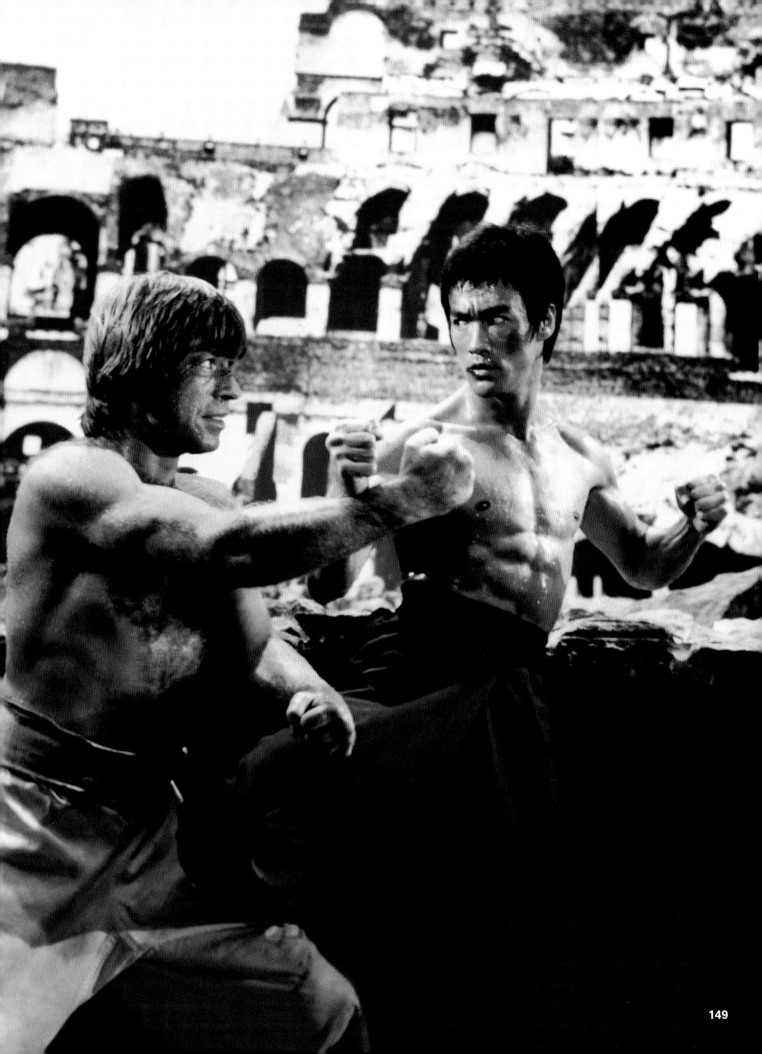

The Way of the Dragon was different from the other movies. We went to Europe for location. I also employed a Japanese photographer because I knew the Japanese had more know-how in that area than those in Hong Kong. This was the first time a Hong Kong filmmaker went to Europe for location shooting.

I wrote it in Chinese and got somebody else to polish it up a bit. I tried writing it in English at first and to have somebody translate it into Chinese, but it didn't work. The translation inevitably loses some of the original ideas. So I decided to write in Chinese with the help of a dictionary. It is quite funny really. I bought this English-Chinese dictionary originally to help me find the suitable English words when I first went to the United States when I was 18. Now I find that I have to use it to find the Chinese words which I have in mind!

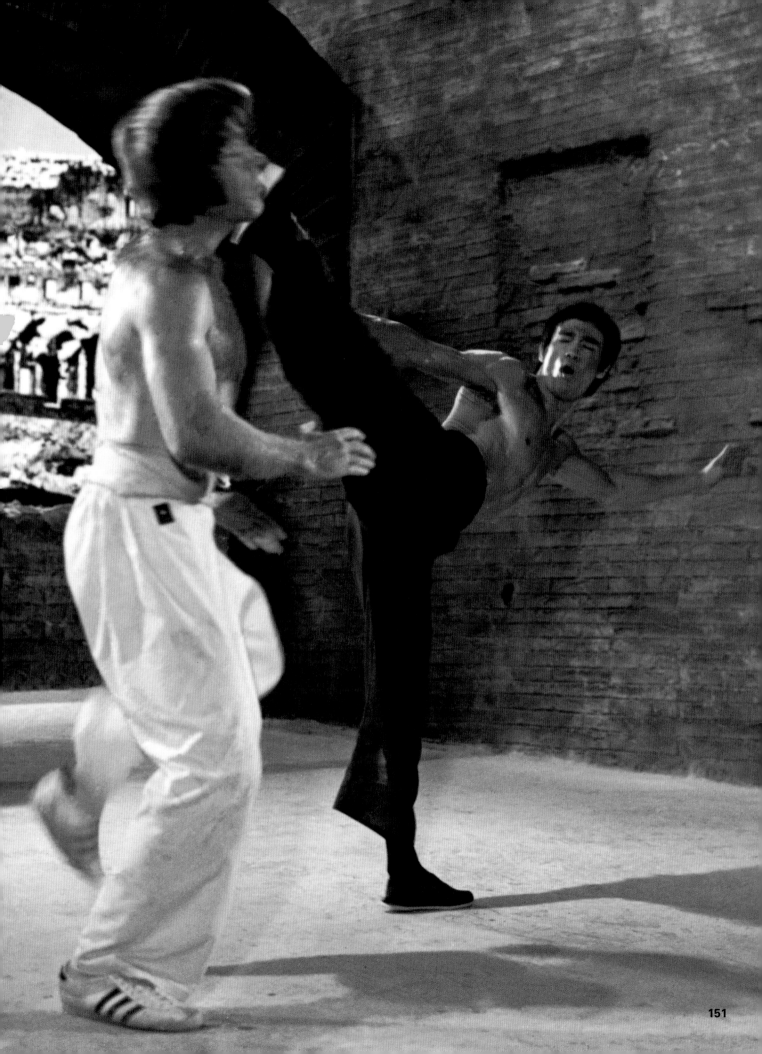

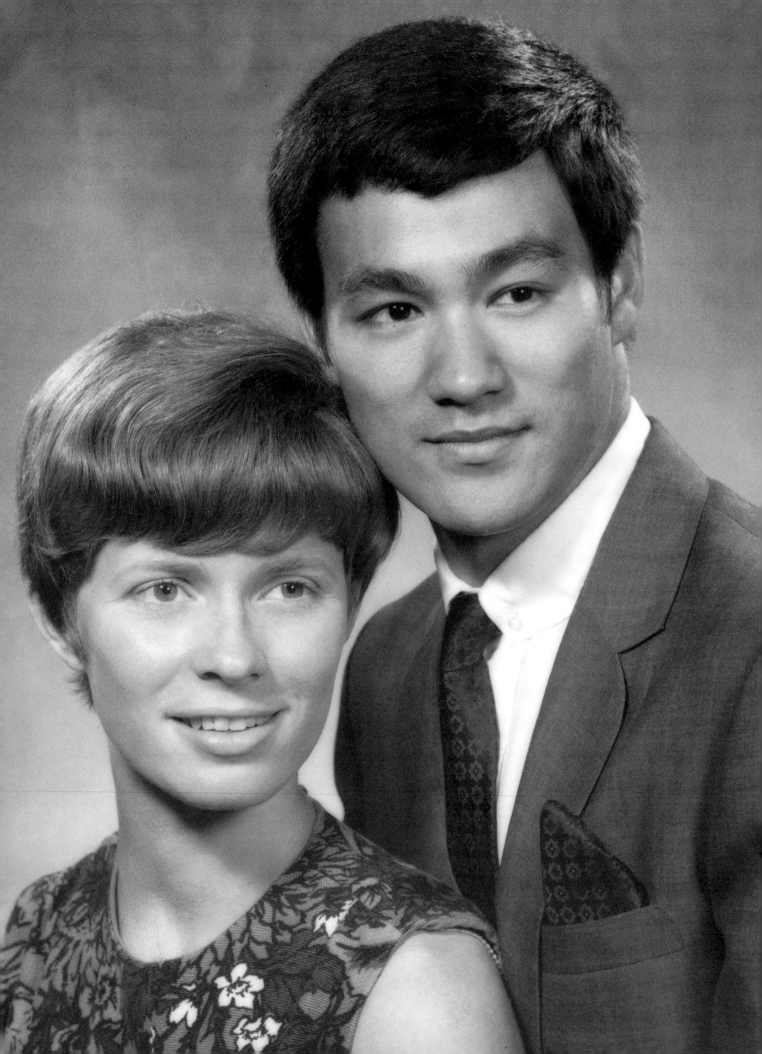

Family

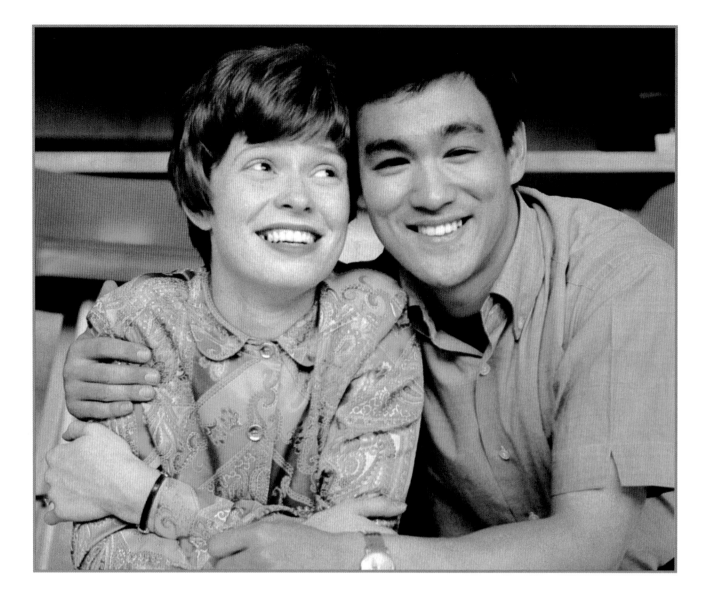

My wife is the luckiest thing that ever happened to me—not *The Big Boss.*

"Linda, thanks for the day when, at the University of Washington, Bruce Lee had the honor to meet you." A quality human being in her own right; giving, loving, stalwart, understanding this animal, Bruce Lee. My companion in our separate but intertwined pathways of growth. A definite enricher of my life. The woman I love and—fortunately for me—my wife.

When we decided to get married, we married. Just like that. We just suddenly decided, *This is it.* So why have an engagement? I remember going over to Linda's house to tell her parents that we wanted to marry. They weren't too happy at first, because they thought I was going to carry her away, across the Pacific. And, to tell you the truth, that was what we'd planned to do—go back to Hong Kong. Linda's mother and father were a little worried, especially because of the situation in Vietnam and Red China. But they were pretty nice about the whole thing... I was only interested in getting married.

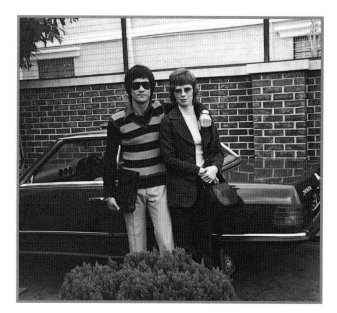

No—language was never a problem between Linda and me! We could always make each other understand.

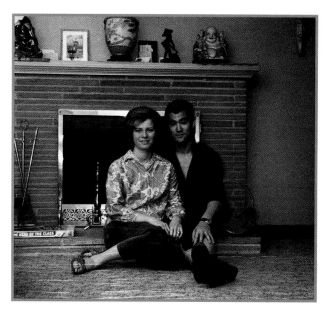

Oh, sure, we compromise sometimes and eat American food. Like, for instance, would you believe steak and fried rice?

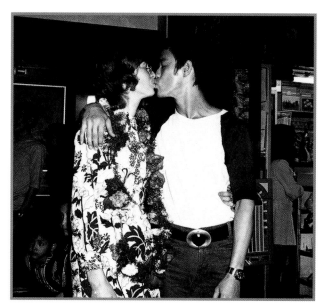

*Linda and I aren't one **and** one. We are two halves that make a **whole**—two halves fitted together are more efficient than either half would ever be alone!*

You have to apply yourself to be a family.

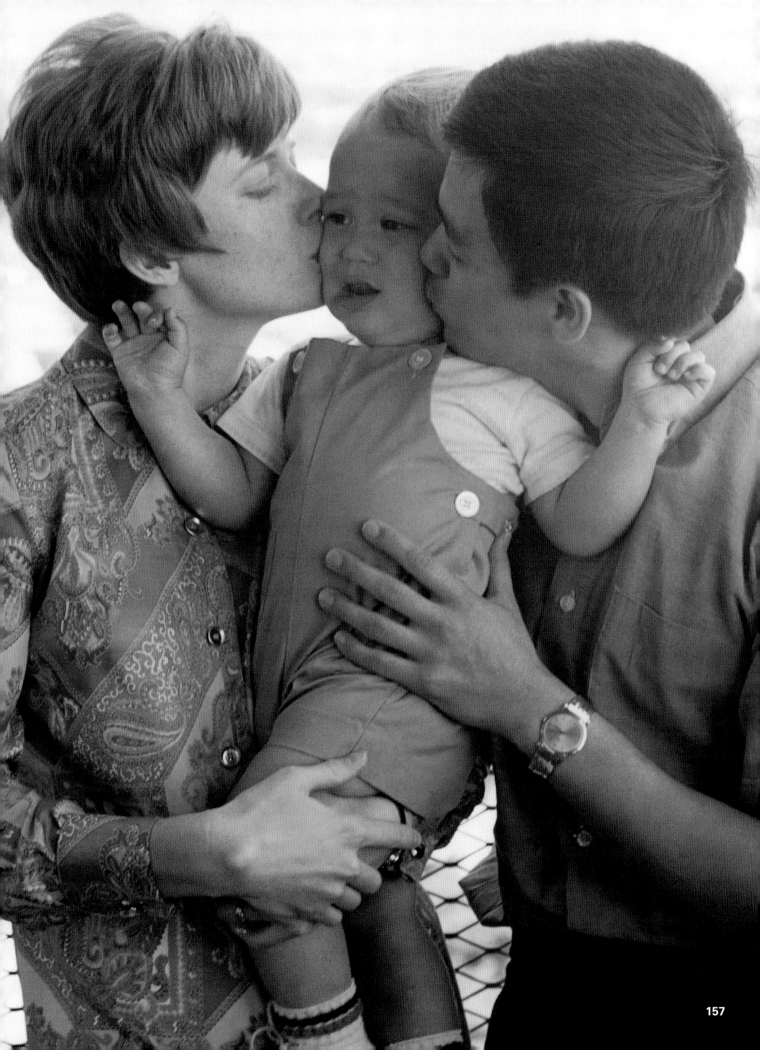

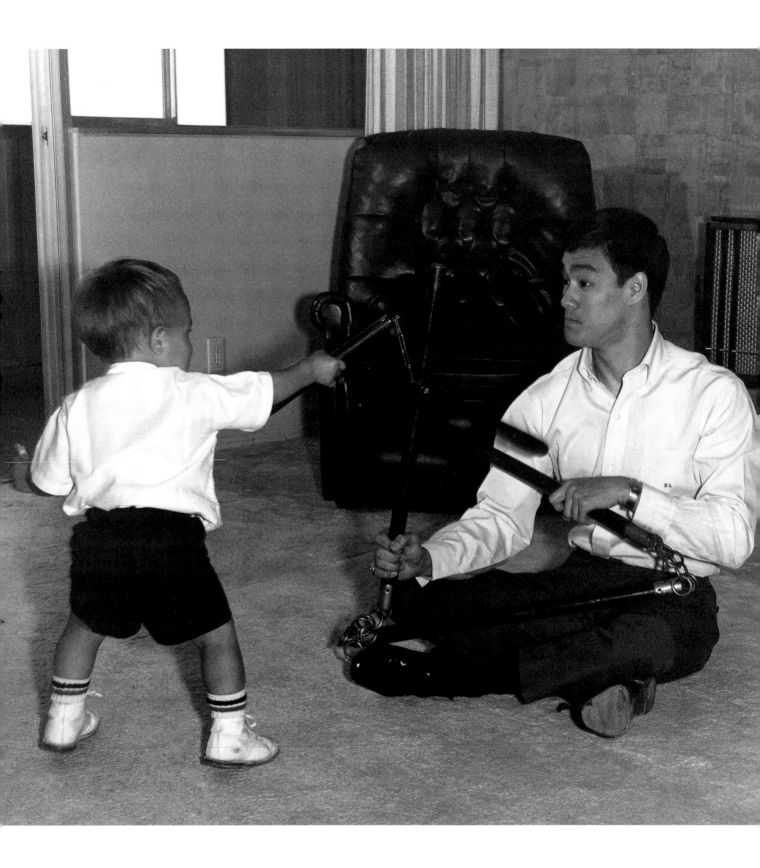

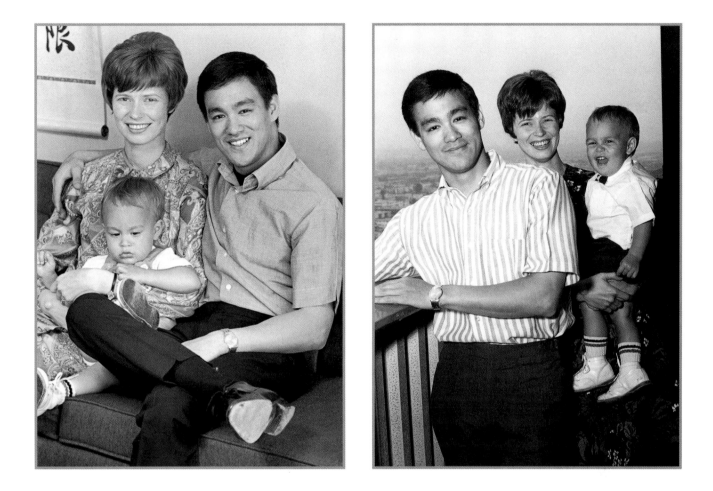

Marriage is a friendship, a partnership based solidly upon ordinary, everyday occurrences. Marriage is breakfast in the morning, work during the day—the husband at his work, the wife at hers—dinner at night and quiet evenings together talking, reading or watching television.

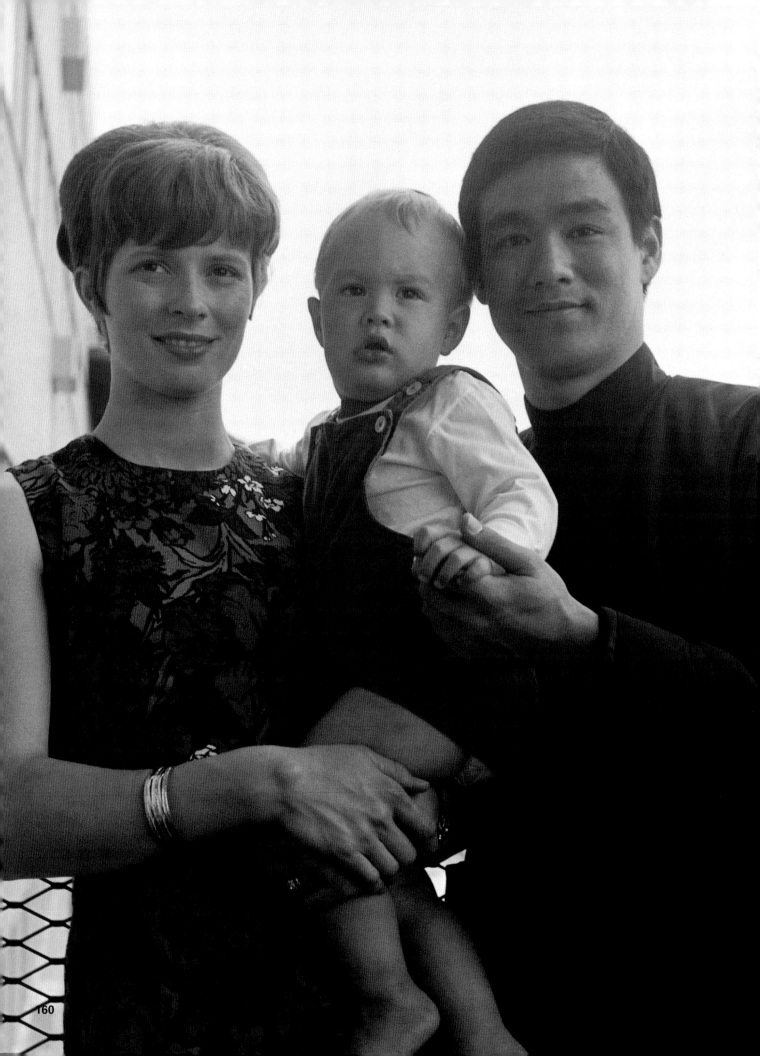

160

When Linda was pregnant the first time I was quite confident that it was going to be a boy. In fact, we only chose a boy's name for the unborn baby. We didn't even bother thinking of a girl's name. And our first child was a blond, gray-eyed Chinaman—maybe the only one around: Brandon Bruce Lee.

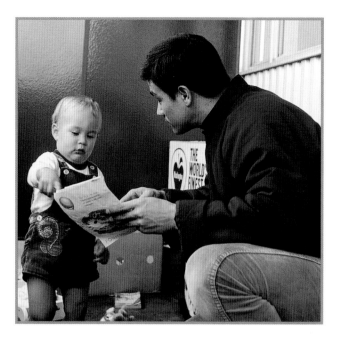

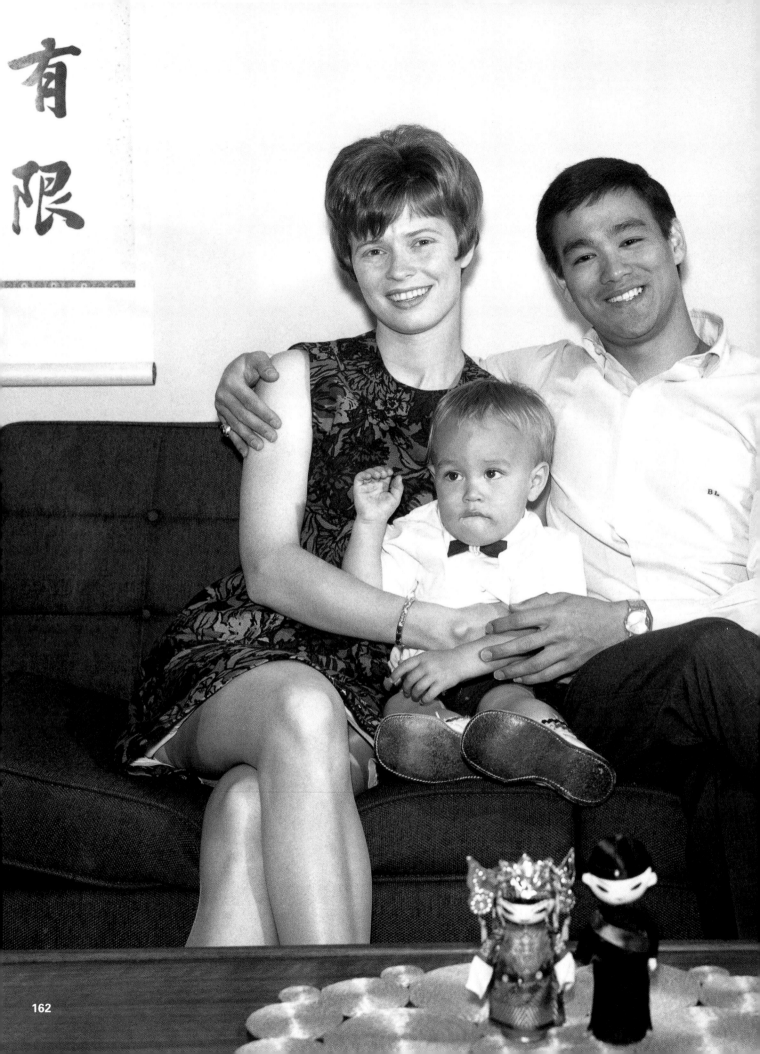

162

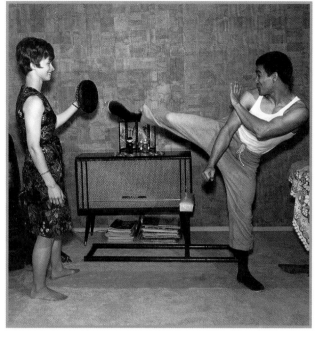

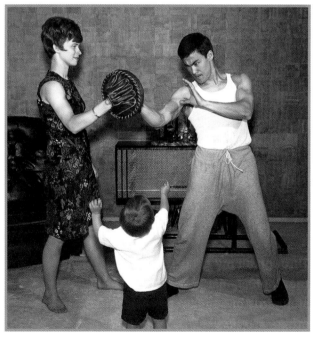

Through all my children's education will run the Confucianist philosophy that the highest standards of conduct consist of treating others as you wish to be treated, plus loyalty, intelligence, and the fullest development of the individual in the five chief relationships of life: government and those who are governed, parent and child, elder and younger sibling, husband and wife, and friend and friend. Equipped in that way, I don't think they can go far wrong.

Brandon takes after me. He is full of energy, always running around and never sitting still for a minute.

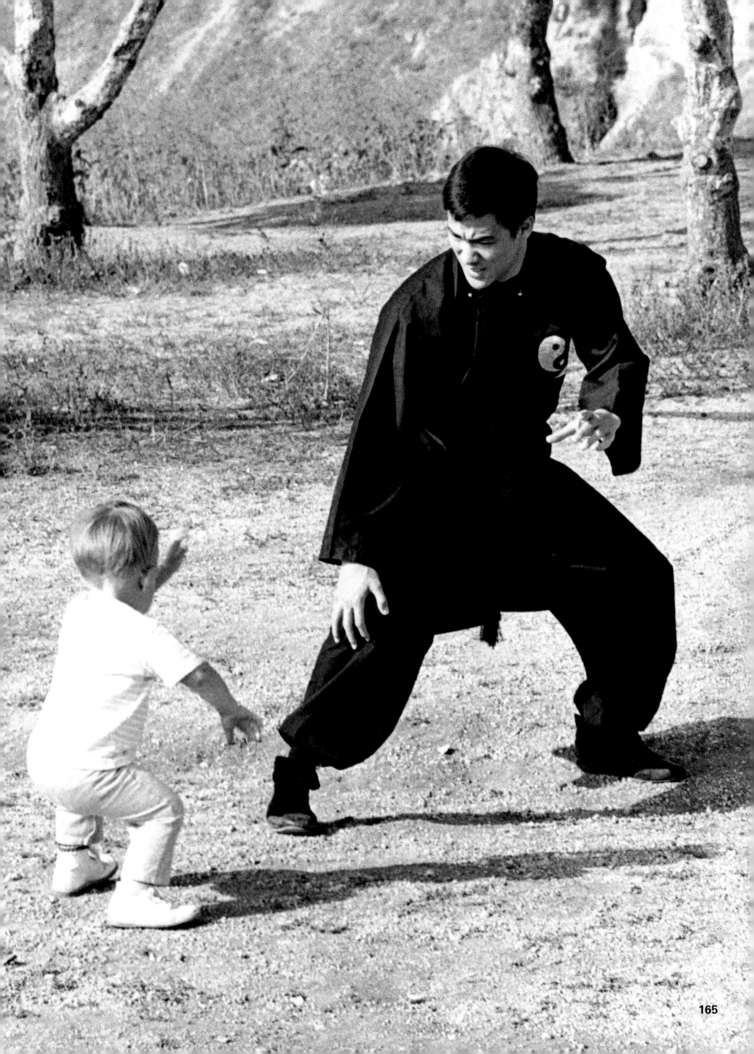

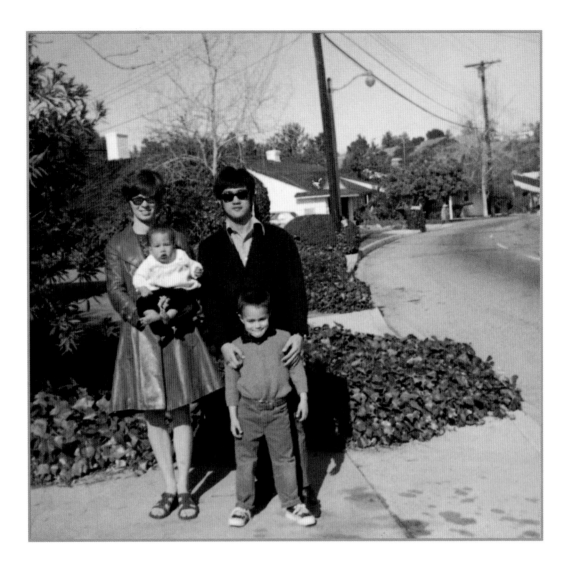

The second time I had decided it was going to be a girl, so we only chose a girl's name—and we had Shannon.

I will teach my children that nothing is superior in every respect. The Occidental education is excellent in some ways, the Oriental in others. You will say, "This finger is better for one purpose; this finger is better for another." But the entire hand is better for all purposes.

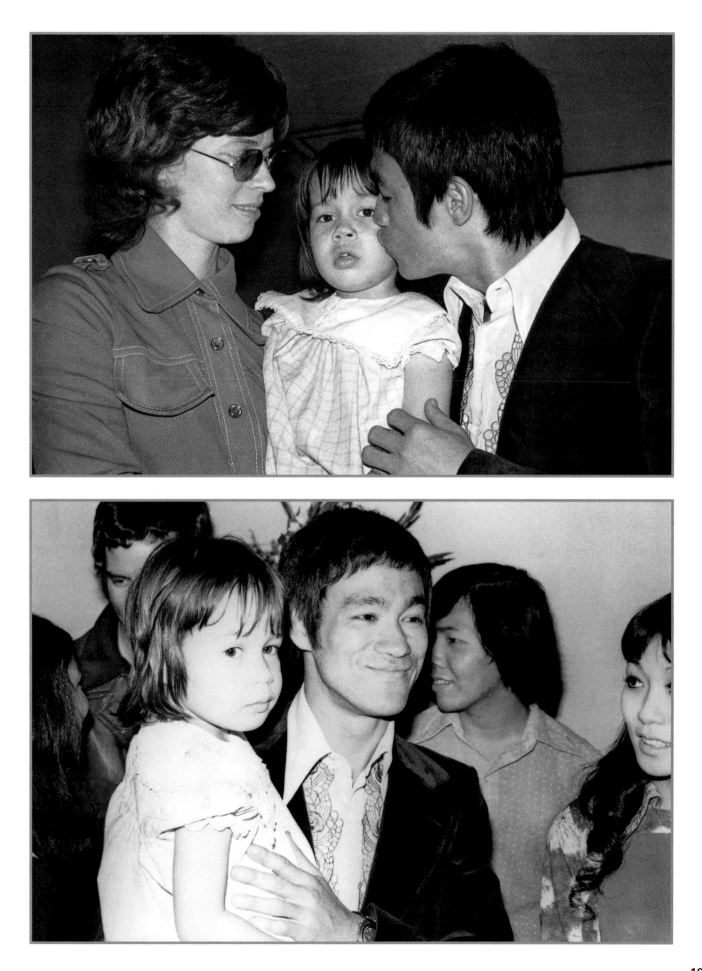

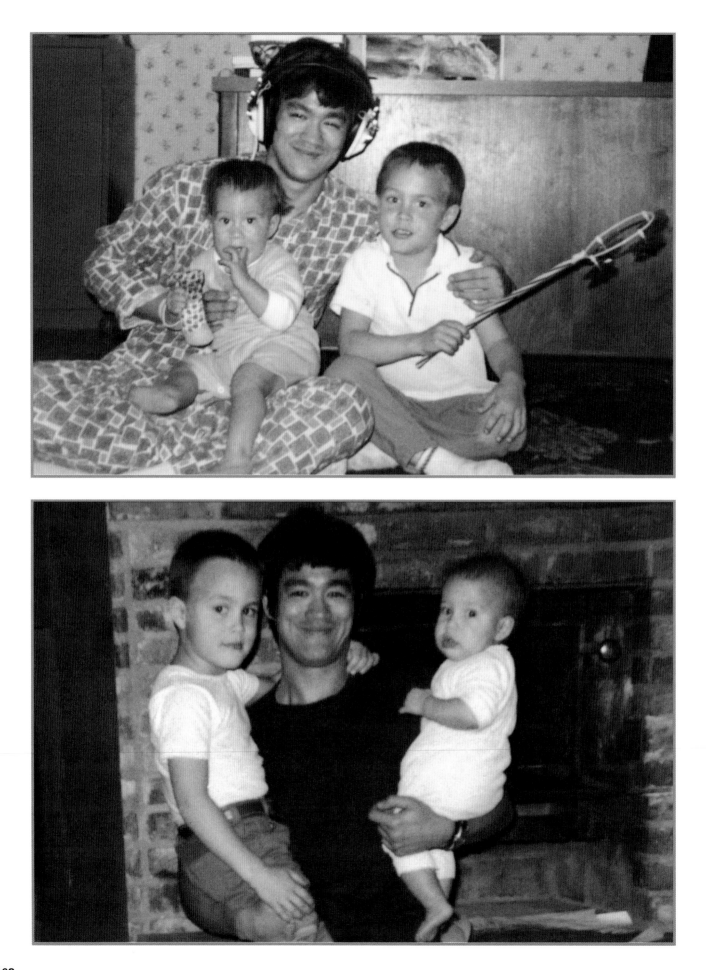

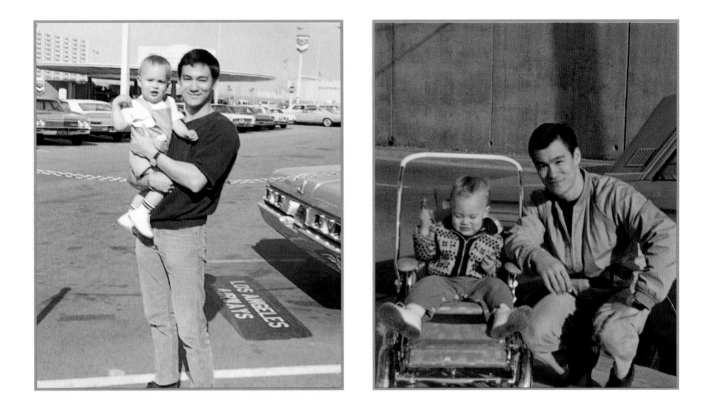

Marriage is caring for children, watching over them in sickness, training them in the way they must go, sharing worry about them and pride in them.

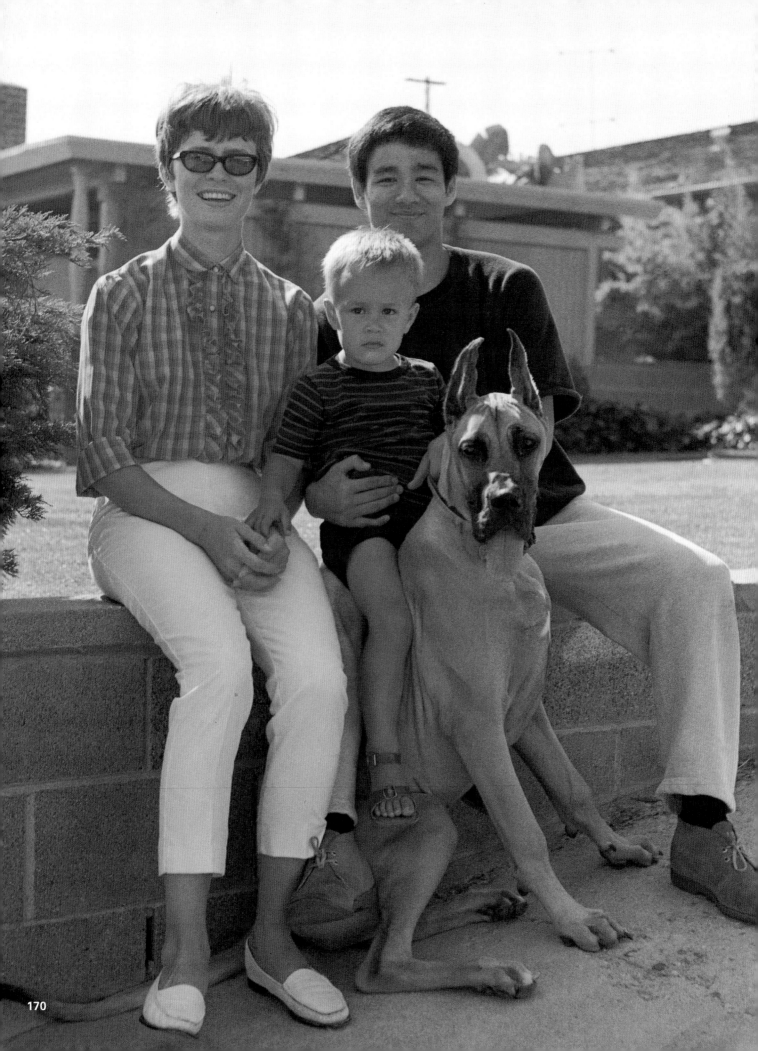

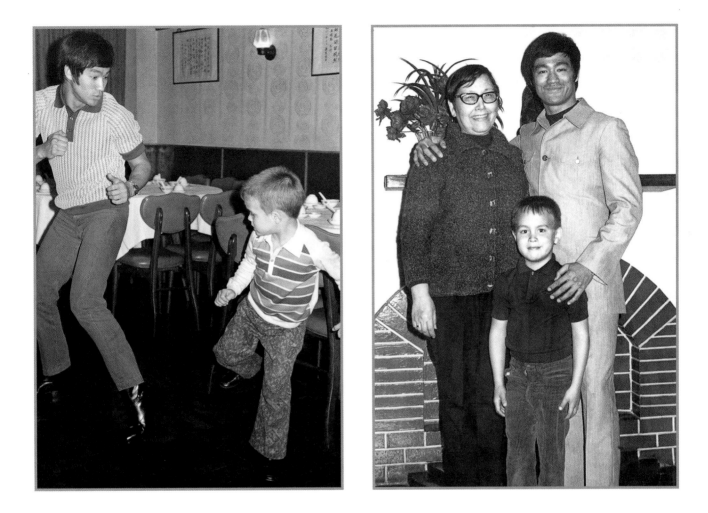

I will play … and joke with my [children], but business is business. When the subject is a serious one, you don't go around trying to keep from hurting feelings. You say what must be said and set the rules which must be set without worrying about whether [they] like it or not.

I don't know where he's going—but he's on his way.

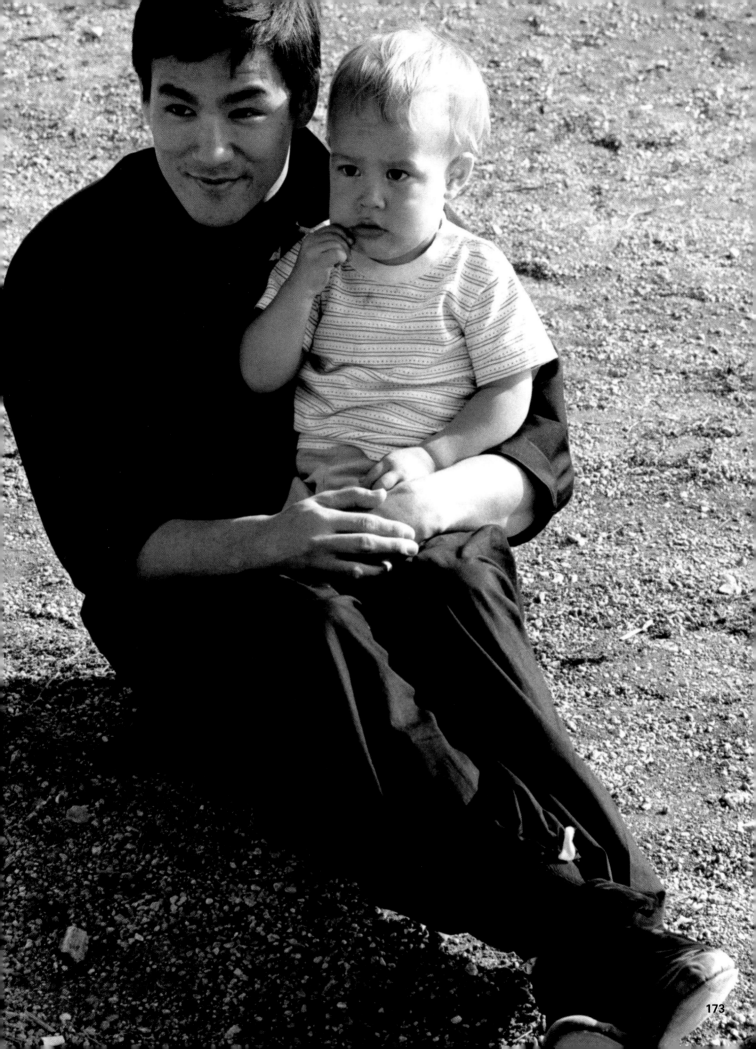

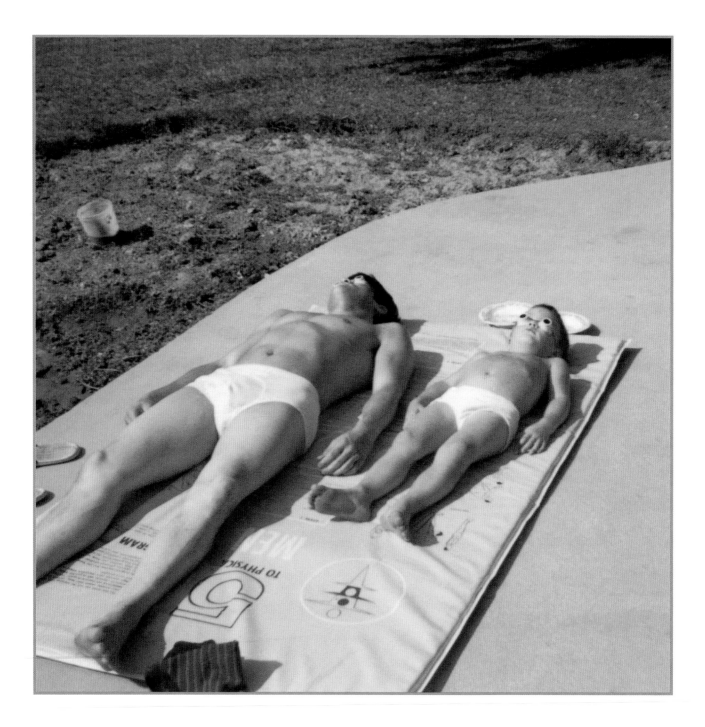

I will teach Brandon that each man binds himself—the fetters are ignorance, laziness, preoccupation with self, and fear. He must liberate himself, while accepting the fact that we are of this world, so that "In summer we sweat; in winter we shiver."

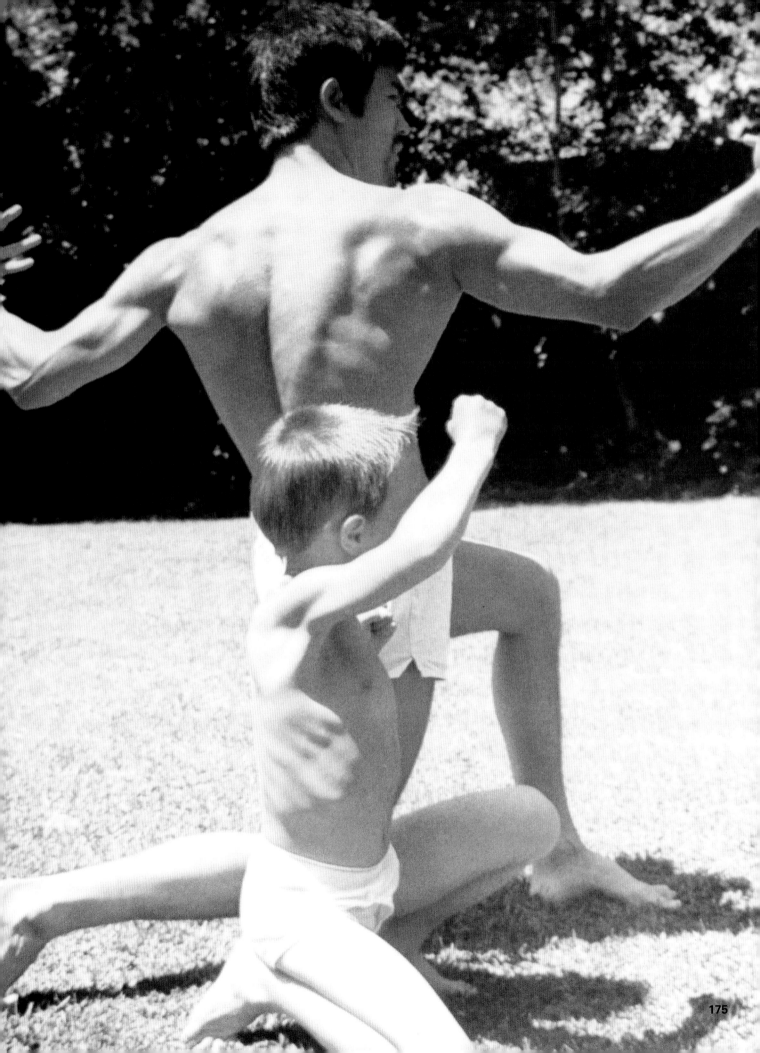

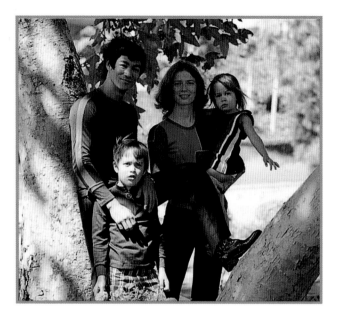

In daily living, one must follow the course of the barrier. To try to assail it will only destroy the instrument. And no matter what some people may say, barriers are not the experience of any one person, or any one group. They are the universal experience… To refuse to be cast down, that is the lesson. Walk on and see a new view. Walk on and see the birds fly. Walk on and leave behind all things that would dam up the inlet—or clog the outlet—of experience.

Even though I, Bruce Lee, may die someday without fulfilling all of my ambitions, I feel no sorrow. I did what I wanted to do. What I've done, I've done with sincerity and to the best of my ability. You can't expect much more from life.

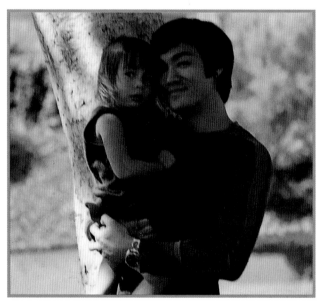

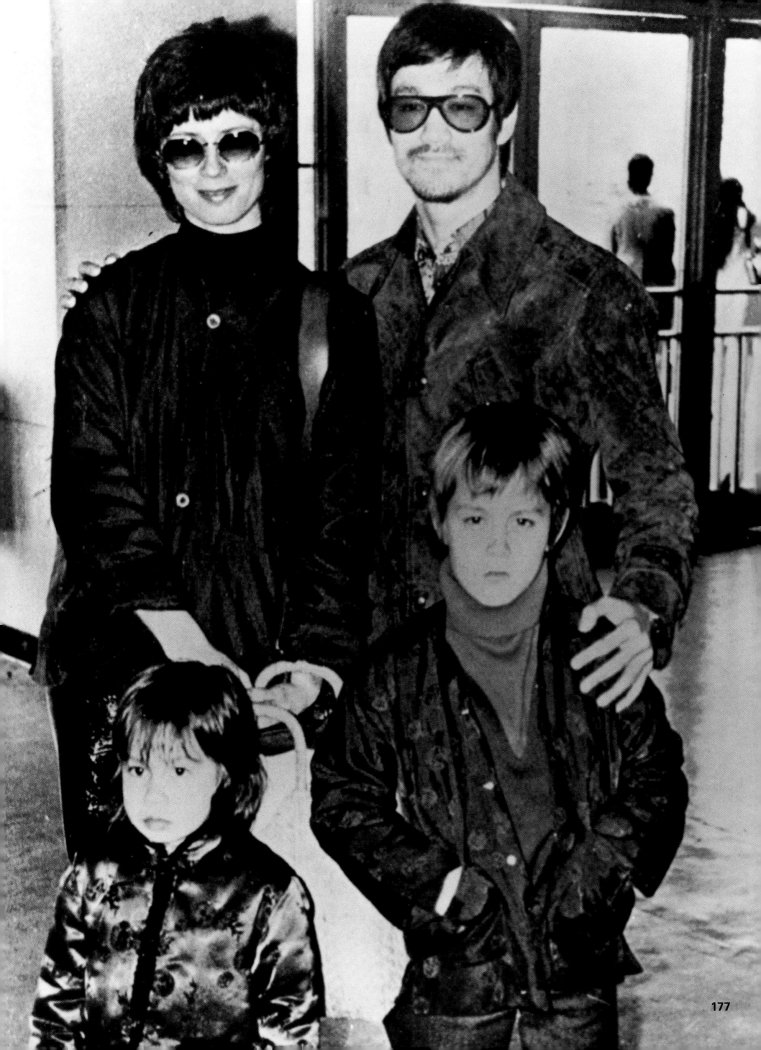

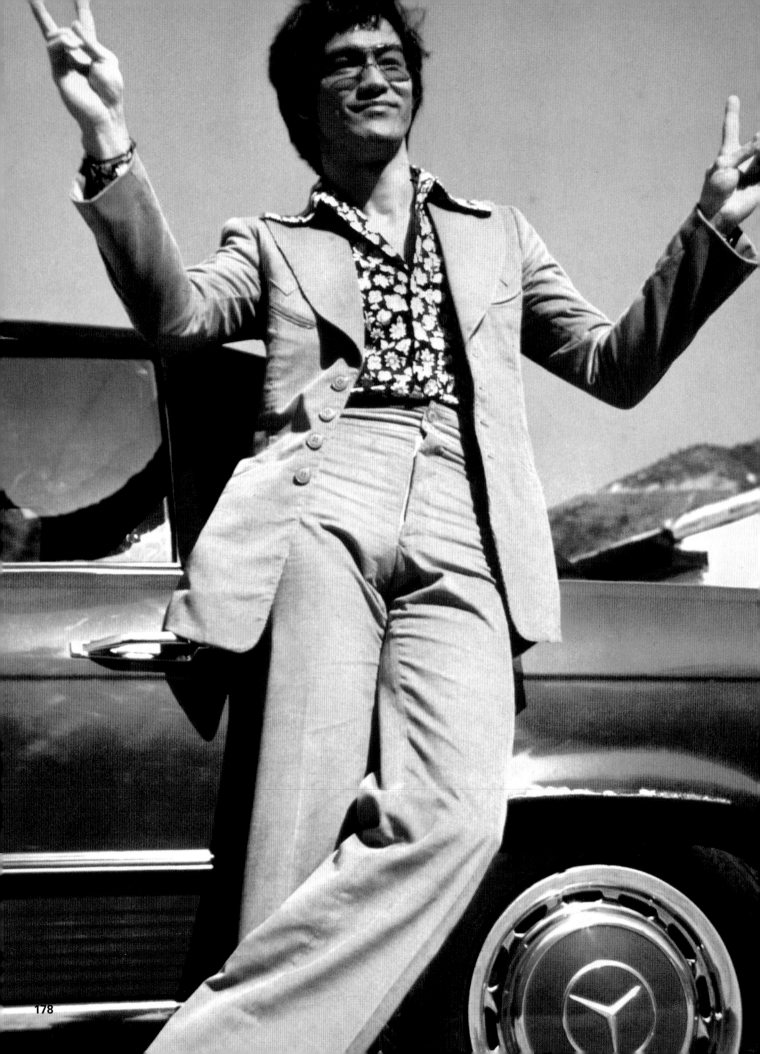

Epilogue

Like the wind before him,
Like the warrior he came.
But his time would be short
And soon to be gone,
But his legacy remains.

In June 1998, Warner Bros. and the Toronto Worldwide Short Film Festival presented the world premiere of a poignant documentary tribute to a man whose death twenty-six years before had impacted Hollywood and the world in a way not seen since the loss of James Dean in 1955. The year was 1973, and the man was Bruce Lee.

His untimely passing left a void that to this day remains unfilled. As an actor, martial artist, philosopher, and family man he had the power to heal, to inspire, to motivate, and to make this world a better place. This was the legacy he left us. Bruce Lee was the *real thing*.

In the documentary *Bruce Lee: In His Own Words,* writer/director John Little crafted a film of steadfast fidelity to the beliefs and philosophy of its subject matter. The success of the film is in part due to its simplicity. Bruce Lee tells his own story in his own words. His message and his obvious passion for his craft and his quiet understanding of the human condition embrace the viewer with a sense of discovery. Discovery of Bruce Lee, the man, and, ultimately, discovery of one's self. There is also a sense of poignancy and loss for what might have been.

One of the remarkable achievements of *Bruce Lee: In His Own Words* is that the viewer leaves the documentary with a certain feeling of privilege, the privilege of knowing the real Bruce Lee and not just Bruce Lee, the legend. John Little has succeeded in separating the fact from the myth, and as a result we enjoy Bruce Lee in person, culminating in a visual montage of rare moments with friends and family. The film works on many levels, both emotionally and intellectually and with a style that is uniquely its own.

Bruce Lee: In His Own Words opened the 1998 Toronto Worldwide Film Festival, captivated its sold-out audience and carried off the prized "Best Documentary" award. It didn't take long for the world to take notice. John Little's prestigious film was selected to support a 25th Anniversary showing of the fully-restored *Enter The Dragon* feature, at the 1998 Tokyo International Film Festival. *Bruce Lee: In His Own Words* played to standing-room-only audiences and garnered a wealth of positive media reaction. Warner Bros. acquired *Bruce Lee: In His Own Words* for inclusion in a Special Collectors 25th Anniversary Edition Box Set release of *Enter the Dragon*, which has been subsequently released on videocassette, DVD and laserdisc.

Bruce Lee: In His Own Words captures the spirit and humanity of a true legend. In John Little's documentary one ultimately comes to see that there is no distinction between Bruce Lee the legend and Bruce Lee the man—because they are, in fact, one and the same.

—*Brian Jamieson, Warner Bros.*